THE PLAY OF THE CARDS

'A bridge classic, by a famous team.'

Nigel Guthie, *Bridge Plus*

'An excellent book dealing with card play technique from elementary to advanced.'

E.P.C. Cotter,*Financial Times*

'A classic and the ideal reference book for the intermediate player.'

Irish Bridge Journal

BRIDGE BOOKS FROM ROBERT HALE

The Play of the Cards

TERENCE REESE
and
ALBERT DORMER

ROBERT HALE · LONDON

First edition 1967
Second edition 1977
First paperback edition 1991
Reprinted 1993

ISBN 0 7090 4341 4

Robert Hale Limited
Clerkenwell House
Clerkenwell Green
London EC1R 0HT

Printed in Great Britain by
St Edmundsbury Press Limited, Bury St Edmunds, Suffolk
Bound by Woolnough Bookbinders Limited

Contents

Part Two · The Defence

Part Three · End-Plays and Deceptive Plays

Foreword

This book is now published for the first time in a hardback edition. It has been slightly shortened by the omission of a few examples that were 'cute' but not especially instructive, and of some subsidiary diagrams which the reader can work out for himself.

In a book which covers the ground from elementary to the threshold of expert play* the level of instruction is bound to vary even within a single chapter. To some extent the reader must pace himself. Thus a player who does not need to be told how to manage, say, Q–x–x opposite A–x–x, may pass quickly over the first few pages of the first chapter. He will find plenty to bite on in chapters like 'Beating the Odds' and 'Detective Work in the Middle Game'.

We have given much thought to the little injunctions that appear in italics at many points of the text. If studied before and after the sections to which they relate, we believe they will go far to fix the content in the reader's mind.



TERENCE REESE
ALBERT DORMER



*The natural successors to this work are *Reese on Play* and *The Expert Game*, both published by Robert Hale.

PART ONE
Playing the Dummy

1

Building Tricks in a Single Suit

As a builder must know the quality of his materials before he can use them effectively, so a bridge player must know the best plays in each individual suit before he can combine them to carry out a tactical plan. There are only four ways in which a player can win tricks in a single suit and two of these are very simple: (1) playing a high card that no one else can beat, and (2) playing a trump on someone else's trick. The other ways are:

(3) By establishing cards which are not winners but are high enough to win if correctly handled. In the following situation North's king of hearts may win a trick even though the ace is out against him.

	North	
	♡ K 5	
West		*East*
♡ A 8		♡ Q 10
	South	
	♡ 7 3	

If a heart is led from South's hand West may either play low or put up his ace. He cannot stop dummy's king from winning a trick either now or later. The principle seen in this example – leading towards the high card, instead of leading that card itself or leading away from it – has a very wide application.

(4) By establishing long cards, which are the cards remaining in one player's hand when the other three hands are exhausted of that suit.

	♠ A K Q 3	
♠ J 8 5		♠ 10 9 6
	♠ 7 4 2	

After the ace, king and queen have been played, North's 3 is a long card and will win a trick unless an opponent can trump it.

Every trick-building move in a single suit is one of these four kinds. We consider the detailed moves under three headings: Suit Establishment, The Finesse and Safety Play.

SUIT ESTABLISHMENT

When honours are not in sequence, usually lead towards them.

Some suits can be established equally well by leading from one hand as from the other. This is so when there are sufficient high cards of adjoining rank – that is, a sequence.

	(1) *North*		(2) *North*
	K Q J		7 6 3
	South		*South*
	9 5 2		Q J 10 9

You may lead from either hand, as you intend to play a high card and there is no element of manoeuvre. The play is the same when the high cards are divided between the two hands:

	(1) Q 8 3		(2) J 10 7 3
	K J 5		Q 9 4 2

You may lead a low card towards a high card in the opposite hand, or you may lead a high card from either hand. This is safe because there are enough high cards to allow one to be played on each round of the suit. When the high cards are not in such good supply it is generally right to play towards the hand that contains the honour or honours.

	(1) K Q 6		(2) Q J 2
	8 7 5		6 4 3

Suppose that in (1) the declarer leads a high card from the dummy. Following the general principle of capturing an honour

with an honour, a defender will play the ace and declarer will win only one trick. The right play is to lead twice up to the dummy, winning two tricks whenever the ace is held by West, for then it cannot be used to capture the king or queen.

In (2) you must lead twice up to the Q–J–x. This way, you win a trick unless both the ace and king sit over.

When the honour card is unsupported it is equally important to lead up to it rather than away from it:

(1) Q 8 4 (2) J 5 3 2

 A 7 3 A K 4

In (1) the object is to establish dummy's queen. The best way is to lead low from the South hand, hoping that West holds the king. If so, the queen will win a trick either now or later.

It is true that by not playing the ace first you give up the chance of dropping a singleton king in East's hand. That is an exceedingly small chance, however, less than 1 per cent, and furthermore, if West held J–10–9–x–x–x, there would probably have been some indication from the bidding or previous play. Thus, for the sake of control, you ignore the possibility of a singleton king. But with (2) there is a genuine chance of dropping the queen in two rounds, about 18 per cent. Therefore you must play off the ace and king before leading up to the jack.

Play to establish long cards as well as high cards.

We consider next how to build tricks with long cards. If you hold enough winners in a suit you may be able to develop long cards without conceding any tricks at all, but often you will have to let the opponents win one or more tricks on the way.

(1) A K Q 5 3 (2) A K 7 6

 7 2 8 4 3

In (1) you can play off the ace, king and queen, and if the opponents follow to all three rounds you immediately have two long cards in dummy. If one opponent holds four cards, the distribution against you being 4–2, you can still establish one long card by playing a fourth round.

In (2) you must give up a trick to the opponents before you can possibly establish a long-card winner. You can give it up on the first round, or after playing one top card, or after both top cards. The chances of establishing dummy's fourth card are evidently the same in each case, depending entirely on a 3–3 break of the outstanding cards. That is about a 36 per cent chance.

Often the process of establishing long cards is slower.

(1) A 8 7 5 3 (2) 9 8 5

 6 4 2 7 6 4 3

In (1) a 3–2 break of the outstanding cards will enable you to develop two long-card tricks to add to the ace, but you will have to give up two tricks on the way. As before, you can lose these tricks immediately or after you have made the ace. Your method of play will be affected by tactical considerations. For example, playing a notrump contract, you might duck the first round and play the ace on the second round. If you find that an opponent shows void on the second round you can then abandon the suit if you want to. Alternatively, for reasons of entry, you might duck the first two rounds, preserving the ace as an entry card.

In (2) South has no high cards at all, but after three rounds he may find that his own fourth card is a master. In actual play a declarer would seldom set about establishing such a suit, but the opponents, seeing three low cards in dummy, might play it. Of course, South makes a trick only when the suit is divided 3–3.

It is important to understand the chances of developing long cards with different combinations, for in play you will often have a choice beteween developing one suit or another. The full figures are given at the end of this chapter, but the following is a sufficient guide in most situations:

An even number of cards in the opponents' hands is unlikely to divide equally. Thus 2–2 is a little less likely than 3–1, 3–3 less likely than 4–2, and so on. Two cards form an exception: 1–1 is a little more likely than 2–0.

An odd number of cards in the opponents' hands is likely to divide as equally as possible. Such divisions as 2–1, 3–2 and 4–3 are all much better than a 50 per cent chance.

This knowledge helps the declarer to judge where to play for extra tricks when there is more than one suit that can be developed. In the

following examples only the major suits are shown:

(1) ♠ A 8 5 3 (2) ♠ A K 7 6 5
 ♡ K 6 4 2 ♡ 8 6 2

 ♠ 7 6 4 2 ♠ 9 2
 ♡ A 8 5 ♡ A K 4 3

In (1) the opponents hold an even number of hearts and these are not likely to break 3–3, the only division that will help you. But they hold an odd number of spades, and these are likely to divide in the most even way possible, 3–2. You therefore have a better chance of establishing a long spade by ducking twice than a long heart by ducking once.

In (2) East-West hold six cards in both suits and a 3–3 division of either is the same percentage chance. Other things being equal, South would tackle the spade suit rather than the hearts, as a lucky break in spades would yield two long cards. Even if the spades were 4–2, one long card could be established by giving up the fourth round.

Build high cards and long cards in the same suit.

Often there are chances to develop both high-card and long-card tricks in the same suit. It may be important now to lead from the right hand:

K Q J 3

7 6 5 2

Against a 3–2 break South can make three tricks even if he leads from dummy, for after dummy's king, queen and jack have been played both opponents will be exhausted and the long card will be a winner. But there are two situations where leading from the North hand will cost a trick. These are when West holds either a singleton ace or A–10–x–x. If entries permit, therefore, you should plan to attack the suit from the South side. When West has a singleton ace, just one lead from South will save a trick, but when West has A–10–x–x you may have to lead three times up to dummy, which often will not be practicable.

What do you do when the honours are divided between the two
hands? The answer depends on whether you hold more honours in
one hand or the other.

(1) K Q 6 2 (2) J 10 5 4

 J 5 4 Q 6 3

With two honours in North's hand and only one in South's, the
correct line is not unexpected: you lead twice towards the hand that
contains two honours. In diagram (1) South can win three tricks
whenever the suit breaks 3–3 and also when West holds A–x, for
when South leads from his own hand again on the second round, the
ace will beat the air. Similarly in (2) it is desirable to lead twice up
to J–10–x–x. This gains a trick when West holds K–x or A–x.

Next question: suppose there is one honour in each hand? Take
first the occasions when the suit is not equally divided:

(1) K 8 4 2 (2) Q 6

 Q 3 J 7 5 3

The general principle is to lead up to the honour in the shorter
hand. In (1) you lead from dummy and put on the queen. If it holds
you return the 3 and duck in dummy, as you place the ace with East.
On the next round you again play low from dummy. You make a
second trick whenever East holds the ace not more than twice
guarded.

With (2) you lead low to the queen, which will probably lose to
the ace or king. On the next round there are two possibilities. You
can either play East for both ace and king, in which case you will
lead up to the jack, or you may judge that the top honours are more
likely to be divided. In that case you will play low on the second and
on the third round, hoping that the jack will eventually become
established.

When you hold one honour in each hand and the suit is equally
divided you are forced, as bridge players say, to 'take a view'.

K 8 4 2

Q 6 5 3

You can make three tricks from this combination if you can find either opponent (but you must guess which) with A–x. Suppose you think West is more likely than East to possess this particular holding. You lead low to the king and duck on the way back. If you were right, the ace will win and you will make the rest of the tricks. This play, by tradition, is called an obligatory finesse, since after the king has held in dummy you are more or less obliged to play low from hand on the next round. However, the play is not really a finesse, as we shall see in the next section. The same type of play is made with this holding:

<p align="center">J 7 5 3</p>

<p align="center">Q 6 4 2</p>

There is a way of making two tricks if one opponent holds a doubleton honour or holds both honours. Suppose it is East. You lead low from dummy and probably the queen will be headed by the ace or king. On the next round you duck, hoping that the missing high honour will be played by East.

<p align="center">THE FINESSE</p>

<p align="center">*Try to win tricks with honours that are not your highest.*</p>

So far we have been looking at ways of forcing out an opponent's high cards. Finessing is a way of circumventing the high cards by taking advantage of the positional factor in card play.

<p align="center">A Q</p>

<p align="center">7 2</p>

In this elementary situation South leads up to dummy and finesses the queen, winning the trick whenever the king is held by West.

The declarer often needs to take more than one finesse in the same suit.

(1) A Q J 10	(2) A K J 10 9
8 5 3	8 5

If a first-round finesse is successful, South will attempt to re-enter his hand for a second finesse. Sometimes he will be able to repeat the finesse without requiring a second entry:

(1) A Q J 9 4 (2) A J 10 4

 10 7 2 Q 9 5

In (1) you will lead the 10 from hand, so that if it holds you can finesse again immediately. With (2) the best card is the 9. It is not quite so effective, in terms of entry, to lead the queen, for after you have played the 4 from dummy and have finessed the 10 on the second round you will need to re-enter your hand for yet another finesse in case West held K–x–x–x originally.

Lacking a strong sequence, lead low for a finesse.

It is important to realize in these last two examples that you could afford to lead a relatively high card only because you held strong intermediates. The general rule, when you are leading for a finesse, is to lead low. Study these two positions:

(1) A Q J 5 (2) A J 10 7 4

 10 6 2 Q 6 3

In (1) leading the 10 will cost a trick when West holds a singleton or doubleton king. In (2) the queen will cost when West holds a singleton king, for East's 9–x–x–x will control the fourth round. In neither case is there any trick-building advantage in leading the high card, though this may save entries when the distribution is favourable.

To lead a high card would be still worse in these very common situations:

(1) A Q 7 4 2 (2) A Q 10 6 4 2

 J 5 3 J 5

If West holds K–x you can develop five tricks from the first combination by finessing the queen and laying down the ace. If you

lead the jack first you must lose at least one trick however the cards lie, for if West holds the king he will play it on the jack.

The same principle applies in (2). In the conditions of actual play it may be convenient to lead the jack, but this play costs a trick when West holds a singleton king.

With a combination of honours, finesse the lowest first.

When it is possible to finesse more than one card in the opposite hand, you stand to win most tricks by finessing the lower honour.

(1) K J 4 (2) K J 10

 6 5 9 6 5

In (1) the only way to win two tricks is by finessing the jack on the first round, hoping that West will hold both ace and queen. The same principle applies in (2). Here the important card is the queen, not the ace. You begin with a finesse of the 10, winning two tricks whenever West holds the queen. To play the king first would gain only when East held a singleton queen.

The principle of finessing the lowest honour does not apply when you hold so many cards that you could achieve your aim with a single finesse:

(1) A Q 10 6 4 2 (2) A K J 9

 8 7 5 3 7 6 4

In (1) you lead low and West plays the 9. Your best chance is to finesse the queen, not the 10, which would gain only when West held all three outstanding cards. With (2) the normal play is to cash the ace first and finesse the jack, winning four tricks when you find West with Q–x–x. With a card fewer – A–K–J–9 opposite x–x – it would be in order to take the deep finesse of the 9 and follow with a finesse of the jack.

A finesse aimed against two honours in sequence, like K–Q or Q–J, is called a combination finesse.

(1) A J 10 (2) K 10 9 2

 8 5 3 6 5 4

In (1) South finesses dummy's 10 and if this loses he re-enters his hand to finesse the jack. The second finesse will lose only when both missing cards are in East's hand, so there is a 75 per cent chance of winning two tricks. In (2) South finesses first the 9, and later the 10. He has a 61 per cent chance of making two tricks with this combination. If dummy held the 8 instead of the 2 the chances would be as high as 76 per cent.

These are further examples of a combination finesse:

(1) A J 9 (2) Q 10 2

 7 6 4 8 5 3

As usual, declarer begins by finessing the lowest card of the combination. In (1) he finesses the 9, and if this brings forth the king or queen there is a good chance that a finesse of the jack will win on the next round. In (2) the chances of making just one trick by leading up to the 10 first are similar. In each case success depends on the combination of an even chance with a three to one on chance – $37\frac{1}{2}$ per cent.

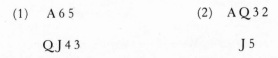

Do not take finesses that do not stand to gain.

There are several important positions where a finesse is playable but is not the best way to develop tricks.

(1) A 6 5 (2) A Q 3 2

 Q J 4 3 J 5

Suppose that in (1) you begin by leading the queen. On any 4–2 division you will end up with two tricks only. Now try playing the ace first, then low towards the Q–J–x. As compared with the other method, you gain when East holds K–10–x–x or K–x, for the queen and jack will both take tricks. Thus when your aim is to establish three tricks it is a mistake to finesse. Playing up to Q–J–x–x gives you a 69 per cent chance of making three tricks. In actual play you may need only two immediate tricks, and then you will lead the queen for a finesse.

Similarly with (2), if you lead the jack, or even small towards the A–Q, you will seldom make more than two tricks. (Remember that

the defender should cover the jack if he holds the king.) The superior line is low from dummy up to the J–x. If East has the king and plays it, three tricks are established. If East plays low from K–x or K–x–x you still make three tricks, for after winning with the jack you duck (or play the ace) on the way back. Playing this way, you have an 18 per cent chance of making three tricks. Again it must be remarked that in the context of a full deal it will often be right to take a straightforward finesse.

With a two-way finesse, consider which option offers the better chance for the maximum number of tricks.

Sometimes it is possible to play either opponent for a particular high card. Even so, one way of finessing may be better than the other.

(1) A J 10 (2) A 6 4 3

 K 9 5 2 K J 10 2

Tackling the first combination with the sole object of winning three tricks without loss, South has a genuine two-way finesse for the queen, but if the aim is to win as many tricks as possible he should play East for the queen, cashing the ace first and continuing with the jack from the North hand. This takes care of a singleton queen with West and also of Q–x–x–x with East. If he decides to play West for the queen, South's best play is to finesse dummy's 10 on the first round; he gives up the chance of dropping a singleton queen in the East hand but can pick up West's Q–x–x–x.

With the second combination the best chance for four tricks, other things being equal, is to cash the ace and finesse through East. South can pick up Q–9–x–x in the East hand without loss, but if those cards are in the opposite hand South cannot win four tricks however he plays.

When the jack is the only missing honour it is usually right to play for the drop when seven cards are in sight. With six cards the finesse is slightly superior.

(1) A Q 10 2 (2) A Q 10 2

 K 9 3 K 9

South can finesse either way for the jack but this is not the best way to win four tricks with the first combination. Unless there is some special clue to the distribution South should start with the ace and king, continuing with the queen and winning four tricks 61 per cent of the time.

With the second combination the jack is less likely to drop since the opponents hold seven cards instead of six. The best chance for four tricks is to lead the king and then finesse the 10.

With eight cards in the combined hands declarer knows the jack will fall unless an opponent shows void on the second round. The art is to leave oneself in a good position should that happen.

(1) A K 3 2 (2) A Q 10 2

 Q 10 6 4 K 9 5 3

By playing the ace and king in the first example South discovers a finesse if East holds J–x–x–x. If West holds those cards the jack cannot be captured. In the second example South can discover a finesse against either hand, so in deciding whether to play West or East for J–x–x–x he will be guided by what he can deduce about the distribution.

When there is reason to suppose that a simple finesse for the queen is likely to lose, declarer will sometimes be able to attempt what is called a backward finesse.

(1) K 5 2 (2) A 9 8

 A J 9 K J 4

These two diagrams present different faces of the same idea. Suppose that South places West with the queen. Instead of taking the normal finesse he can lead the jack from hand. If West covers, South takes a finesse against the 10 on the way back.

Since it depends on two cards being placed in a particular way, a backward finesse offers only a 25 per cent chance of success. For this reason the play is much more the property of the defending side, who may see that ordinary play cannot gain.

 10 8 2
 K 5 4 A J 9 6
 Q 7 3

East is on lead and proposes to tackle this suit. Seeing the 10 in
dummy, he realizes that the lead of the jack may gain if South holds
the queen and is unlikely to lose in any other circumstances. On the
lead of the jack the defenders can win all the tricks. Had East led a
low card instead, South would have ducked and the queen would
have become a stopper.

A backward finesse against the jack is playable with a
combination such as Q–10–8 opposite K–x–x. Here, too, the play is
made much more often by the defence.

 J 6 4
 K 10 8 5 Q 7 3
 A 9 2

If West opens up this suit his right lead is the 10. This way, the
defenders can take three tricks. If West leads low, then declarer will
play low from dummy and will have a double stop.

SAFETY PLAY

*Look for a sequence of play that may provide against
an unfortunate distribution.*

This term 'safety play' has a wide meaning in bridge. It covers many
plays that in fact do no more than provide an extra chance. This first
example is of a safety play in the literal sense:

 A Q 10 6 4

 K 9 5 3

Here the safety play is to lead the ace or queen first, so that you
will be able to pick up J–x–x–x in either opposing hand. The
following are also described as safety plays:

 (1) A J 5 4 3 (2) K Q 9 5 3

 K 9 8 6 2 A 6 4 2

In (1) South cannot win all the tricks if East holds Q–10–x. However, leading the king first is a form of safety play, for it enables South to pick up Q–10–x in the West hand at least. In (2) the safety play is the ace first, as this enables declarer to take two finesses against the J–10–x–x when East shows void on the first round. The same principle arises with these holdings:

(1) A Q 9 6 4 2 (2) K J 7 4

 J 8 5 3 Q 8 6 5 2

In (1), with K–10–x missing, the finesse offers a better chance than playing off the ace. The safety play is to lead the jack, for then if East shows void you can pick up West's K–10–x without loss. Clearly, if you began with a low card and finessed the queen, West's K–10 would win a trick for the defence. With (2) the safety play is to lead the queen first. This enables you to pick up A–10–9–x in the West hand. There is nothing you can do about it if East holds those cards.

It is often a close question whether to finesse or play for the drop. There is a saying, 'eight ever, nine never', which means that with eight cards you should finesse for a queen, with nine cards play for the drop.

(1) A J 7 5 3 (2) A J 7 5 3 2

 K 6 4 . K 6 4

With the first combination, after you have played the king followed by the 6, the odds favour a finesse. With the second combination the odds favour playing for the drop, but very slightly, and if there is anything in the play to suggest that East may be short a good declarer will finesse, playing for a 3–1 break.

Another point to consider is whether you can afford to play off a high card 'for safety'.

(1) A K J 2 (2) A K J 10 3 2

 10 9 6 4 7 5

With eight cards in each example South intends to finesse for the

missing queen. In (1) he should cash the ace first, if convenient, for the queen may be singleton and the finesse can be taken equally well on the second round. In (2) it is better to finesse on the first round. Playing off the ace may drop a singleton queen, but meanwhile you have lost the chance of picking up the whole suit when East holds any other singleton and West holds Q–x–x–x.

The most frequent opportunities for safety play occur when declarer can afford to lose one trick in the suit, but not more. The term is most apt when the chance of winning all the tricks is deliberately forgone, as in these two examples:

(1) A Q 8 5 2 (2) A K J 3

 7 6 4 3 7 6 4

As often, the safety move consists in refusing a normal finesse. In (1) the play that gives the best chance of four tricks is the ace first. Then South returns to hand to lead up to the queen. The safety play gains when East has a singleton king. In (2) the safety play is similar: play off ace and king, then return to hand to lead up to the J–x. This saves the vital trick when East has Q–x.

These are two cousinly plays that find their way into most of the text-books:

(1) A 9 5 (2) K J 3

 K J 7 4 2 A 9 6 5 2

With (1) the safest play for four tricks is to lay down the king and then lead low with the intention of finessing the 9 if West follows with a low card. This play is proof against any 4–1 division. With (2) the play is king first, then back to hand for a lead up to the J–x. This again is safe for four tricks against any 4–1 break.

There are also occasions for the opposite stratagem. Instead of playing off high cards, as would seem normal, declarer finesses for safety.

(1) K 5 3 (2) A 4

 A 10 7 4 2 K Q 9 8 3

In (1) you play off the king and follow with the 5, on which East plays low. Now you must finesse the 10, because East may have started with Q–J–x–x. In (2), if the objective is to make four tricks safely, not five, you play the ace and then take a deep finesse of the 8 on the second round. If West follows suit the remaining cards will be high. The deep finesse gains when East holds J–10–x–x–x. Note that it would not help East to split his honours, playing the 10 or jack on the second round, for then the 9 and 8 would be equals against the remaining honour.

The same idea appears here in another form:

K 10 3 2

A 9 8 5 4

You can make certain of losing only one trick by leading low from either hand and putting in the 9 or 10 if no honour comes up. This play takes care of the 5 per cent chance of the wrong opponent holding Q–J–x–x.

There is a further point worth making in connexion with the holding above. Suppose that, playing to make five tricks, you lead the king and the queen or jack appears from West. Now you have the choice between playing for the other honour to drop on the next round or playing East for J–x–x or Q–x–x. In this situation, and most like it, the better chance is to finesse on the second round.

Many close decisions arise when a suit is divided 4–4.

(1) K 10 4 3 (2) J 6 3 2

 A 9 6 2 A K 8 5

One way to play the first combination is to finesse dummy's 10 and follow with the king if this loses. This plan wins three tricks unless East holds a lone honour and offers a 94 per cent chance. The same chance, initially, is offered by leading from dummy and finessing the 9. How you play will depend on whether you expect West or East to be short in the suit.

In the second example the safety play for three tricks is to cash the ace and lead up to dummy's jack if the 9 or 10 appears. You win three tricks except when East holds Q–10–9–x.

In choosing the examples for this chapter we have sought to

illustrate principles that are common to many similar situations. Admittedly, the play that is technically right is often tactically wrong at the table; but as we said at the beginning, you cannot fashion a good design unless you know what your materials are capable of doing.

PROBABILITIES OF DISTRIBUTION

Two cards will be divided 1–1 fifty-two times in a hundred, 2–0 forty-eight times.

Three cards will be divided 2–1 seventy-eight times, 3–0 twenty-two times.

Four cards will be divided 3–1 fifty times, 2–2 forty times, 4–0 ten times.

Five cards will be divided 3–2 sixty-eight times, 4–1 twenty-eight times, 5–0 four times.

Six cards will be divided 4–2 forty-eight times, 3–3 thirty-six times, 5–1 fifteen times, 6–0 once.

Seven cards will be divided 4–3 sixty-two times, 5–2 thirty-one times, 6–1 seven times, 7–0 less than 0·5 times.

The Early Play in Notrumps

The first thing to do in any notrump contract is to count your winners. If they fall short of what is required, you must form a plan that may produce the extra tricks you need. It is easy to let one's mind wander to an attractive stratagem without first reflecting on how many tricks are needed, and this can beckon you down many a blind alley.


 ♠ Q J 5
 ♡ K 8
 ♢ 7 6 2
 ♣ K J 10 9 6
 ♡ 10 led
 ♠ A 6
 ♡ A 4 2
 ♢ A K Q J 10
 ♣ 8 4 3


You are in 3NT, a heart is led, and you note that there are eight winners – one spade, two hearts and five diamonds. A sure way of arriving at the ninth is to play ♡ A on the opening lead and continue with ace and another spade. This forces out the king and establishes the queen in dummy.

You may think that is very simple, but do not underestimate the importance of the approach. On an off-day many players might endanger the contract by failing to observe that only one extra trick was needed. For example, South might allow himself to be diverted by the promising club suit. You can see what may happen then. A club finesse loses to the queen and the opponents clear the hearts. No guarantee now that you will not lose two clubs and three hearts.

There is another way of muddling it. South might duck the opening lead instead of winning with the ace. As you may know,

that form of play is often correct. But on this hand a heart continuation removes the king, and then there is no certain way of making a ninth trick in time.

We look next at a number of tactical strokes. Remember, before you put any of them into effect, that the first step always is to count the sure winners.

PLAYING FROM DUMMY TO THE FIRST TRICK

To make maximum tricks, normally play 'second hand low'.

With most suit combinations your position will be more secure if the opponents lead. You gain because, when the suit is led from your left, you play last and can play high or low according to what the opponents have done. You stand to win the trick cheaply or lose it cheaply. Do not dispel that advantage by playing a high card from the dummy on the opening lead.

When possible, high cards should be used to kill the opponents' high cards. In the following examples the lead is assumed to come from your left.

(1)		Q 6 4			(2)		K 7 3	
	J 8 5 2		K 9 7			Q 10 6 4		A 9 5
		A 10 3					J 8 2	

If you tackle (1) yourself you make only one trick against best defence. Now suppose that West leads the 2. If you played the queen from dummy, again you would end up with only one trick. Play low, and you are sure of two tricks, for you can win economically with the 10 or the ace, according to what East does.

With (2) you would not make a trick if West led the 4 and you put up the king from dummy. Remember the guiding principle: *second hand low.*

(1)		A J 2			(2)		A Q 5	
	10 8 6 3		Q 7 4			K 9 4 2		10 8 3
		K 9 5					J 7 6	

When in (1) West leads the 3 you have what is known as a 'free finesse', in the sense that you can put in the jack without fear of losing the trick. But this would be poor play, for the presence of the 9 gives you an extra chance for three tricks. You play the 2 from

dummy, and as the cards lie East must either sacrifice the queen or
let you win with the 9. And suppose West held the queen and east
the 10? Nothing is lost; you head the 10 with the king and the finesse
of the jack will still win later.

In the second example West's lead of the 2 presents you with three
tricks – so long as you play from dummy on the first trick.

When dummy is short, consider whether to play high.

There are (as always at this game) exceptions to the rule. They
occur especially when there is a 'now or never' element about the
play of the high card.

(1) Q 7 (2) J 6 2

 A 6 5 A K 4

In (1) the queen is only once guarded and the best chance to make
a trick with it is to play it at once. If you play low, and East has the
king, he will not place it on the executioner's block; he will put in an
intermediate card like the 8 or 9 (see 'Finessing against the dummy',
page 118). Similarly, with (2) the best chance for a third trick is to
go up with the jack, hoping that West has led away from the queen.

Here are more situations where the best way to extract some value
from dummy's high card is to play it at once:

(1) J 5 (2) J 6

 K 3 2 A Q 7

With (1) put up the jack on the opening lead. If West has led from
A–Q, and you can keep East out of the lead, you will have a double
stop. With (2) also you play the jack, hoping it will hold. Then, if
you can lose the lead to West rather than East, he will be unable to
continue the suit without giving you three tricks.

This is a very common holding:

K 6

Q 7 4

Best, as a rule is to go up with dummy's king. Then again, if you

can lose the next trick to West you may have, at any rate for the moment, a second stopper.

In the next two examples dummy has a doubleton honour, but now the high card will play a useful role at a later stage.

 (1) J 5 (2) 10 2

 Q 6 4 A J 7

With (1) you ensure one trick, and with (2) two tricks, by playing low from dummy on the opening lead.

When dummy holds two significant cards it is usually right to play one of them on the first round.

 (1) Q J 2 (2) J 10 5

 A 6 3 A 7 3

In (1) you go up with the queen, and if West has led away from the king you have the possibility of two more tricks. In (2) the play of the jack or 10 ensures two tricks unless East has both king and queen. It is also right to play one of dummy's touching cards with J–10–x opposite K–x–x, or 10–9–x opposite A–K–x or A–Q–x.

When there is a choice between high and low, consider what your opponent is most likely to have led from.

We look first as occasions when, if there are no outside clues, the choice is marked. Here a low card is led by West:

 (1) J 6 3 (2) A 10 2

 A 9 3 K 8 5

With (1) the jack will be right if West has led from K–Q, the 2 if he has led from K–10 or Q–10. Clearly the better chance is to play low. If dummy held J–9–x and declarer A–x–x or A–x, similar considerations would determine the play from dummy – the 9, not the jack. With (2) the problem is whether West has led from Q–J or from either Q–9 or J–9. Again, there are two chances against one, so it is right to play low from dummy.

In the next two examples correct play will save you from a later guess:

(1) Q 10 5 (2) Q 10 5

K 6 3 A 4

In both cases you should play the 10 from dummy. Suppose you seek to defer the guess by playing low on the first round; then perhaps the 9 will fetch your ace or king and on the next round you will have to decide whether to put in the queen or 10. You increase your chance of a double stop by playing the 10 and smoking out the jack immediately. If the 10 is covered by the jack you still have the chance of finding West with the other high card in front of dummy.

In the next two examples you have a genuinely open guess:

(1) Q 4 (2) J 4 2

A 10 A K 9

In (1) your problem is whether West has led from the king or the jack. In (2) you do better to play the jack if West has led from the queen, a low card if West had led from the 10.

The reader of a previous book by one of the present writers wanted his money back because he was not offered any guidance about the play of the following combination in 3NT doubled, West having led the 5:

K 6

J 4

'It made 1000 points difference on this deal and of course the opponents won the rubber with a slam on the next,' wrote this correspondent morosely.

The author forbore to remark that there must have been at least one better contract than 3NT by South – namely, 3NT played by North. The situation presents, of course, an open guess at notrumps; in a suit contract you would play low, for defenders seldom underlead aces on the first trick.

HOLDING UP ON THE FIRST TRICK

Unless you fear a switch, hold up a stop card in the suit led.

We turn now to a different aspect of the play to the first trick. Even when there is no problem about how many tricks you can win in the suit led, you still have to decide at what moment you will part with your winner or winners.

Against notrumps the defenders will usually lead a suit in which they hope to establish long cards. The chances are that it will pay you to hold up for at least one round, and often for as long as you can. The reason, which is concerned with communications, is easy to see from an example like this:

```
              ♠ K 7 2
              ♡ 6 3
              ◊ J 10 8 4
              ♣ A 9 4 2
♡ 4 led
              ♠ A Q 8
              ♡ A 10 8
              ◊ K Q 5 2
              ♣ K 7 6
```

You are in 3NT and a low heart is led. You can count six top winners and will look for the other three in diamonds. If the hearts are 4–4 you cannot lose the contract, but suppose West has five hearts and East three: now the position of the ace of diamonds is critical. If East holds that card you are safe – so long as you refuse to part with the ace of hearts until the third round. If you win the first or second round then obviously East will return a heart when he comes in with the ace of diamonds.

Hold-up play is often right even when you hold two stoppers in the suit led:


 ♠ 6 3 2
 ♡ A Q 8
 ◊ K 9 7
 ♣ Q J 9 2
 ♠ 7 led
 ♠ A K 5
 ♡ K 10 6
 ◊ A Q 2
 ♣ 10 7 6 5


Again the preliminary plan is easy to form when West leads a spade against 3NT. You have eight top winners and will need to force out ace and king of clubs to develop an extra trick in that suit. Who will win the race – you to establish the clubs or the defenders to establish the spades? It will depend on the disposition of the two suits, but you can greatly improve your prospects by holding up on the first lead. Suppose that East holds ♣ K–x–x and ♠ J–x. If you win the first spade and attack clubs, East will win and lead his remaining spade. That way, you will lose two clubs and three spades. You win the contract by holding up at trick 1, for if East wins the first club he will have no spade to lead.

Before you decide to hold up, you must naturally consider whether a switch to another suit by the defenders might be still more damaging.


 ♠ A K
 ♡ 8 6 5
 ◊ Q 10 4 2
 ♣ Q J 8 3
 ♡ Q led
 ♠ 9 8 2
 ♡ A K 2
 ◊ K J 7 6
 ♣ K 10 2


West leads a heart against 3NT and, on the surface, the situation is similar to the last example. The difference is that a switch to spades, if you duck, will be damaging, and also looks likely. It is

therefore better to win and tackle a minor suit. If the defenders return a heart, you can hold up this time.

WHICH SUIT TO DEVELOP

With an equal choice, attack the suit in which the defenders hold a sure winner.

When you find yourself in the lead for the first time you will generally have to decide which suit to develop and sometimes the choice may not seem clear. Here are two principles that will be a sound guide on such hands:

Develop a long suit in which you have top losers.

Develop the suit that will yield the greatest number of tricks.

Very often the same suit will meet both conditions, as in this example:



♠ Q 7 4
♡ A 6 2
◇ Q 10 8 5
♣ K 6 4

♠ 3 led

♠ K 10 5
♡ K J 5 3
◇ J 9
♣ A Q 7 3



West leads ♠ 3 against 3NT. East wins with the ace and returns the 6, which you can take in either hand. After the play to the first trick you can count seven top winners. Where to go for the extra two? You could find one in clubs if the suit were to break 3–3, one in hearts if either the finesse were right or the suit were to divide 3–3. If you find East with Q–x–x you may even make two extra tricks in hearts.

However, there is no need to calculate the odds, for the best suit to develop is diamonds. Here you have two top losers already, so by leading diamonds you will not be letting the defenders make tricks that they could not otherwise have made. Also, the tricks you plan to develop in diamonds are certainties. You can be sure of the contract unless West holds five spades and the ace and king of diamonds. If West had opened the bidding you would have to take that into account and perhaps form a different plan.

On the following hand, where you are again in 3NT, your object

is to retain chances in as many suits as possible.

```
                        ♠ K Q 2
                        ♡ A Q 6 5
                        ◊ 3 2
                        ♣ K J 6 4

    ♠ J led

                        ♠ A 6 4
                        ♡ 10 3 2
                        ◊ A K 7 6 4
                        ♣ A 8
```

The spade lead is not dangerous and you will have time to look for the ninth trick in hearts, diamonds or clubs. First, you will reject the club finesse; apart from other considerations, that can come later. It would also not be clever to play on hearts with no guarantee of developing an extra trick and the risk of establishing tricks for the other side. An additional precept emerges from this example:

Attack the suit that opponents can attack themselves, rather than a suit which they cannot effectively open up.

On all grounds, therefore, you must play on diamonds first. At least one diamond must be lost, so you may as well duck the first round, maintaining communications. If the suit turns out to be 5–1, the other chances in the hand still remain. If all follow to the second round you can surely establish a long diamond.

THE DANGER HAND

From the start, plan to keep the dangerous opponent out.

When one defender has long cards to cash and the other has not, the first player is described as the 'danger hand'. In a slightly different sense a danger hand may also exist when a lead is feared from a particular side.

```
(1)              8 6 5        (2)            J 10 3
      Q 10 4 2          K 9 7        9 8 6          K Q 7 4
              A J 3                          A 5 2
```

In (1) West leads low and the king loses to the ace. Now East is the danger hand so far as this suit is concerned. In (2) West's lead of the 9 is covered by the 10, queen and ace. This makes West the danger hand.

Many stratagems in play are designed to prevent the danger hand from obtaining the lead.



♠ 7 6 3
♡ J 2
◊ K J 9
♣ A K J 5 3

♠ 5 led

♠ K J 4
♡ A 6 4
◊ A Q 8 6
♣ 8 6 2



West leads a low spade and East plays the 10, which you must take. You now need four club tricks and you want to keep East out of the lead in case West began with A–Q–x–x–x of spades. You do not, therefore, make the normal play of cashing the ace of clubs and later finessing the jack. Instead, you play off ace and king. If the finesse would have won – if West began with Q–x–x – you don't mind losing the third round to him. The advantage of the play is that you prevent East from winning unnecessarily with Q–x.

Here is a slightly more complicated hand of the same type:



♠ 10 4
♡ K 7 6 2
◊ A Q 8 3
♣ K J 9

♣ 4 led

♠ A 9 6
♡ A 5 4
◊ 10 9 4 2
♣ Q 10 6



This time the contract is only 2NT. West leads a club, and in the hope of concealing the fact that you are well protected in this suit you go up with the jack from dummy. However, East wins with the ace and makes the feared switch to a low spade. West wins with the jack and plays king of spades and another spade, which you win with the ace. It looks now as though East has two more spades to make, so you do not tackle diamonds normally by taking two finesses. Taking all measures possible to prevent East from gaining

the lead, you play a diamond to the ace, return to hand with a club, and lead another diamond. If only low cards have appeared, your best chance is to go up with the queen, playing East for J–x.

When the aim is to keep a particular opponent out of the lead there are special ways of playing almost every combination. Suppose that West is the danger hand and that your holding in a side suit is:

8 7 6 4 3

A K 5

The way to tackle the suit, if you have enough entries to dummy, is to lead twice up to the A–K. If East plays the queen on the first or second round, you let it hold. You thus establish the suit safely whenever East holds Q–x or any three cards. Other plays of this kind are described in Chapter 5.

When there are two cards to force out, attack the danger hand first.

Another important tactical move consists of attacking the danger hand before the danger has fully developed. That is to say, when there are two winners to force out, you first extract the winner from the hand that threatens to establish long cards.



♠ A 7 3
♡ K 5 2
◇ A Q J 6 4
♣ 7 3



♠ 4 led



♠ K 8 5
♡ Q J 4
◇ 10 9 3 2
♣ A K 6



West leads a spade against 3NT. If the diamond finesse is right the contract cannot fail, but if it is wrong a trick will be needed from hearts. It would be a mistake here to hold off the first lead, because the defence might well switch to clubs, where the danger is at least as great. Suppose you win the first spade and finesse in diamonds. East might win and lead a second spade. Now, if West began with five spades and the ace of hearts, you will lose three spades, a heart and a diamond.

The solution is to attack the entry of the danger hand by playing a round of hearts before touching diamonds. Once the ace of hearts has gone, West is no longer dangerous.

Sometimes the danger hand cannot be kept out so surely, but you can improve your chances:


 ♠ Q 10
 ♡ A 10 3
 ◊ K Q 10 9 2
 ♣ J 5 3
 ♠ 3 led
 ♠ K 7 4
 ♡ J 6 5
 ◊ J 8 6 3
 ♣ A Q 4


West leads ♠ 3, dummy plays the 10 and East's ace wins. When West drops the 2 on the second round, it looks as though spades are 5–3 (this is on the assumption that West has led fourth best from his long suit).

If you drive out ◊ A you will still need a trick from clubs, so the best play is to take the club finesse immediately, switching to diamonds if it holds. That way, you are safe unless West holds both key cards. If you tackle diamonds first you risk defeat when West holds ♣ K, regardless of who holds ◊ A.

PROBLEMS OF COMMUNICATION

Preserve entries to the hand in which you aim to establish long cards.

More than half the tricks in notrump contracts are won by low cards, and one of the main problems in play is to be in the right hand to cash them. After the first appraisal – how many winners and how to develop the extra tricks – you must examine the entry situation. In general, it will be right to preserve entries to the hand where you hope ultimately to establish long cards.

```
                        ♠ K 7 3 2
                        ♡ K Q 8
                        ◊ A 5
                        ♣ A Q 9 2
  ♠ Q 9 8 5                              ♠ J 6 4
  ♡ J 5 3                                ♡ 10 9 6 4
  ◊ K 4 3                                ◊ Q 8 7
  ♣ J 7 4                                ♣ K 10 8
                        ♠ A 10
                        ♡ A 7 2
  ♠ 5 led                ◊ J 10 9 6 2
                        ♣ 6 5 3
```

You are in 3NT and West leads the 5 of spades. West might have
led away from ♠ Q-J, and if there were no special considerations
you would let the lead run up to your A–10. But here you will need
entries for your diamond suit, so the right play is to go up with the
king of spades and play ace and another diamond. If West wins and
leads a club, go up with the Ace, cross to ♡ A, and lead the jack of
diamonds, forcing out the queen. Now you still have the ace of
spades as an entry card. If you let the first spade run up to your own
hand you would be an entry short to establish and run the
diamonds.

Unblock with a high card to save entries.

Often a special manoeuvre within the suit led is necessary to
establish entries. Suppose that you are playing notrumps and the
opponents attack the following suit:

```
                        K J 6
      3 led
                        A 9 4
```

West leads the 3, dummy plays low and East puts in the 8. If you
are short of entries to dummy you must win with the ace, not the 9,
so as to obtain an extra entry by finessing the jack. True, East may
have played the 8 from Q–8–x, but if the two entries to dummy are
badly needed you must take that risk. Similar play may be advisable
with the following holdings:

(1) Q 7 4 (2) Q 10 6
 5 led 4 led
 K 10 3 A J 3

We assume in both cases that dummy is short of entries. With (1)
dummy plays low and East plays the 9. You must head this with the
king, trusting that West holds the ace. If you win cheaply with the
10, West can manoeuvre to deny you entry. With (2) you can be sure
of a later entry to the table by playing low from dummy and winning
with the ace. (You can, of course, obtain an immediate entry by
playing the queen or 10, but we are assuming that you will want the
entry later in the play, after you have developed another suit.)

It is often possible to establish additional entries by unblocking in
a suit which you hold strongly. In the following deal you may want
to lead three times from dummy. You can do so if you play the clubs
correctly.

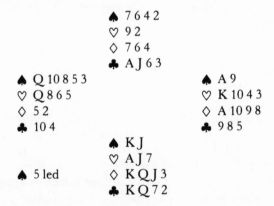

 ♠ 7 6 4 2
 ♡ 9 2
 ◇ 7 6 4
 ♣ A J 6 3
 ♠ Q 10 8 5 3 ♠ A 9
 ♡ Q 8 6 5 ♡ K 10 4 3
 ◇ 5 2 ◇ A 10 9 8
 ♣ 10 4 ♣ 9 8 5
 ♠ K J
 ♡ A J 7
 ♠ 5 led ◇ K Q J 3
 ♣ K Q 7 2

A spade is led against 3NT, the ace goes up and you take the next
trick with the king. You cannot make the contract if West began
with five spades and the ace of diamonds, so you can forget that
possibility and concentrate on playing diamonds the best way to win
three tricks. By leading three times from dummy you can succeed
provided the ace is with East. To obtain the necessary entries, cash
♣ K and lead the 7 to dummy's jack. When both opponents follow,
lead a diamond to the king and overtake ♣ Q with the ace. After
another diamond lead re-enter dummy by leading ♣ 2 to the 6. Of
course, if clubs were 4–1 you could not afford to overtake the queen
with the ace, but this would show up on the second round.

Overtake high cards to save entries.

Defenders will often hold up a stopper to create entry trouble. A standard counter is to overtake high cards.

(1) K Q 10 8 6 4 (2) K 10 9 8 5 3

J Q

With (1), if you had entries to spare on the table you would lead the jack and let it run. But suppose dummy has only one sure entry. The best chance then is to overtake the jack with the queen and continue the suit. You will win five tricks if the suit breaks 3–3 or if the 9 falls in two rounds.

With (2), assuming that there are two entries to dummy, you must overtake the queen and the king and continue the suit from that side, forcing out the jack and ace in turn.

Here are two situations where the overtaking play may cost a trick but save an entry.

(1) K 10 9 5 3 (2) A 9 8 4 2

AQ KQ

If there is only one entry to the table and you need precisely four tricks, the play with (1) is to overtake the queen on the second round. With (2) the advantage of overtaking is less obvious. If the suit is 3–3, then clearly you will lose one trick by overtaking the queen, but you will still make the four tricks you need. The advantage arises when either opponent holds 10–x or J—x. After overtaking the queen with the ace you follow with the 9, forcing out the remaining honour.

Duck early to save entries.

Ducking plays are a regular feature of the traffic from one hand to another. Sometimes the play cannot cost a trick, sometimes it may sacrifice a trick for safety.

(1) A 8 5 4 3 (2) A Q 5 4 3

K 6 2 K 6 2

With (1) you must lose one trick even against the most favourable division. For reasons both of control and of entry, it is normal to duck the second round. With (2) you can run five tricks without loss if the suit breaks 3–2. But suppose you need four tricks only and have no side entry to dummy. Then you must duck on the second round in case the suit is breaking 4–1.

The next two positions are similar to one another:

(1) A Q 6 4 2 (2) K 9 7 4 2

 8 5 6 3

With (1) you need four tricks and have no outside entry to the table. You must duck the first round and hope that West holds K–x–x. With (2) you can win three tricks only if the suit is 3–3 and West holds the ace. If you have only one entry to dummy it is no use leading up to the king; you must duck the first round and play up to the king on the second round. A feature of both these examples (and indeed of most ducking plays) is that it makes no difference from which hand you lead on the first round.

The Early Play in Trump Contracts

If you hold a fair trump suit, and especially if partner has a fit in the same suit, you will generally make more tricks playing in the suit than you would at notrumps. More trick-building manoeuvres are available and also you have sure protection against long suits in the defending hands. Both those advantages are seen in the following deal:

In a notrump contract South could make only eight tricks – five spades, two hearts and one diamond. There is little chance to develop extra tricks, and in any case West's natural lead is a club, enabling the defenders to take the first five tricks.

In a spade contract the element of trump alters the situation and South makes ten tricks. If clubs are led, the stopping power of the trump suit enables South to ruff the second round. He should continue with ace of hearts and a heart ruff, two rounds of trumps and another heart ruff. The two ruffs produce a total of ten tricks.

Count your losers as well as winners.

It is more difficult to plan a suit contract than to plan notrumps because there are more ways of winning tricks. There are also more ways of losing them, since it is legal for the defenders to ruff too.

Some ways of building tricks conflict with other ways. For example, if you plan to win extra trump tricks by taking ruffs in both hands without drawing trumps, you cannot at the same time count on developing tricks in the side suits, for the opponents will be in control of the trump situation. It is therefore essential to form an overall plan before embarking on any isolated tactical manoeuvre.

In planning notrumps, you were advised to count winners before doing anything else. The same holds good in a suit contract, but now it is equally important to count losers too. One of the advantages of playing in a trump contract is that you can often side-step losers that would be inescapable at notrumps.


 ♠ K Q 3 2
 ♡ J 10 5
 ◊ 10 4
 ♣ 8 7 3 2

 ♣ K led
 ♠ A 7
 ♡ K Q 9 8 7
 ◊ A 9 3
 ♣ A 6 4


South is in four hearts and ♣ K is led. The first move is to count winners. There are four trump tricks, three spades and two aces, and the tenth trick can come from a diamond ruff in dummy. It will be necessary to concede a diamond before one can be ruffed, and this must be done before trumps are touched, for otherwise the defenders may continue trumps and kill the ruff.

The count of winners is satisfactory, but before making a move South should also count losers. If he wins with ♣ A and ducks a diamond, the defenders will cash two club tricks, with the ace of trumps to follow.

There is a simple way round. Having won with ♣ A, cash three rounds of spades, pitching a losing club. This leaves only three losers – a trump, a diamond and a club – so now you can go ahead with the original plan.

WHEN TO DRAW TRUMPS

Pull all the adverse trumps if you will still have enough tricks.

When you see that you can draw trumps and still have enough tricks

for the contract, draw them at once. Don't let the defenders score
unnecessary ruffs.

♠ A 5 4
♡ K 6 3
◇ K Q 4
♣ 10 7 4 2

♣ K led

♠ Q J 6
♡ A J 10 7 4 2
◇ A 6
♣ A 3

This is an easy enough hand to play in six hearts, but even players
of some experience have been known to make a simple error. South
wins the club lead with the ace and can see twelve top tricks if he is
able to draw the trumps without loss, for he will throw a club on the
third diamond and lose just one spade. Technically, the first move
should be a low heart to the king, for if East happens to hold
Q–9–x–x these can be picked up. We will say that both opponents
play low on the first round, and East plays low again on the next
round. The odds slightly favour playing for the drop now, and South
should go up with the ace. Then, and not before, he should take the
discard of a club on the third diamond.

The pitfall that would entice some players is to try for the club
discard immediately. This might cost the contract if either opponent
held a doubleton diamond and was able to ruff the third round.

The question of how soon to draw trumps often arises on the
opening lead:

♠ K 2
♡ K 9 3 2
◇ A Q 10 5
♣ A 7 2

◇ 6 led

♠ A 9 5
♡ A Q J 6 4
◇ J 4 3
♣ J 5

A low diamond is led against six hearts. Counting a spade ruff in

dummy, you can make twelve tricks by way of five hearts, two spades, a ruff, one club and at least three diamonds. The simple and correct line is to go up with ♢ A, draw trumps and give up a trick to ♢ K. Unless trumps are 4–0 you do not need even to take the spade ruff until you have drawn trumps. Almost the only way you could go down would be by finessing the diamond and running into a diamond ruff. (It is true that West might hold six diamonds, but a 5–1 break is far more likely than 6–0.)

Do not draw the opponent's master trump unless you are in complete control.

It is not, as a rule, either necessary or advantageous to extract a master trump held by an opponent. On this type of hand it would be a calamitous error:

```
                 ♠ K 4 2
                 ♡ A K 7
                 ♢ A 8 7 2
                 ♣ J 5 3
     ♢ 5 led
                 ♠ A 9 7 5 3
                 ♡ 9
                 ♢ 10 4
                 ♣ Q 10 9 6 2
```

Playing in four spades, you win the diamond lead and draw two rounds of trumps for fear of ruffs. After discarding a diamond on the hearts you can afford to lose a trump and two clubs, but you cannot afford to lead a third round of trumps, since a red suit return would reduce you to one trump while there were still two clubs to force out. There is no problem if you attack clubs after ♠ A–K.

We could have made this example a little trickier by giving South A–J–x–x–x instead of A–x–x–x–x. It would be wrong, then, to take the normal finesse in trumps, for if it lost you would not have time to establish clubs. You should play off king and ace, making the contract whenever the trumps are 3–2.

Force out the master trump when dummy has a suit to run.

There is one time when you must force out the master trump. That is when you have a suit to run in dummy and must not let the opponents interrupt your communications.

♠ A 8
♡ 7 5 3
◇ A K 9 4 2
♣ Q 6 2

♡ K led

♠ K 10 7 5 4 3
♡ Q
◇ Q 10 3
♣ K 10 5

Playing in four spades, you ruff the second round of hearts and play off ace and king of spades, to which all follow. Now it would be unsound to play on diamonds, leaving the master trump at large. An opponent might strike with this trump on the third round of diamonds; then he would exit with a heart and you would be in danger of losing two club tricks. If instead you force out the winning trump, only J–x–x–x with East will interrupt the run of the diamonds. The correct way to tackle the diamonds, by the way, is to lead the 10 to the king, then back to the queen. If it turns out that West began with J–x–x–x you can finesse dummy's 9.

Keep a trump in dummy when necessary to stop the run of an enemy suit.

If you follow the first rule for planning the play at a suit contract – count your losers as well as winners – you will not be tripped up by situations where drawing all the trumps would leave you wide open. It is often necessary to keep a trump in dummy to prevent the defenders from cashing winners in one side suit while you are establishing tricks elsewhere.

♠ 6 5 3
♡ K Q 10
◇ A 2
♣ Q J 10 5 2

♠ K led

♠ A 7 4 2
♡ A J 9 8 5
◇ 10 7
♣ K 4

Playing in four hearts, you win the spade opening and observe that you can establish enough winners by drawing trumps and

driving out ♣ A. When you count your losers, however, you note that if you take out all dummy's trumps the defenders may be able to cash three spades when they come in with ♣ A. The play, therefore, is to draw only two rounds of trumps before tackling clubs; then dummy's third trump is protection against the fourth round of spades.

Sometimes a low trump in dummy will play a double role. It will take care of a side suit and also provide an entry to dummy after the opponents have played their master trump.



♠ A K 4
♡ 9
◇ K J 8 3 2
♣ J 7 6 4

♡ Q led

♠ 9 7 6 5 3
♡ A 8 2
◇ A Q 6
♣ 8 3



South is in four spades, hearts are led and the ace wins. South can count ten tricks on the expected 3–2 division of the trump suit – four trumps, five diamonds and ♡ A. However, he cannot afford to play three rounds of trumps (the usual tactics when there is a suit to run), for the defenders will then be able to cash two hearts. Nor can South afford to ruff his two losing hearts, using a high trump, as this would inevitably set up an extra trump trick for the opponents.

The solution is not to ruff any hearts but to play just the ace and king of trumps before running the diamonds. The defenders may ruff a diamond with the master trump, but dummy's small spade takes care of the heart continuation and also provides entry to the remaining diamonds.

RUFFING LOSERS WITH DUMMY'S TRUMPS

To profit most, ruff with small trumps in the short trump hand.

On the majority of deals the declarer has more trumps than dummy and he does not add to his total of tricks by ruffing in his own hand. But when declarer ruffs in dummy he gains extra tricks. You must consider this type of play whenever dummy contains a side suit

shorter than one of your own side suits.

```
                        ♠ 9 5 4
                        ♡ A 8 7 3
                        ◊ A 7
                        ♣ A 5 4 2
        ♠ 3 led

                        ♠ A K Q 7 2
                        ♡ 6
                        ◊ 10 6 3 2
                        ♣ Q J 7
```

South plays in four spades and a trump is led. Observing that he could easily ruff hearts in his own hand, a player who did not form a proper plan might ruff a heart, cross to dummy and ruff another. This is like taking money out of one pocket and putting it in another, with the additional disadvantage that you are weakening your control of the hand. Disaster will follow if either opponent holds four trumps.

The proper approach is to note that you have nine probable winners (five trumps, two red aces and at least two clubs) and can easily obtain a tenth by ruffing a diamond, where dummy has a shortage. The first move, after winning the trump lead, is to play ace and another diamond, preparing for a diamond ruff.

The majority of ruffs are made with small trumps, as in the last example. Sometimes you can afford to ruff high and reduce the danger of an overruff. Often you will have to decide whether to ruff low and chance an overruff or ruff high at the risk of weakening the trump suit.

```
                        ♠ A 9 8
                        ♡ 7 3
                        ◊ Q 8 4 3 2
                        ♣ 9 7 2
        ♣ 5 led

                        ♠ K Q J 3 2
                        ♡ A K 6 4
                        ◊ 10 5
                        ♣ K 4
```

The contract is four spades and clubs are led, South winning the

second round. Needing two heart ruffs to add to the eight winners he already holds, South plays ace, king and another heart. It would be foolish to ruff high at this point, for South will have to ruff again later and East is more likely to follow suit now than on the fourth round. So ♠8 is played from dummy, and all follow. Having returned to hand with a club ruff, South leads his last heart. When West follows suit South knows that East has no more hearts, so the question is whether to ruff with the 9 or with the ace. There is about a fifty-fifty chance that East will not be able to overruff the 9 with the 10, but a much better chance that the trumps will break 3–2. South ruffs high, therefore, and hopes to draw trumps with the K–Q–J.

In the course of your career you will play many hands with a delicate trump holding like the hearts below. (At least, you will if your bidding is good.) The usual technique is to duck one round of trumps, then cash the ace, leaving the opponents with the master trump.



♠ A 2
♡ 10 7 6 4
◇ A 5 4 3
♣ A 8 7

♠ 6 led

♠ K 9 8 3
♡ A 8 3 2
◇ Q J 7
♣ K 6



A spade is led against four hearts and you observe that if trumps are 3–2 you should be able to hold your losses to two trumps and one diamond. This is assuming two spade ruffs in dummy, and clearly an opponent will be able to ruff the fourth round. You must not allow the opponent with two trumps to ruff in this way, but at the same time you cannot afford to draw three rounds of trumps. The solution is to win the spade lead in dummy and play a small trump from each hand. On any return, cash the ace of trumps before taking your two ruffs. The opponents may make their master trump by overruffing, but that is a trick you always had to lose.

BUILDING LONG CARDS BY RUFFING

Ruff in either hand when this helps to establish a long side suit.

One of the most valuable uses of the trump suit is to help establish a
second suit, either in dummy or in the declarer's hand.

```
              ♠ J 10 7 4
              ♡ A 8 5 4 3
              ◇ 7 2
              ♣ A 10
    ♠ 3 led
              ♠ K Q 9 8 6
              ♡ 9
              ◇ A K 8 6
              ♣ K 7 5
```

Against six spades the defenders begin with ace and another
trump, both following. You can count nine tricks – four trumps in
your hand, a heart, two diamonds and two clubs. You can boost this
to eleven via two diamond ruffs in dummy, so need one more trick
for slam. Often you cannot gain by ruffing dummy's losers with
winning trumps in your own hand, but here you may profit by
ruffing hearts three times, as this will establish dummy's fifth heart
if the suit breaks 4–3. You must play ace of hearts and ruff a heart
before touching any of the other entries to dummy. Otherwise you
will find you are short of entries.

Very often, too, you will use dummy's trumps to establish a
second suit of your own. This common type of hand needs accurate
management:

```
                    ♠ K J 10 8
                    ♡ 5
                    ◇ J 8 6 2
                    ♣ A 7 4 3
    ♠ 6 4 2                          ♠ 5 3
    ♡ 10 7 4                         ♡ K J 8 3
    ◇ A K 7                          ◇ Q 10 9 3
    ♣ K J 9 5                        ♣ Q 10 6
                    ♠ A Q 9 7
                    ♡ A Q 9 6 2
    ◇ K led         ◇ 5 4
                    ♣ 8 2
```

South plays in four spades and the defence can go in various ways. Let us say, first, that West cashes two diamonds and switches to a trump. Now South must aim to establish his heart suit. A little experiment will show that he cannot ruff three hearts in dummy and draw the opposing trumps, which is necessary if he is to enjoy the fifth heart. He can ruff hearts twice, and the real choice is whether to play for ♡ K to fall in three rounds or to finesse the queen. With seven cards missing, the finesse is a better chance than dropping the king, so the right sequence is: win West's trump lead in dummy, finesse ♡ Q, ruff a low heart; return to ♠ Q, ruff a heart, ruff a diamond and draw the last trump; then the South hand is high except for one club.

An instructive point arises if the defence cashes only one diamond and then switches to a trump. Again South must finesse ♡ Q, but now he must cash ♡ A before beginning to ruff hearts. Otherwise, after ♡ Q, heart ruff, trump, heart ruff, declarer will have no quick entry to hand. East can win any lead from the table and give his partner a ruff of the fourth round of hearts.

Finally, you may think it better for the defence to begin with three rounds of diamonds, forcing South to ruff. Declarer must then cross to ♣ A, finesse ♡ Q, ruff a heart, return with a trump and so forth. He always makes the contract when the heart finesse wins, the hearts are 4–3 and the trumps 3–2.

Note that if he encountered this third plan of defence it would be vain for South to attempt to make all eight trumps separately. Fairly soon he would have to concede a club trick to create sufficient ruffing entries to his own hand. A trump lead from the defenders at that point would ruin him.

Another important manoeuvre in suit establishment is what is known as the 'ruffing finesse'. Here you may use the power of trumps to take a finesse the wrong way round, as it were.

```
                      ♠ A Q J 10 3
                      ♡ Q 4
                      ◊ K 7 4
                      ♣ 8 5 2
      ♠ 8 7 5                          ♠ K 9 6 2
      ♡ K 8 5                          ♡ J 9 7 3 2
      ◊ 10 8 3                         ◊ 9
      ♣ Q 10 7 3                       ♣ A 9 4
                      ♠ 4
                      ♡ A 10 6
      ♣ 3 led         ◊ A Q J 6 5 2
                      ♣ K J 6
```

South plays in five diamonds and West leads ♣ 3. East wins with the ace and returns the 9. From South's point of view it is possible, but not probable, that a finesse of ♣ J will win. As other chances are offered, he goes up with the king.

Now a straightforward finesse of ♠ Q, if it succeeded, would probably win the contract, for South would be able to discard a club on ♠ A, give up a heart and ruff a heart. But if the finesse lost, he would quickly be defeated. The ruffing finesse is a much superior line. Declarer plays off ◊ A and ◊ Q, but does not take a third round at this point, as the king of diamonds may be needed as an entry. Instead, he leads a spade to the ace and returns the queen from dummy. If East covers, then South ruffs, draws the last trump and makes the rest of the tricks. Suppose that ♠ Q is not covered; then South discards his losing club. West may be able to win, but the heart losers can be discarded on the remaining spades. The ruffing finesse makes the contract safe against almost any distribution.

PLANNING A CROSSRUFF

When you aim to score ruffs in both hands, first cash your winners.

The advantage of playing in a suit contract instead of notrumps is most marked when you can make all or most of your trumps separately. To play a hand so is called crossruffing.

♠ A 8 4 2
♡ 9
◊ K 8 3 2
♣ 9 7 5 3

♠ 6 led

♠ K Q J 3
♡ A 8 6 4
◊ A 7
♣ Q 6 2

You have a good chance to make ten tricks in spades, even after a trump opening lead. Win in the closed hand, cash ♡ A and ruff a heart. Return to ◊ A and ruff another heart. After cashing ◊ K, ruff a diamond with a small trump in the South hand, taking the chance that West will not overruff. If this works, claim the contract by ruffing the last heart with dummy's ace of trumps.

When you decide to play a hand on crossruff lines you should always start by cashing the side winners unless you need them for entries. The deal on page 52 would have been an obvious candidate for a crossruff had the defenders led anything but a trump. South would cash his side winners, then crossruff the rest of the hand, conceding a trick to the ace of spades. Here is a full deal showing the importance of cashing side winners:

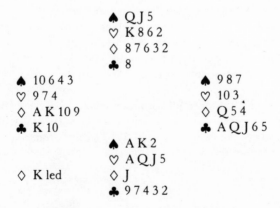

♠ Q J 5
♡ K 8 6 2
◊ 8 7 6 3 2
♣ 8

♠ 10 6 4 3 ♠ 9 8 7
♡ 9 7 4 ♡ 10 3
◊ A K 10 9 ◊ Q 5 4
♣ K 10 ♣ A Q J 6 5

♠ A K 2
♡ A Q J 5
◊ K led ◊ J
♣ 9 7 4 3 2

You are playing in four hearts and West begins with two rounds of diamonds. The best chance of game is to make seven trump tricks to add to the three spade tricks. To prepare the crossruff you must give up a club, and even if the defenders return a trump there will still be enough trumps left.

Having won the trump return, however, you must cash the spades before crossruffing. If you do not, the defenders will throw spades while you are ruffing the minor suits and you will never be able to cash your spade winners.

A crossruff with winning trumps is called a high crossruff and is very effective play. Usually declarer cannot afford to crossruff high until he has used up the small trumps, but there are hands where the sequence is reversed: you make the high ruffs early on, avoiding any possibility of an overruff.

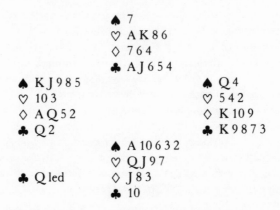

West has bid spades, so playing in three hearts you decide it will not be safe to ruff spades twice with low trumps in dummy. Furthermore, when West opens ♣ Q you judge that he may be short in that suit, making it dangerous to ruff clubs low more than once in your own hand. Instead of trying to make all the trumps separately, the safe play is to aim to make just seven of them. Take one low ruff in each hand, then crossruff with high trumps – the ace and king in dummy, the queen and jack in the closed hand. You will reach a position where you will need only one more trick and still hold ♡8 in one hand, the 9 in the other, with only the 10 against you.

DUMMY REVERSAL

Calculate whether you can take more tricks by making dummy the long trump hand.

Another basic play is the dummy reversal, where the normal order of things appears to be reversed.

In an ordinary ruffing game you win extra tricks by making one or

more ruffs in dummy to add to the trump length in your own hand.
Sometimes you can win more tricks by reversing this process, adding
ruffs in the closed hand to the trump length in dummy.

$$\spadesuit \ Q\,J\,10$$
$$\heartsuit \ J\,10\,2$$
$$\diamondsuit \ A\,8\,5\,3$$
$$\clubsuit \ K\,Q\,7$$

◊ 4 led

$$\spadesuit \ A\,K\,5\,3\,2$$
$$\heartsuit \ A\,5\,4$$
$$\diamondsuit \ 10$$
$$\clubsuit \ A\,J\,6\,3$$

You are in six spades and a diamond is led. At first sight it seems
that you have only eleven winners and need to find a lucky heart
situation to make an extra trick in that suit. By reversing the
dummy, however, you can add three diamond ruffs in the closed
hand to the three natural trump tricks in dummy. Together with six
outside tricks, this is enough for slam.

Win with ace of diamonds, ruff a diamond, lead a small trump to
the 10 and ruff another diamond with ♠ K. Cross to ♣ K, ruff the last
diamond with ♠ A and re-enter dummy with ♠ J. If the spades were
3–2, dummy's ♠ Q will draw the last adverse trump. On this trick
you discard one of your heart losers. There you see the characteristic
sign of a dummy reversal: when you can reduce your own trumps to
a point where they are shorter than dummy's trumps, then a
dummy reversal is probably the right game.

4

Trump Control and Timing

In the last chapter we discussed the basic stratagems in the play of suit contracts, but we touched only lightly on the battle for trump control. As this frequently determines the outcome, it is a battle worth winning.

One of the motives for playing in a suit contract rather than in notrumps is the stopping power of the trump suit, which will usually prevent the defenders from cashing long cards. But if a defender holds more trumps than you, or if he obtains the lead when all the trumps are gone, he can cash long cards. You will have lost trump control.

Defenders, therefore, will frequently aim to shorten your trumps so that one defender will hold more than you. Or they will hold up a trump winner in a situation where you cannot force out the winner without losing control. In this chapter we show how declarer may be able to counter such tactics.

HOW TO GAIN A TEMPO

Be prepared to lose an 'unnecessary' trick in the trump suit when trump control is more important than single tricks.

Many deals amount to a race to establish tricks, the time element being decisive. Sometimes a player makes a special move to change the timing of the hand in his favour. If this move succeeds he is said to gain a tempo. This may make a difference of several tricks.

Tempo is frequently important in the handling of the trump suit itself. We have already seen that, with A–x–x opposite K–x–x–x–x, it usually serves no purpose to play a third round of the suit after you have cashed the ace and king. It merely loses a tempo. We also saw that with A–x–x opposite K–J–x–x–x it can be right to play off the ace and king, refusing the finesse. To save a tempo it may also be wise to give opponents a chance to make more trump tricks than possibly belong to them.

♠ Q 10 5
♡ K 6 4
◇ K J 9 4
♣ 9 8 6

♣ K led

♠ A 8 7 4 3 2
♡ A 2
◇ 10 6 5 3
♣ 7

Playing in two spades, you ruff the second club and cash the ace of spades, to which all follow. Now it would be a mistake to play a second round. If East began with ♠ K–J–x he would draw two trumps and force again in clubs, reducing you to one trump, with the diamonds still untouched. The safe play in two spades is to tackle diamonds after the ace of spades. That way, you keep losers to a maximum of five tricks.

USING DUMMY'S TRUMPS TO KEEP CONTROL

Whenever possible, accept a force in the short trump hand.

To gain trump control, the defenders must force you to ruff in the hand that contains long trumps – usually the closed hand. Generally it will not help them to force you to ruff in the short trump hand. When the opponents make forcing leads, therefore, your best counter is to take the strain in dummy instead of in your own hand. The standard way to achieve this is to refuse to ruff until dummy is out of the suit led.

♠ A 10 2
♡ 8 7 5
◇ J 9 5
♣ K 8 3 2

◇K led

♠ K Q J 6
♡ A K 6 3
◇ 7
♣ A Q J 7

The contract is four spades and diamonds are led. If you ruff you will not be able to stand a 4–2 trump break. As you can afford to lose

three tricks you discard hearts on the second and third rounds of diamonds. Dummy can cope with any more diamond leads.

To shelter behind dummy's trumps as long as possible, it is often wise to clear a side suit before drawing trumps.


 ♠ K 6 5 3
 ♡ K J 4
 ◇ K J 9
 ♣ 7 6 4
 ♣ J led
 ♠ A 9 7
 ♡ A Q 10 6
 ◇ 10 8 6 3
 ♣ A 5


You are in three hearts and the jack of clubs is led. Suppose you win and draw trumps. Even if they are 3–3 you will need to find the diamond finesse right, for otherwise the opponents will run their clubs before you can make any diamonds. On such hands, where the trump situation is delicate and there are side winners to force out, it is usually right to broach the side suit even at the risk of a ruff. So, finesse for ◇ Q at once. You may lose two diamonds and a ruff, but in that case, as we have seen, the contract was probably unmakable anyway. If opponents win with ◇ Q and continue clubs, discard a spade. Thereafter, dummy's hearts will be protection against a further club lead.

Give up a trump trick while there is still a trump in dummy
to protect against a force.

Suppose you have a trump holding such as A–K–x–x opposite Q–x–x. If you play out the top winners and the suit breaks 4–2, there will be no trump in dummy to shield you from forcing leads. So, when you can afford to lose a trump trick but nct to lose control, it may be right to duck the first round of trumps.

♠ 10 5
♡ 6 3
◊ K 6 4
♣ K Q 9 6 4 2

♡ K led

♠ A K Q 6 3
♡ J
◊ Q 9 5 2
♣ A 8 5

A heart is led against four spades and you have to ruff the second round. (This would not be the moment to refuse the ruff, for you might then lose four tricks.) The safety play now is a low spade. Then there is nothing much they can do to you, barring very bad breaks. If instead you play off A–K–Q of spades and they break 4–2, you will be badly placed. You can play on clubs, but if the opponents have played before they will refuse to ruff until the third round and then they will force out your last trump. If all this happens, it is little satisfaction to tell partner that better bidding on his part would have carried you to five clubs.

Many tricky problems have the same theme as the last example. With a trump holding such as A–K–J–10 opposite dummy's 9–x–x it may be good play to lead the jack and then the 10 of trumps to blunt the attack of an opponent who holds Q–x–x–x.

WHEN YOU CANNOT ESCAPE BEING FORCED

If you lose trump control, make all the trumps you can in what way you can.

In the last chapter it was remarked that some ways of winning extra tricks conflict with other ways. If you plan to crossruff you cannot count on cashing long-card tricks. Fortunately for declarers, this principle also applies in reverse. The defenders, by playing a forcing game, may prevent you from cashing long cards in side suits, but meanwhile they allow you – in fact, help you – to make all the trump tricks that are going. In the following deal the declarer follows the ju-jitsu principle of turning his adversary's pressure to his own advantage:

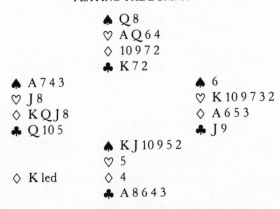

♠ Q 8
♡ A Q 6 4
◇ 10 9 7 2
♣ K 7 2

♠ A 7 4 3
♡ J 8
◇ K Q J 8
♣ Q 10 5

♠ 6
♡ K 10 9 7 3 2
◇ A 6 5 3
♣ J 9

◇ K led

♠ K J 10 9 5 2
♡ 5
◇ 4
♣ A 8 6 4 3

Playing in four spades, you ruff the second diamond lead and, noting the possibility of a force, play ace, king and another club. (If someone ruffs, the contract would have been impossible anyway.) West wins the third round and returns a diamond, pursuing his original plan. You ruff and observe that the opponents have prepared the ground for a high crossruff. You ruff a club with ♠ 8 and it does not matter if you are overruffed; then ♡ A and a heart ruff, and ♠ Q will take care of your last club.

The next example illustrates a standard manoeuvre in defence which the declarer on this occasion is able to counter:

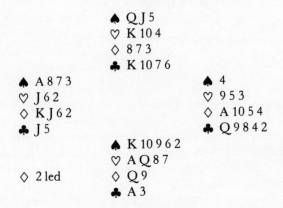

♠ Q J 5
♡ K 10 4
◇ 8 7 3
♣ K 10 7 6

♠ A 8 7 3
♡ J 6 2
◇ K J 6 2
♣ J 5

♠ 4
♡ 9 5 3
◇ A 10 5 4
♣ Q 9 8 4 2

◇ 2 led

♠ K 10 9 6 2
♡ A Q 8 7
◇ Q 9
♣ A 3

West leads a low diamond against four spades and you ruff the third round. You play a low spade to the queen and return the 5. On this trick East discards a club and West correctly holds off. This places you in something of a dilemma. If you play another trump

West will win and another diamond will kill you (that was the point of West's hold-up). The best chance is to fall back on a kind of crossruff game. For this to succeed, you must be able to cash your plain winners without sustaining a ruff. You play off three hearts and two clubs, reaching this position:

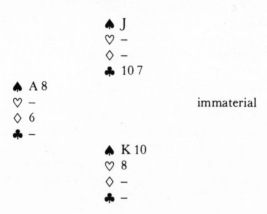

♠ J
♡ –
◊ –
♣ 10 7

♠ A 8
♡ –
◊ 6
♣ –

immaterial

♠ K 10
♡ 8
◊ –
♣ –

The lead of ♡ 8 holds West to one trick. You will note that for this ending to succeed, dummy must hold a higher trump than West's second trump. Many players would spoil their chance by playing the queen and jack of trumps on the first two rounds, not realizing the possible advantage of retaining a high trump in the short hand.

Finally, there are times when declarer says in effect: 'All right, if you want to play a forcing game, I will accept the force and make as many trumps in my own hand as I can.'

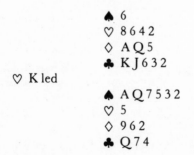

♠ 6
♡ 8 6 4 2
◊ A Q 5
♣ K J 6 3 2

♡ K led

♠ A Q 7 5 3 2
♡ 5
◊ 9 6 2
♣ Q 7 4

South plays in two spades and West, who has opened the bidding with one heart, leads the king of hearts, followed by the ace. Now if everything went well – if the spades were 3–3 and East held the king

– you might make a lot of tricks on this hand, by finessing ♠ Q and drawing trumps. However, that would not be the best way to tackle a part-score contract. After ruffing the second heart, lead a club and, if the king holds, ruff another heart. Then finesse ◇ Q and lead a fourth heart. East may go in with an intermediate trump, between the jack and 8, on this trick. In that case do not overruff but discard a diamond, planning later to ruff a diamond with a low trump. This sort of hand is not easy to define or classify, but it occurs often and you will acquire the technique with experience.

TESTING A SIDE SUIT BEFORE DRAWING TRUMPS

Do not fear an adverse ruff when the ruff will not cost you a trick.

Now we leave problems of control and turn to certain forms of timing and safety play connected with the trump suit. The injunction at the head of this section may not in itself seem meaningful, but the point is not difficult to follow in an example like this:

```
                    ♠ A 7 4
                    ♡ 9 7 4 3
                    ◇ K 8 2
                    ♣ 9 7 5

   ♠ Q led
                    ♠ K 8 2
                    ♡ 5
                    ◇ A Q 6 5
                    ♣ A K Q 10 3
```

You are in five clubs and a spade is led. Barring an unexpected loser in trumps, the main problem is the fourth round of diamonds. The plan of the average player in such a situation is to lead out five rounds of clubs, hoping that a defender with four diamonds may discard one. We do not by any means disparage that form of play, but it so happens that there is a better method. Cash two clubs only, then play ◇ A, ◇ K, and low to the queen in that order. Your main hope is to find the player (if any) with four diamonds also holding the outstanding trump. Then you will be able to ruff the fourth diamond. Note that this manoeuvre cannot cost even if it does not gain. If the queen of diamonds is ruffed, for example, dummy's trump will take care of the fourth diamond, which would have been a loser if you had drawn trumps.

There was a special reason why we advised playing the diamonds in the order, ace, king, up to the queen. Suppose this were the full deal:

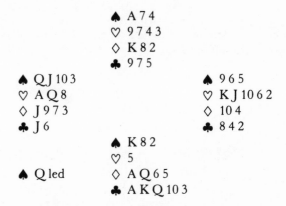

♠ A 7 4
♡ 9 7 4 3
◊ K 8 2
♣ 9 7 5

♠ Q J 10 3
♡ A Q 8
◊ J 9 7 3
♣ J 6

♠ 9 6 5
♡ K J 10 6 2
◊ 10 4
♣ 8 4 2

♠ K 8 2
♡ 5
◊ A Q 6 5
♣ A K Q 10 3

♠ Q led

Here you are not successful in finding four diamonds and three trumps in the same hand, but another resource comes to your aid when you reach this position:

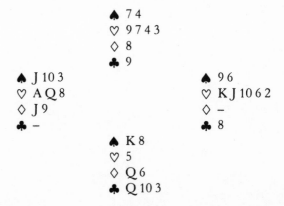

♠ 7 4
♡ 9 7 4 3
◊ 8
♣ 9

♠ J 10 3
♡ A Q 8
◊ J 9
♣ -

♠ 9 6
♡ K J 10 6 2
◊ -
♣ 8

♠ K 8
♡ 5
◊ Q 6
♣ Q 10 3

When you lead the diamond from dummy East may ruff, but he will be ruffing a loser. A spade from dummy later goes on ◊ Q and a spade is ruffed. If East declines to ruff the third round of diamonds, then South wins with ◊ Q and trumps the last diamond.

You see the importance of leading up to a protected honour on the third round of the suit? This is a very common principle of play when there is any danger of a ruff. Often declarer will want to develop a side suit of this sort:

6 4 2

A K 7 5 3

It is in order to play the ace from hand, but for the next lead South should cross to dummy if possible. Then if East has a singleton he won't be able to ruff the king.

Means of Access

In a general way, you have to consider communications on every hand. No matter how straightforward a contract may seem, it will nearly always be possible to muddle it by cashing or developing tricks in the wrong order. The best way to avoid a silly mistake is to play the deal through in your mind.


 ♠ A 7 4
 ♡ Q 8 2
 ◊ 10 5 2
 ♣ 9 5 4 3
 ♡ 4 led
 ♠ K 8 3
 ♡ A K 6
 ◊ A K 7 4
 ♣ K J 10


You are in 3NT and a heart is led. You have seven winners and can establish two more in clubs. The normal way to tackle the club combination is by leading towards the jack, but the comparative scarcity of entries to the table should warn you that there may be communication problems.

If you win the heart opening with dummy's queen and finesse ♣ J, losing to West's queen, you will have no problems if a red suit comes back. But suppose a spade is returned: you win with ♠ K and play a club, but the ace wins immediately and spades are continued. Dummy's ♠ A is forced out while you still have a high club in your hand. The suit is blocked and you cannot cash ♣ 9.

The conclusion is that you must preserve the entries to the table. You must win the heart lead in the closed hand and lead clubs from there, forgoing the finesse but making sure of nine tricks.

Now suppose a spade is opened instead of a heart. Having held up

for one round, you should win with ♠ A and tackle clubs in the normal way, finessing the jack. The difference is that if the finesse loses, dummy's remaining entry cannot be forced out.

No special act of adroitness is needed to make this contract; just care to win in the right hand. We look next at some of the many tactical coups within the field of communications.

BUILDING EXTRA ENTRIES

For extra entry to one hand, unblock high cards in the opposite hand.

The simple unblocking play is the commonest of the entry-creating strokes. By playing an unnecessarily high card from one hand you allow extra tricks to be won in the opposite hand. We have already seen how combinations like K–Q–7–2 opposite A–J–8–4 can be managed so as to provide extra entries to one hand or another. Similar technique may be needed here:

$$A\ 10\ 9\ 2$$
$$J\ 7\ 6 \qquad\qquad\qquad\qquad 3$$
$$K\ Q\ 8\ 5\ 4$$

Normal play to guard against a 4–0 break is to start with a high card from the closed hand. You must also unblock by playing the 9 or 10 from dummy, otherwise you cannot run five fast tricks when East holds J–x–x–x.

$$A\ 9\ 5\ 3\ 2$$

$$K\ J\ 10$$

You cash the king and continue with the jack, the queen coming up from West. If dummy holds no side entry you must duck to make sure of the long cards. A somewhat better play is to run the 10 on the first round, for West may duck with Q–x or Q–x–x.

When a suit is in obvious danger of being blocked, look out for a chance to shed an obstructive card:

(1) K Q 6 5 2 (2) K 7 6 5 3 2

 A 10 8 7 A 10 8

With (1) discard the 7 if you have a chance. Otherwise the suit will be blocked when an opponent holds J–x–x. With (2) you cannot possibly run six fast tricks unless you are able to disembarrass yourself of the 8.

Unblocking is often necessary as part of a safety play.



A Q 8 5 4

10 7 6 3 J

K 9 2



To guard against East's holding a singleton honour, you cash the ace and lead back to the king, uncovering the finesse. Unless you unblock the 9 on the first round you will need a side entry to dummy before you can run the suit.

Many unblocking possibilities occur at the first trick. It is easy to play the following combinations too quickly:

 (1) J 10 8 (2) J 9 4

 K 9 4 Q 7 3

Against (1) West leads the 3, dummy plays the 10, and East the ace. If an entry to dummy is required, unblock with the king. Against (2) West leads the king, presumably from A–K. To be sure of an entry to dummy, drop the Queen.

Look for unusual finesses to win extra entries.

Many entry plays are founded on variations of this position:



K 10 4

A Q 2



You lead the 2 and finesse dummy's 10. If West has played low from the jack, dummy now has an extra entry.

Pursuing this theme, declarers have been known to finesse spot cards in situations like this:



J 6

A K Q 10 9 7 2



Needing two entries to dummy, South leads the 2 and finesses the 6 if West plays low. You may note that in both examples West, if alert, can scotch the play by going in with his high card.

In the following situation the defenders cannot prevent the entry finesse:



A 10 7

Q 3



West leads low and East wins with the king. South drops the queen, later finessing the 10. The next combination is similar but less well known:



J 5 3

9 8 7 K Q 4 2

A 10 6



Needing two entries to the closed hand, you go up with dummy's jack when the 9 is led. If you do not, East can keep you out of the closed hand after you have won his queen with the ace.

There are entry-creating possibilities in a first-round finesse against the queen with such a combination as the following:



A J 9 8 4

K 10



You are playing in notrumps and are short of entries to dummy. A possible way of tackling the combination is to lead the 10, overtaking with dummy's jack. Whether it holds or not, you intend to overtake the king with the ace on the next round. That way, even if you do not establish the long cards you make certain of two entries to dummy. You would adopt that technique on a hand like this:

```
                    ♠ 10 4 3
                    ♡ 10 7
                    ◇ A J 10 9 4 2
                    ♣ 8 2
   ♠ K 9 8 6                      ♠ J 5 2
   ♡ Q 9 8 5 4                    ♡ K 6 3
   ◇ 7 5                          ◇ Q 8 3
   ♣ 10 5                         ♣ K 9 7 6
                    ♠ A Q 7
                    ♡ A J 2
   ♡ 5 led          ◇ K 6
                    ♣ A Q J 4 3
```

West leads a heart against 3NT, the ace winning. The best plan is to lead ◇ 6 and put in the jack. A good player in the East position will refuse to win, for he can see that this will set up the whole suit. You use the entry in dummy to finesse ♣ J. When this holds, you overtake ◇ K with the ace and finesse clubs again, making the contract even though clubs break 4–2.

If the defenders are bound to hold up a winner, consider whether you can exploit the situation to gain an entry or tempo.

There are many occasions like the above where you can steal a trick, or gain an entry, because the opponents cannot afford to win the suit you are leading. Here is a simple hand in which the declarer takes advantage of the fact that the defenders must duck:

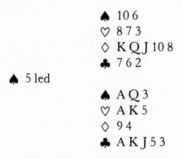

```
                    ♠ 10 6
                    ♡ 8 7 3
                    ◇ K Q J 10 8
                    ♣ 7 6 2
   ♠ 5 led
                    ♠ A Q 3
                    ♡ A K 5
                    ◇ 9 4
                    ♣ A K J 5 3
```

You are in 3NT and ♠ 5 is led. You put in the 10, as West may have led from K–J, but East covers with the jack and you have to win with the queen. Now it is obvious that you must establish clubs, for the defenders will shut out the diamonds by a simple hold-up.

Nevertheless, the diamond suit is a key factor in the development of the hand. You cash ♣ A and cross to ◊ K, which must win. Now you finesse ♣ J and can afford to lose this trick.

ENTRIES IN THE TRUMP SUIT

Use dummy's trumps for entry as well as for ruffs.

When dummy has a side suit and few high cards outside you will often need the trump suit for entry. In this first example the side suit is blocked and you have to risk an adverse ruff while playing off the high cards.

```
                         ♠ K J 9 3
                         ♡ 7 6 4
                         ◊ 8
                         ♣ J 8 7 3 2

        ♠ 2 led

                         ♠ A Q 10 6
                         ♡ K 5 2
                         ◊ Q 6 4
                         ♣ A K Q
```

You are in four spades and a trump is led. Assuming a 3–2 trump break, there will be no problem if East holds ♡ A. If West holds ♡ A you will need to run the clubs before losing the lead. However, you cannot draw three rounds of trumps, cash ♣ A–K–Q, and enter dummy with the fourth trump, as you need a ruffing trick to make game.

The best sequence is to cash ♣ A–K, enter dummy with a second trump, and play a club to the queen. East may fail to ruff even if he has the opportunity.

In the next two examples it is not so clear at first that the trump suit may be required as a means of entry:

♠ 7 4 3
♡ K 6 5
◇ A Q J 6 2
♣ Q 4

♠ K led

♠ Q 9
♡ A Q 10 7 3
◇ K 10 4
♣ A 8 5

Playing in four hearts, you ruff the third round of spades. Now the normal way to play this trump combination is ace, then low to the king, so that you can pick up a possible J–x–x–x in East's hand. That would be a mistake here, for you can afford to lose a trump trick and must allow for the possibility of West holding the long trumps. The right game is to play off the ace and queen. Then, if either defender has four trumps, switch to diamonds until an opponent ruffs. Dummy's king of hearts will draw the last trump and leave declarer in the right hand.

Another common stratagem is to abandon a likely trick in the trump suit for the sake of a valuable entry to dummy.

♠ A Q 6 5 3
♡ J 6 2
◇ 10 5 4
♣ 7 3

♣ J led

♠ K 7
♡ A 8 5
◇ A K J 9 6 3
♣ A 8

After an abortive attempt to reach a slam you finish in five diamonds. What do you think is the safest line after you have won the first club trick? There may be thirteen tricks for the taking, but equally the diamonds may be 3–1 and the spades 4–2. In that case, straightforward play will leave you a trick short. The correct card at trick 2 is the jack of diamonds! The opponents win, cash their club trick, and lead a heart. You go up with the ace, cash ◇ A and then, if there is still a diamond outstanding, you play king and ace of spades, ruff a low spade with ◇ K, and cross to dummy with the 10

of diamonds. Now the long spades will be good (we hope) for two heart discards.

Note that it would be a mistake to begin with ◊ A and then lead the jack. A third diamond would remove the entry from dummy before you had established the spades.

When you are using trumps to ruff, or going from hand to hand in the trump suit, always, as a matter of technique, keep the entry situation fluid by playing middle cards. For example, with K–Q–10–9–3 opposite A–8–5–2, ruff with the 9, not the 3. Leading a round of trumps (or any other suit) with K–Q–J–9–7 opposite A–10–8, play the jack to the ace, keeping two entries to both hands. Sometimes it will make a difference.

As a rule, the object of ruffing in the short hand is to gain tricks. Sometimes, as here, the ruff does not create an extra trick, but it provides an important entry:

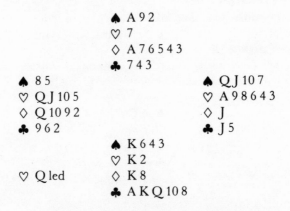

```
                    ♠ A 9 2
                    ♡ 7
                    ◊ A 7 6 5 4 3
                    ♣ 7 4 3
    ♠ 8 5                          ♠ Q J 10 7
    ♡ Q J 10 5                     ♡ A 9 8 6 4 3
    ◊ Q 10 9 2                     ◊ J
    ♣ 9 6 2                        ♣ J 5
                    ♠ K 6 4 3
                    ♡ K 2
    ♡ Q led         ◊ K 8
                    ♣ A K Q 10 8
```

You are in six clubs. The heart opening is won by East and ♠ Q comes back. As you intend to establish diamonds, you go in with ♠ K. When both opponents follow to two rounds of trumps, it is time to pause.

If diamonds are 3–2, it will do no harm to play two rounds before drawing the last trump, but if they are 4–1 you will need an extra entry. You can obtain this by ruffing ♡ K. Leaving the trump at large, therefore, you play the king and ace of diamonds. East shows out but fortunately does not hold the outstanding trump; now you ruff a diamond, ruff ♡ K, and ruff another diamond, establishing the two long cards, which are all you need.

It was not easy for East to judge, but a heart continuation at trick

two would have been more effective. It would have forced South to use the ruffing entry prematurely.

ATTACKING THE DEFENDERS' COMMUNICATIONS

Even in a suit contract you should often hold up for one round.

So far we have been considering how to improve declarer's entries. It can be equally important to obstruct the defenders' communications. In notrumps the hold-up in the enemy suit is a standard manoeuvre and it is often right in a suit contract as well. Suppose you hold A–x–x opposite x–x–x, with no prospect of quick discards. It will usually be good play to hold off for one round, because the distribution may well be 5–2 and the player who has the five cards may never regain the lead. Even with A–x opposite x–x–x it is good technique to hold up because you make it more difficult for the opponents to go from hand to hand afterwards. Here there is an immediate tactical advantage in the hold-up:

```
                    ♠ A 10
                    ♡ 8
                    ◇ 10 6 4 3
                    ♣ K 10 9 6 5 2
    ♠ K led
                    ♠ 8 4 3
                    ♡ A K Q J 5 3
                    ◇ A K 5
                    ♣ Q
```

You are in four hearts and West leads the king of spades. If you win this trick you can be cut off from the dummy and will probably lose a club, two spades and a diamond. By ducking you present the opponents with a dilemma. If they lead a trump, the ace of spades will be an entry for the king of clubs after you have forced out the ace; and if they lead a spade to kill the entry you will be able to ruff the third round of spades.

Release a high card early if this will block the enemy suit.

Holding up is not the only way to cut communications. Sometimes you can disconcert the opposition by answering the first knock on the door. At notrumps the following is a standard situation:

 A 4

 10 9 5 2

When West leads small, you play the ace first time. West will not
hold K–Q–J, so you cannot gain by playing low; but if the suit is 5–2
you block it by playing high, isolating East's doubleton honour. The
same play is usually right with this combination:

 A 7 6
 5 led
 J 8 2

If you can attack the entry of the West hand, go up with the ace.
This will gain when East holds K–x or Q–x and lose only when West
has led from K–Q.

This is a slightly different situation:

 10 3
 Q 6 2 A 9 8 5 4
 K J 7

You land in notrumps after East has bid this suit. When the ace
goes up and the 5 comes back, you put in the king. Now the
opponents will need at least two entries before they can cash the
long cards.

The same sort of play is possible when the cards lie like this:

 6
 J 9 3 A K 8 7 4
 Q 10 5 2

East has bid spades and West leads the 3. East wins with the king
and returns the 7. Now West may have led from A–x–x or from
J–x–x. If from A–x–x it makes no great difference whether you play
the queen or the 10 at this point, for the suit will be cleared and
the opponents will run the long cards when they regain the lead; but
if West holds J–x–x, then the play of the queen will block the run of
the suit.

A characteristic of blocking plays – indeed of all entry plays – is
that they are available to the defenders as well as the declarer. The

following manoeuvre is often used by both sides.



Q 10 6

9 8 7 A J 3 2

K 5 4



On the lead of the 9 dummy's queen is played. After winning with the ace East cannot continue the suit without yielding a trick. If East happened to be the dummy, it would be right for the defender sitting North to go up with the queen in the same way.

The Scissors Coup

This sparkling coup is the purest form of communication play. Its sole object is to snip communications.



♠ 10 9 8 2
♡ A K 5
◇ 7 6 4
♣ A 8 3



♠ A Q 5 ♠ 4
♡ 9 3 ♡ 10 8 6 4 2
◇ A K 8 5 3 ◇ Q J 10
♣ J 10 7 ♣ 9 6 4 2



♠ K J 7 6 3
♡ Q J 7



◇ K led ◇ 9 2



♣ K Q 5



You are in three spades, West having bid diamonds. On the lead of ◇ K East drops the queen, indicating that he holds the jack. Realizing that he has a good chance to obtain a ruff of the third round of hearts, West switches to ♡ 9, which you win in dummy. If you lead a trump now, West will play a second heart and a ruff will follow when East comes in with ◇ J. Instead, you must play a diamond at once, so that the entry will be snipped off before it can be used for a heart ruff.

AVOIDANCE PLAY

Develop your suits so that a dangerous opponent has to duck or give away a trick.

Any stroke that aims to keep a particular opponent out of the lead while you establish tricks can be described as an avoidance play. Thus in the chapter on notrumps the plays that aimed to keep out a dangerous hand were of the avoidance type. The term is also used in respect of some special plays where it may not be immediately obvious that it makes a difference which hand you lead from. This is a standard example:

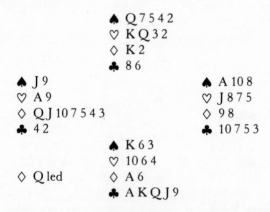

You land in 3NT after West has opened three diamonds. When a diamond is led you can see seven winners and can establish one more in each major suit. However, West may hold one of the missing aces and if you tackle the major suits in the wrong way East may win and clear the diamonds while his partner still holds an entry.

It may seem that you have to guess which major suit to play first, but you can make the contract no matter which ace West holds. Win the diamond opening in dummy and lead a small spade towards the king. If East holds the ace he must duck or give you enough tricks for game. When you win with ♠ K you develop your ninth trick in hearts.

When writing about the 'danger hand' in an earlier chapter we described some ways of keeping a particular opponent out of the lead. A simple method is the deep finesse:

A 8

K Q 10 6 4

Suppose that you need four tricks from this suit. Clearly you can shut out East by finessing the 10 on the second round. If West is the danger hand, lead the 4 and put in the 8 unless West plays a higher card. West can defeat this manoeuvre only when he has J–9–x–x and even then he may fail to put in the 9.

In the next two examples declarer accomplishes his object by leading up to the high cards:

(1) A K 6 4 (2) A Q 6

 8 7 5 3 8 7 5 4 2

These are variations of a type of position we have already noticed. South wants to establish long cards without letting East into the lead. In (1) he should play up to the ace, then return to hand and lead low again. If West has the queen it is allowed to hold whenever it is played. With (2) a similar stratagem is employed against the king. Finesse the queen, then return to hand for a second lead.

In the examples so far, one defender's hand had been 'dangerous'. Avoidance.tactics can also be used where no danger hand exists but where a tempo can be gained by a skilful manoeuvre.

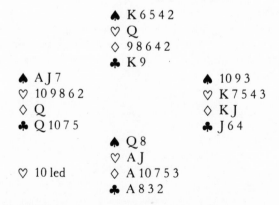

 ♠ K 6 5 4 2
 ♡ Q
 ◇ 9 8 6 4 2
 ♣ K 9

♠ A J 7 ♠ 10 9 3
♡ 10 9 8 6 2 ♡ K 7 5 4 3
◇ Q ◇ K J
♣ Q 10 7 5 ♣ J 6 4

 ♠ Q 8
 ♡ A J
♡ 10 led ◇ A 10 7 5 3
 ♣ A 8 3 2

Against 3NT, West opens ♡ 10 and you head the king with the ace. If you play ace and another diamond your last heart stop will be

removed and you will have only eight tricks. The only play that gives you a chance is to lead a low spade up to dummy. If West holds A–x–x he must duck – or allow you to make four spade tricks. After ♠ K has held you run breathlessly to the diamonds.

We end this chapter with a pretty example of avoidance play which many good players would miss.

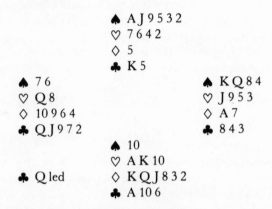

You are in 3NT and West leads ♣ Q. You put on the king from dummy and the suit is now safe from attack by West. Four tricks from diamonds will be enough and it is essential, if you are going to lose two tricks in the suit, to prevent East from winning the first of these. So you lead ◇ 5 from dummy at trick 2 and put in the 8! West will win and probably switch to spades. You go up with the ace, cross to ♡ A, and clear the diamonds.

Of course, you could also win this contract by going up with a high diamond on the first round and returning a low diamond to the ace. But that would be 'double dummy' – the sort of play you could make only if you had seen all the hands.

6

Beating the Odds

To know the mathematical odds is useful; to be able to improve on them by drawing inferences from bidding and play is invaluable. A player who can do that will make his mark, even though he may seem to less inspired opponents to be merely a lucky guesser.

As you develop your game, you will play more and more according to your own estimate of the lie of the cards than according to mathematical expectations. Some factors that help to form such an estimate – the reliability of opponents' bidding, the standard of the defence, and the sort of awareness that goes by the name of 'table presence' – are two imprecise to be included in the analysis. But there are technical factors, too, and we now consider these.

DEDUCTIONS FROM THE BIDDING

Do not hesitate to follow a diagnosis to its conclusion.

There can be two opinions about the reliability of inferences drawn from the operations of non-expert opponents. Some say that the average player bids more reliably than he plays. Others maintain that the play of the cards gives rise to much sounder and more exact conclusions.

Our own contribution to the controversy is the observation that many players, even when there are clear deductions to be drawn from the bidding, fail to act upon them when this involves unorthodox play. Consider this situation:

```
                    ♠ 6 3 2
                    ♡ A 9 8 6 3
                    ◇ A J 5
                    ♣ Q 9
    ♠ Q led

                    ♠ A K
                    ♡ Q 7 2
                    ◇ K Q
                    ♣ J 10 8 6 5 2
```

With North-South vulnerable, the bidding has gone:

South	West	North	East
1 ♣	Double	Redouble	1 ♠
1NT	Pass	2NT	Pass
3NT	All pass		

West opens ♠ Q and East plays the 10. The question is whether there is any future in the 'book' play of trying to establish clubs or whether a less orthodox line is needed.

The club play will fail if spades are 5–3, for the defence will make three spades and two clubs. East was not obliged to bid over the redouble, so is likely, on the play, to hold ♠ 10–9–x–x–x. A realistic declarer, therefore, would not give much for his chances of making the contract by playing on clubs. Instead, he would take a look at the heart suit, keeping the bidding in mind.

As it seems that West hold only Q–J–x in spades he is likely, on his take-out double, to hold four cards in the other major suit. This means that the hearts can be established if East's singleton is the jack or 10 (or if he holds J–10 doubleton). In the light of the bidding, this seems a better prospect than playing on the club suit. So, for our money, lead the queen of hearts at trick two.

Always pause for reflection when a defender who has opened the bidding turns up with a singleton. You will generally find that very illuminating, as here:

♠ 10 8 6 2
♥ A 6 4 2
♦ K 10 5
♣ 10 4

♣ 2 led

♠ J 9 3
♥ K J 9 5
♦ A Q 4
♣ A J 9

You play in 3NT after East has opened one club. East plays the queen of clubs on the lead of the 2 and you win with the ace, noting that West seems to have led the lowest of four cards. Counting two tricks in clubs, you have seven winners. The natural place to look for the extra tricks is in hearts, for East may well hold Q–x or Q–x–x. But before leading a heart to the ace and finessing the jack, it costs nothing to play off two top diamonds. This is done to see if anything turns up; and indeed it does, for East discards a spade on the second diamond.

Now what can you conclude from that? East has opened one club on what appears to be a four-card suit. He would not normally do that if he held a five-card major, so you may reasonably take his distribution to be 4–4–1–4. You lead a heart to the ace, therefore, and finesse the 9 on the way back, telling West to hold his cards up. Then you force out ♣ K and use ♦ K as an entry for a second finesse in hearts.

If you become declarer after an opponent has made a call that defines his hand pattern fairly closely, such as 1NT, a take-out double, or a pre-emptive bid, you will have a good clue to the distribution. A point to remember about take-out doubles is that the fewer honour cards are missing, the more likely is your opponent's double to be based on a three-suiter such as 4–4–4–1 or 5–4–3–1, with a shortage in the suit doubled.

One of the most revealing overcalls is the Unusual Notrump. If you buy the contract after this weapon has been brandished you will often make a couple of extra tricks.

```
                        ♠ 10 6 3
                        ♡ A K 9 8 5
                        ◇ A 3 2
                        ♣ J 6
        ♠ 5                                 ♠ Q J 9 8
        ♡ 10                                ♡ Q J 6 3 2
        ◇ K 10 8 7 6 4                      ◇ J
        ♣ K Q 8 4 2                         ♣ 10 9 7
                        ♠ A K 7 4 2
                        ♡ 7 4
  ♣ K led               ◇ Q 9 5
                        ♣ A 5 3
```

With neither side vulnerable, the bidding goes:

South	West	North	East
	Pass	1 ♡	Pass
1 ♠	1NT	Pass	2 ♣
3 ♣	Pass	3 ♠	Pass
4 ♠	All pass		

West's bid of 1NT is in pursuance of the popular convention whereby an overcall in notrumps that cannot be genuine shows length in the lowest-ranking unbid suits. Over East's two club response you have a difficult call and resolve the problem by bidding the enemy suit, eventually reaching the borderline spade game.

You duck the lead of ♣ K and win the continuation. Had there been no opposition bidding you might have taken a club ruff and tried to set up the hearts, but such a plan would fail on the expected bad breaks. Knowing that West is short in both majors and that East holds corresponding length in those suits, you aim instead to make your small trumps by ruffing hearts.

Cash the top trumps, noting West's singleton, and play three rounds of hearts, ruffing in the closed hand. East is now marked with only four cards in the minor suits, but provided one is a diamond you are safe. Ruff a club, ruff a heart, cross to ◇ A and ruff dummy's last heart, leaving East's master trumps to fall superfluously on West's winning cards.

After a pre-emptive bid, make a complete review.

Everyone knows that normal mathematical expectations fly out of the window when a pre-emptive bid has been made. To gauge how far to go in placing the partner of the pre-emptive bidder with length in the remaining suits, you may have to take many small factors into account. Suppose, for example, you land in four spades after your left-hand opponent has opened three clubs. Your trump suit is K–Q–10–x–x–x opposite A–x, and after both opponents have followed to the ace your problem is whether to finesse the 10 on the next round or play to drop the jack.

If you had nothing further to work on, this could be a close decision. In practice, you will usually spot one or more additional clues. Is the three club bidder vulnerable? If so, his clubs are likely to be longer – and his spades shorter – than if he were not vulnerable. Has he the top clubs? If not, he is likely to hold a seven-card suit rather than a six-timer. Has your right-hand opponent disdained an opportunity to support his partner's suit? This may suggest that he holds 'nuisance value' in your suit and was not anxious to encourage a sacrifice. Has the opening lead supplied a clue of any kind? It usually does!

DEDUCTIONS FROM THE OPENING LEAD

Ask yourself, 'What is the opening leader's plan?'

As we shall see in Chapter 8, the opening lead is the first step in a long-range plan of defence. If you can deduce what that plan is, even in general terms – active, passive, forcing, ruffing – you will learn a great deal about the opening leader's hand.

Take the example we mentioned – how to play K–Q–10–x–x–x opposite A–x. Suppose these are the two hands:

♠ A 5
♥ A 7 6 4
♦ Q J 10 2
♣ 7 5 2

♣ K led

♠ K Q 10 8 6 2
♥ J 8
♦ K 9 8 4
♣ J

With neither side vulnerable, the bidding has gone:

South	West	North	East
	3 ♣	Pass	Pass
3 ♠	Pass	4 ♠	All pass

East wins the club lead with the ace and returns the 6, which you ruff. You play ♠ A and both defenders follow small. On the spade lead from dummy East again plays small.

It seems certain that West held seven clubs originally, and 7–3–2–1 is a far more common distribution than 7–2–2–2. If West had held a red singleton he would probably have led it, so it is more likely that his singleton is in spades. Even if the situation looked borderline before, the 10 finesse is now clearly marked.

Equally strong inferences are available when a defender does seem to be looking for a ruff. A short suit lead is always more attractive for a player who has a trump trick, so you will often have a clue to the defender's trump holding.

```
                        ♠ J 10 3 2
                        ♡ 10 8 6
                        ◇ A Q J 7
                        ♣ 6 5
        ♠ 5 4                           ♠ A Q 8 7
        ♡ K 7 2                         ♡ 4 3
        ◇ 10 9 4                        ◇ 6 5 3 2
        ♣ A Q 10 9 7                    ♣ K J 2
                        ♠ K 9 6
                        ♡ A Q J 9 5
        ♠ 5 led         ◇ K 8
                        ♣ 8 4 3
```

With North–South vulnerable, the bidding has gone:

South	West	North	East
1 ♡	2 ♣	2 ♡	3 ♣
Pass	Pass	3 ◇	Pass
3 ♡	All pass		

West opens the 5 of spades, the ace wins and a spade comes back. You play the 9, which holds. Without looking at the East–West

cards, how do you continue?

It is unlikely that West, with a safe enough lead in clubs, would try for a spade ruff unless he held K–x–x in trumps. With only ♡ K–x a ruff would be unlikely to benefit him, while to lead a spade without a trump control would be worse than pointless. Therefore South should not take the heart finesse, nor play ace and another trump, but should take three rounds of diamonds, discarding the red-hot king of spades.

A lead from an unattractive combination is especially indicative. Say that you play in notrumps after bidding hearts and the defender leads a diamond from a holding like A–x–x or K–x–x or A–J–x–x, none of which would be a primary choice if there were good alternatives. Already you may conclude that his holding in spades and clubs is still more unattractive. That may well assist you later in the play to place the honours, and even the length, in those suits.

Not quite so reliable, but still better than nothing, is the inference you can draw when a defender chooses a safe lead in one suit when he might (with a similar holding) have made the same sort of lead in another suit. Suppose that you play 6NT and are missing an odd king and queen in two unbid major suits. The lead is a club, a suit in which you hold all the honours. Now there is a slight inference that the leader has honours to guard in the majors. One way of looking at it (a perfectly logical way, in a mathematical sense) is this: If the leader had held nothing of value in spades, hearts or clubs, he might have led a spade or a heart just as much as a club. The fact that he has led a club affords some presumption that he did not have an equivalent holding in the other suits.

A particularly valuable inference can be drawn when a defender refrains from the obvious lead of the unbid suit. Say that your holding of this suit is x–x in dummy, K–J–x in hand. Always expect the player who would not lead the suit to hold the ace. With the queen, still more with no honour at all, he would have led it.

An opening trump lead is always significant in one way or another. Sometimes – particularly when only one suit has been mentioned – the trump lead is passive. You may conclude that the opener has no strong alternative. When at least two suits have been bid, and either dummy or declarer can be marked with a good side suit, the lead of a trump contains a special message. It means that, in the view of the defender, the side suit is not going to produce as many tricks as the declarer hopes. If declarer plays in four spades after bidding spades and hearts, or if dummy has bid, say, one

diamond and two diamonds, a trump lead will surely mean that the side suit is breaking badly. If it were not, then the lead would be poor tactics for the defence. Here is a typical situation:

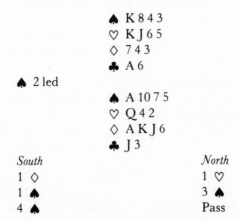

```
                        ♠ K 8 4 3
                        ♡ K J 6 5
                        ◇ 7 4 3
                        ♣ A 6
      ♠ 2 led
                        ♠ A 10 7 5
                        ♡ Q 4 2
                        ◇ A K J 6
                        ♣ J 3
```

South	North
1 ◇	1 ♡
1 ♠	3 ♠
4 ♠	Pass

On the spade opening East plays the queen and you win with the ace. On a second round of trumps West plays the 9 and East the 6.

If the rest of the hand goes badly you may lose a trick in each suit. Assume at this point that the diamond finesse is wrong, for if it is right the contract will be lay-down. There is still a chance of discarding a club on the fourth round of one of the red suits. The question is, which red suit will you attack?

West's lead of a trump is your best indication. It suggests that he does not expect you to set up many tricks in your first suit, diamonds. He may well have something like ◇ Q–10–x–x. You play on hearts, therefore; if the opponents win and attack clubs, you continue hearts, hoping to discard a club on the fourth round. You still have the chance of the diamond finesse.

COUNTING THE HAND

To beat the odds, try to figure out the suit lengths in the unseen hands.

When you can judge the distribution of the opposing hands you are said to 'have the count'. From that point the play becomes easier and much more accurate. Obtaining a count may be hard work until you are used to it, but it is also the beginning, and not far from the end, of all expert play.

A count of the hand does not merely tell you how the suits are

breaking; it also enables you to place high cards more surely. If you are missing six spades including the queen and you know that West holds two spades and East four, East is twice as likely to hold the missing queen.

To get a count, you start with individual suits. We start with a deal where you gain a sure count of three suits before taking a critical finesse.

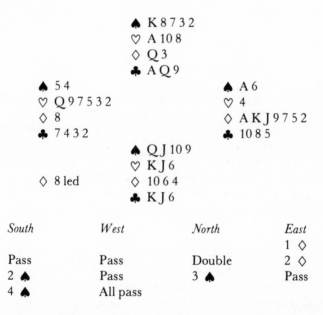

	♠ K 8 7 3 2	
	♡ A 10 8	
	◇ Q 3	
	♣ A Q 9	
♠ 5 4		♠ A 6
♡ Q 9 7 5 3 2		♡ 4
◇ 8		◇ A K J 9 7 5 2
♣ 7 4 3 2		♣ 10 8 5
	♠ Q J 10 9	
	♡ K J 6	
◇ 8 led	◇ 10 6 4	
	♣ K J 6	

South	*West*	*North*	*East*
			1 ◇
Pass	Pass	Double	2 ◇
2 ♠	Pass	3 ♠	Pass
4 ♠	All pass		

The defence begins with three rounds of diamonds and dummy ruffs. East wins the first round of trumps and exits with a trump. You can count nine of East's cards now – seven diamonds and two spades. Before tackling hearts you cash three rounds of clubs and when East follows suit you know he cannot hold more than one heart. You therefore lay down ♡ K and finesse against West with complete confidence.

When you are trying to count the opposing hands, what the defenders have not bid can be as informative as what they have bid. On the next deal you draw an inference from an opponent's silence.

```
                    ♠ Q 6 4
                    ♡ A Q J 8
                    ◊ Q J
                    ♣ K J 8 7
  ♠ J 9 5 3                        ♠ 2
  ♡ 9 4 2                          ♡ 6
  ◊ K 6 4 3 2                      ◊ A 10 9 8 7 5
  ♣ 10                             ♣ Q 6 5 4 3
                    ♠ A K 10 8 7
                    ♡ K 10 7 5 3
  ◊ 3 led           ◊ –
                    ♣ A 9 2
```

You play in seven hearts after East has passed as dealer, not vulnerable. On the diamond opening lead you ruff East's ace and draw three rounds of trumps. A 3–2 spade break would produce thirteen tricks, as two of dummy's clubs would go away on the long spades; but the actual lay-out disappoints and you need to win three club tricks. By the time you have established the spades you know that East began with only one heart and one spade. With seven diamonds headed by the ace, and 1–1–7–4 distribution, he would probably have opened three diamonds as dealer. So you exclude this distribution and place him with at least five clubs. An orthodox finesse for the queen cannot work. Instead, you play low to the king and finesse the 9 on the way back.

To get a perfect count like this is very satisfactory, but do not despise a count that is incomplete. On the following deal South has a count of only one suit, but that is enough to suggest an unorthodox line of play.

```
                    ♠ A K 6 2
                    ♡ K 8 7
                    ◊ Q 5 2
                    ♣ 10 8 7
  ♠ J 8 5 3                        ♠ Q 9
  ♡ Q 6 4 2                        ♡ 3
  ◊ A 9                            ◊ K J 8 7 6 3
  ♣ J 6 4                          ♣ 9 5 3 2
                    ♠ 10 7 4
                    ♡ A J 10 9 5
  ◊ A led           ◊ 10 4
                    ♣ A K Q
```

With both sides vulnerable, the bidding goes:

South	West	North	East
1 ♡	Pass	1 ♠	Pass
2 ♡	Pass	3 ♡	Pass
4 ♡	All pass		

West begins with ace and another diamond and East plays a third round, on which you discard the almost certain spade loser. East exits with a club and the question is how to play trumps.

The normal percentage play is low to the king, finessing on the way back. As you have a count of the diamond suit, however, you know that West holds eleven cards outside that suit and East only seven. West is much more likely to hold ♡ Q, so you lead the jack for a first-round finesse.

DISCOVERY

Force the opponents to provide you with clues to their holdings.

We have been considering so far how to draw deductions from the information provided by the opponents' bidding and play. There are ways of going out and looking for that information. Called 'discovery play', this is one of the fine-art departments of card play.

We have already seen examples of discovery play being used to test the distribution. We look now at another branch – the discovery of high cards. The idea is to force the defenders to reveal unimportant cards so that you can draw inferences about the important ones.

```
                    ♠ A 10 6 2
                    ♡ K Q 4
                    ◊ J 7
                    ♣ 10 6 5 3

       ♣ K led
                    ♠ Q J 9 8 5 3
                    ♡ 9 6
                    ◊ K 10 4
                    ♣ J 2
```

After two passes you open a semi-psychic one spade in third position. Partner raises you to three spades and West leads ♣ K,

followed by a low club to his partner's ace. You ruff the third round of clubs, run ♠ Q successfully and draw the remaining trump. The next play should be the king of hearts, and on this round or the next you discover who holds the ace of hearts.

By this time you should have some picture of the diamonds. If West turns up with ♡ A in addition to ♣ K–Q and ♠ K (already known) you will play East for the ace of diamonds; and if East reveals the ace of hearts, in addition to ace of clubs, you will play him for the queen of diamonds rather than the ace, as with three aces he might have opened the bidding.

There is an element of discovery play in many of the commonest situations in the game. Take this familiar combination:

7 4 2

K Q 10 5

You want to find out quickly where the ace lies so that you will know whether or not to finesse the 10 later. Most players lead low to the king, expecting West to put on the ace if he has it. In an average game this may be sound tactics, but an expert West, if you play this suit early at notrumps, may duck with A–x–x. Not expecting you to make this lead up to an unsupported king, he will place you with K–Q and may seek to mislead you. The better card to play, therefore, is the queen. Now it is more difficult for a good defender to hold off, as he may be giving you a trick and a tempo, should your suit be headed by Q–J, not K–Q.

There is sometimes an art in playing a combination like this:

A Q 5

J 10 8 4

This is a side suit in a trump contract and you may want to know before drawing trumps whether the finesse is going to win. It would be a mistake to lead the jack because East, with K–x–x–x, might hold off, and it would be dangerous to finesse again. If you lead low to the queen you are more likely to discover who holds the king.

Here is a discovery play with an unexpected twist:

```
                          ♠ K 7 6 4
                          ♡ K J 10
                          ◊ J 9 3
                          ♣ K J 5
        ♡ 5 led

                          ♠ —
                          ♡ 9 7 6
                          ◊ A Q 10 8 4 2
                          ♣ A Q 9 4
```

After a pass by East you open one diamond and become declarer in five diamonds. East wins the heart lead with the queen, cashes the ace and leads a third round, to which all follow. Now the contract appears to depend on the diamond finesse, but a little discovery is in order. You lead ♠ K from the table. If it appears that East holds the ace, you will not play him for the guarded king of diamonds as well. Your only chance will be to drop a singleton king in West's hand.

It is true that East might hold the ace of spades and not play it on the king. If he plays low without a tremor, the only advice we can give you is to finish the rubber quickly and cut into an easier game.

7

Detective Work in the Middle Game

As the play progresses, your picture of the unseen hands will become clearer, yet there still may be some blank spots. There are two principal ways of filling them in. You can draw inferences from the way the defenders are playing and, if still in doubt, you may make an assumption about the lie of a key card. Then you can test the validity of that assumption by reviewing the opponents' bidding, or lack of it.

Both techniques depend to some extent on the standard of the opposition. The more accomplished they are, the more surely you can make deductions. The sort of reasoning that we are going to describe is safe only against reasonably sound players.

INFERENCES FROM THE DEFENDERS' PLAY

Look for an explanation whenever your opponents fail to make an expected move.

Some inferences immediately strike the mind. For example, if you finesse the jack from K–J–10 and it fetches the ace, you place the queen without having to think. Many inferences are less obvious than this, but simply require that you direct your mind to them. A good habit, though it has to be cultivated, is to have in mind how you expect an adversary to react to a given situation. When he fails to react in the expected way, the red light blinks and you know that an opportunity for detective work has presented itself.

Here is an example of a defender failing to make an expected move. East–West are trying to establish long cards against a notrump contract and it would be normal play for West to duck to maintain communications.

```
                        ♠ 8 2
                        ♡ A 7 2
                        ◇ A 7 5 4
                        ♣ Q J 9 6
     ♠ 5 led
                        ♠ Q J 6
                        ♡ K J 6 4
                        ◇ K Q 8
                        ♣ A 10 7
```

You open 1NT and North raises to 3NT. A spade is led, the ace wins and the 9 comes back. West wins with the king and on the third round of spades East drops the 3. If the opponents are following normal conventions of play, you can take it that West has led from a five-card suit. The question arises, why has he not made the normal ducking play on the second round to maintain communication with his partner? The answer must be that he has an entry card on which he relies – no doubt the king of clubs. (It might, in certain circumstances, be a mistake for West, holding five spades and ♣ K–x, to duck the second spade; later in the play South might exit with a spade, forcing a return away from ♣ K.)

It is safe to conclude, at any rate, that the club finesse will lose. South should therefore attempt to develop seven tricks in the red suits, although this will mean taking the heart finesse as well as finding a 3–3 break in either hearts or diamonds.

In many situations, especially towards the end of the play, a defender will be anxious to gain or to avoid the lead. His manoeuvres may then be highly indicative.

```
                        ♠ K J 7 5 3 2
                        ♡ 7 4
                        ◇ Q 8
                        ♣ 8 6 3
     ♠ 6                                    ♠ 9
     ♡ K J 9                                ♡ Q 8 6 5 3 2
     ◇ J 6 3 2                              ◇ K 9 5
     ♣ A Q 10 9 5                           ♣ K J 4
                        ♠ A Q 10 8 4
                        ♡ A 10
     ♣ A led           ◇ A 10 7 4
                        ♣ 7 2
```

South	West	North	East
1 ♠	2 ♣	2 ♠	3 ♣
3 ◇	Pass	4 ♠	All pass

West holds the first trick with ♣ A and his best defence, as the cards lie, is to switch to a heart at once. This is not so easy to judge, however, and we will say that West leads a second club to his partner's king. East knows that a third club will not stand up, so he leads a heart, which you win with the ace.

Even though you may not yet be an expert in elimination play, it will probably occur to you to draw a round of trumps, ruff dummy's third club and exit with your second heart. West's jack holds the trick and now, clearly, he must open up the diamonds, for if he plays anything else you will get a ruff and discard.

When West leads a low diamond you have a guess, in theory, but it is a very easy guess to resolve. If East did not hold the king of diamonds he would surely have overtaken the second heart and led a diamond through the declarer. You read East for the king, therefore, and play the low diamond from dummy, not the queen.

In trump contracts you can often construct the defenders' trump holdings from the way they handle the side suits. On the following deal the fact that East did not try to promote a trump trick for his partner is the tip-off.

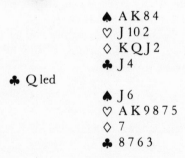

♠ A K 8 4
♡ J 10 2
◇ K Q J 2
♣ J 4

♣ Q led

♠ J 6
♡ A K 9 8 7 5
◇ 7
♣ 8 7 6 3

The contract is four hearts, East having opened one club. West wins the first trick with the queen of clubs and East the next with the king. East returns a trump and you go up with the ace, West playing low. Can you make any deduction about the missing queen? East must have it, for otherwise he would have played a third round of clubs, enabling West to make his queen in front of dummy. Holding ♡ Q–x–x, East refrains from leading a third club, as he knows that

partner's inability to ruff a high will make the finesse obvious.

Draw inferences from an opponent's discards.

When the defenders are discarding on a long suit they will generally provide quite reliable indications of their length in the other suits. Here is a well-known situation:

A K 8 5

Q 6

This is a side suit in a trump contract, and while trumps are being drawn an opponent lets go a card in this suit. The one thing you can be sure of is that he has not made the discard from four cards, as he can see the length in dummy. He may have discarded from two or three, but it is more likely that he began with five; and if he discards twice he probably began with six.

Expert defenders, when they see that they will have to find a number of discards, organize these in a way that will not help the declarer. Most players make the easiest discards first. If eventually they have to bare an honour, the protecting card will be the last card they throw; and much can be deduced from this.

In general, do not assume that opponents have presented you with tricks. Take this very common holding:

K J 10 3

A 7 4

While you are playing off another suit at notrumps, both defenders discard once from this suit. Now do not imagine that one player has obligingly discarded Q–x–x and the other from x–x–x. Undoubtedly the queen is still guarded. You may be able to judge which defenders is more likely to have been short in the suit. If you cannot, and you begin, say, with ace and a low card, then incline towards the finesse.

As you approach the end game, note especially when a defender has been late, or reluctant, to discard from a particular suit. This reluctance provides a good clue when at the end of a hand you have to tackle this combination:

5 4 3

K J

Perhaps you began with more cards in this suit, but now you are down to this simple guess. You lead low from dummy and East follows suit. Now if East has discarded once or twice from this suit he is more likely to hold the ace than the queen. If the discards have been from the other side, and East has been clinging on to three cards until late in the hand, the probability is that East has been keeping a guard to the queen.

The same sort of inference may be available with a combination like this:

A 8 6 2

Q 10 4

You are playing notrumps and quite early in the play East, not under great pressure, has discarded from this suit. Requiring two tricks from it, later in the hand you play low to the ace and return the 2. East follows and the choice now is whether to put in the 10 or the queen. In effect, you are playing East for an original K–x–x–x or J–x–x–x. Which is more likely? Surely that he began with K–x–x–x, as with that holding he would be ready to discard, whereas from J–x–x–x he would be less inclined to. It is because they think about things of this sort that good players get the reputation of being good guessers.

Don't play as though the defenders had X-ray eyes.

To draw the kind of inferences we have described, you have to assume that your opponents are defending intelligently. But you should not assume that they can see through the backs of your cards. Try to look at things from their angle, remembering that what may be obvious to you may be hidden from them. You will then be able to draw inferences in such mundane situations as the following:

(1) A K J (2) A K 3

 10 6 3 J 10 6

In each case an apparently even-money finesse is offered. Now suppose that in the middle game West leads the suit. In (1) this does not change the odds much, since West knows that you can finesse whether he leads the suit or not. In (2), however, West's lead of the suit does mean that the queen is more likely to be in East's hand. West probably does not know that you hold both the jack and 10. Therefore he would be less willing to lead away from the queen, which could give you a free trick if you held J–x or J–x–x.

These two holdings present a similar comparison:

(1) A Q J (2) A J 4

 8 5 3 Q 7 3

In the first example West, at some point in the defence, leads the 6 and dummy's queen holds. This tells you little about the position of the king. West may have led from the king because it gives no trick away or because he hopes to win the fourth round; or East may be holding up the king, expecting declarer to repeat the finesse.

In the second example West leads the 6 during the middle game, dummy plays low, East puts on the 10 and the queen wins. The strong probability here is that the finesse is wrong. With K–x–x West would not be inclined to lead through dummy's A–J–x, as this would give away a trick when South held Q–x–x or 10–x–x. Assume, therefore, that East has made a normal finesse against the dummy, holding K–10–x.

There is an important difference between these two situations:

(1) K J 5 3 (2) K 8 5 3

 8 4 J 4

You are playing a suit contract and West at some point leads a low card through dummy. You cannot afford to lose two quick tricks in the suit. With (1) you have little indication, for if West holds either the queen or the ace he gives nothing away by leading the suit. All one can say about this is that most players are rather less inclined to play from the queen than from the ace.

With (2) you should normally assume that West has led from the ace, not the queen. From West's point of view, underleading the ace is probably the only way for the defence to make two immediate

tricks. It is true that a good player will sometimes underlead the
queen in this situation, especially when it is essential to attack the
suit quickly, but in general you should read West for the ace. The
principle to remember is that you must not let a defender diddle you
out of a trick you would surely make if you had to play the suit
yourself.

When a defender makes what from your side you can see is a
mistake, there is much to be gained by asking, why has he done
that? On the following deal you find yourself with an unexpected
chance to make the contract. Reflect upon how that has come about,
and the answer will solve an apparent guess.

```
                    ♠ A K 7 4
                    ♡ 8
                    ♦ J 8 2
                    ♣ A Q 8 7 4
    ♠ J 9                              ♠ Q 8 6 5 3
    ♡ K Q 10 9 7 3 2                   ♡ A 6 4
    ♦ A 7 5                            ♦ Q 9 4 3
    ♣ 3                               ♣ 9
                    ♠ 10 2
                    ♡ J 5
    ♡ K led         ♦ K 10 6
                    ♣ K J 10 6 5 2
```

With both sides vulnerable, the bidding goes:

South	West	North	East
			Pass
Pass	3 ♡	Double	4 ♡
5 ♣	All pass		

North's double is for take-out. Against five clubs West wins the
first trick with ♡ K and shifts to ♠ J. Having drawn trumps you
eliminate the major suits by ruffing two spades in hand and a heart
in dummy. You discover meanwhile that West began with a
doubleton spade and a singleton club. On the bidding and play, a
seven-card heart suit looks likely and West must therefore hold three
diamonds. Thus there is no point in playing for a doubleton
diamond honour in one hand or the other. (If you thought West
might hold ♦ Q–x, for example, you could lead towards ♦ K and

then exit with a small diamond, forcing West to win and concede a ruff-and-discard.) Instead, you cross to dummy and lead ◊ J, which is covered by the queen, king and ace. West now returns ◊ 5 and the question is whether you should put up dummy's 8, playing West for the 9, or duck in dummy, playing West for the 7.

The clue lies in the fact that West has blundered in releasing ◊ A. Had West ducked the king of diamonds you would have had to lose two diamond tricks. You should now ask yourself whether West would have been more likely to make that mistake when holding A–9–x or A–7–x. With A–9–x the right defence would be fairly obvious. So you play West for A–7–x and put in the 2 from dummy.

Reject a line of play that you could not have pursued without the opponent's help.

A principle of play already noted is that when good defenders offer you the chance to do something you wanted to do but couldn't, it cannot be healthy to accept. A common example is when the defenders present you with an entry for a finesse which you could nòt otherwise have taken. For example:

 ♠ K J 3 2
 ♡ Q 9 7 5
 ◊ K 8 6
 ♣ 8 4

 ♣ J led

 ♠ A
 ♡ A 8 6 4 3 2
 ◊ A 7 4 2
 ♣ A Q

Playing in six hearts you win the club lead and lay down ♡ A. Both follow, but the king is still out. You cash a second club and the ace of spades, then exit with a trump. West wins and leads a spade. What do you make of that?

The spade finesse is mathematically a better chance than to bring down the queen in three rounds. But why should West give you the chance? You can be sure the finesse is wrong, so you go up with the king and ruff the third round. Even if the queen does not drop there may be a squeeze in spades and diamonds.

In the next example a defender gives you a chance to avoid a finesse, but you should not be deflected.

♠ K Q 10
♡ A Q J 3
◊ A Q 9 5
♣ K 6

♣ 2 led

♠ J 7 6 5 3
♡ 8 4 2
◊ K J 10
♣ 10 7

North opens 2NT and you land in four spades. On the club lead you put up the king, the ace wins, and the 5 comes back. West wins with the queen and plays a diamond, which you win in dummy. When ♠ K is led, East wins with the ace and returns ♣ J. How do you play?

The first thing to assume is that East has a count of the club suit and knows he is giving you a ruff and discard. If you accept the opportunity to ruff in dummy and get rid of a heart loser from your own hand, you are too trusting. Expending one of dummy's trump honours will leave you with a second trump loser if East has ♠ A–9–8–x. You should assume that the heart finesse is right, for if East held the king and could see that trumps were breaking 3–2 he would not give you a ruff-and-discard. So you ruff in your own hand and draw trumps, pursuing the plan you would have had to follow without the defenders' 'help'.

PLAYING ON AN ASSUMPTION

When you make an assumption about a card or suit, consider what must follow if that assumption is right.

You will often see that a hand contains a finesse which must be right if you are to make your contract. In forming a general plan you assume that the finesse *is* right. Certain consequences may follow from that. Let us look at this sort of problem in the context of just two suits:

♡ K J
◊ 6 4 2

♡ 5 3
◊ Q 7 5

Imagine that you need to make three tricks out of these two suits. You have to assume that ◊ A–K are on your right. From that it may follow, in an actual hand, that West must hold the ace of hearts. So you play hearts on that basis.

This is one of the most interesting and undeveloped forms of play although the principle was noted thirty years ago in *Reese on Play*. Correct reasoning on the following hand will save you from taking a line of play that cannot possibly win the contract.

 ♠ 9 6 2
 ♡ Q 8 6 5 3 2
 ◊ J 3
 ♣ K 8

 ♣ J led

 ♠ K J
 ♡ A 10 7 4
 ◊ K 8 6 2
 ♣ A 7 5

After three passes you open one heart and finish in four hearts. You win the club opening with the king and play a trump to the ace, East dropping the 9 and West the jack. Hoping that West holds ♡ K, you eliminate clubs and exit with a trump, but East wins and returns ♠ 7. How do you play?

If you think the situation presents a guess, that is true in a sense – but if you guess to put up the king of spades you are making a play that does not fit into the picture you have formed.

The point is quite simple. The ace of diamonds must be with East, for otherwise you have no chance. On that assumption, East cannot have the ace of spades as well, for he passed originally and has already turned up with ♡ K and presumably ♣ Q. In your overall picture, East must hold the ace of diamonds and the queen of spades.

On the next deal, playing on an assumption enables you to make a winning play that at first sight appears against the odds.

```
                    ♠ Q 6 2
                    ♡ 8 3
                    ◇ J 5 4 2
                    ♣ A Q J 8
    ♠ 9 8 7 3                      ♠ J 5 4
    ♡ A 4 2                        ♡ Q J 10 7 5
    ◇ 8 7 6                        ◇ K 9 3
    ♣ 6 4 2                        ♣ K 5
                    ♠ A K 10
                    ♡ K 9 6
    ♠ 9 led         ◇ A Q 10
                    ♣ 10 9 7 3
```

After East has passed you open 1NT and are raised to 3NT. You win the lead of ♠ 9 and take the losing club finesse. Knowing that his partner holds nothing much in spades, East switches to ♡ Q, which you duck, West playing the 4. East now continues with ♡ J and you have to decide whether to put up the king or duck again.

Whatever happens in hearts you are unlikely to make your contract without the diamond finesse. If East holds ◇ K as well as the cards he has already shown, he cannot hold ♡ A, so you must duck the second heart lead.

Assume a card to be wrong when you can bear it to be wrong, and see what follows from that.

There is another side to 'playing on an assumption'. Often you can say to yourself, 'If such and such a card in suit A is right, I must make the contract no matter how I play suit B.' On these occasions it is advisable, if you are tackling suit B first, to assume that the critical card in suit A is wrong and see what follows from that.

```
                    ♠ K 8 6 3
                    ♡ K 10 5
                    ◇ 10 8
                    ♣ K Q 5 2
    ♠ A 4                          ♠ Q 7
    ♡ Q 8 6 3                      ♡ A J 7 4
    ◇ J 9 6 4                      ◇ K 7 5 3 2
    ♣ 8 4 3                        ♣ 9 6
                    ♠ J 10 9 5 2
                    ♡ 9 2
    ◇ 4 led         ◇ A Q
                    ♣ A J 10 7
```

After three passes you open one spade and finish in four spades. West leads ◊ 4, East plays the king and you win with the ace. You lead ♠ J and West plays low.

You have to guess in spades, and other things being equal there is a slight advantage in running the jack. (East may have A–x or Q–x, but there is the additional possibility of West holding both honours.) Here, another consideration enters. If the ace of hearts is with West, it does not matter how you guess in spades. Therefore you should assume that the ace of hearts is with East. In that case, West will probably hold the other ace. There is a sound argument, therefore, for going up with the king of spades.

When only one distribution will worry you, consider what would follow if that distribution existed.

You may need to make assumptions about distribution just as much as about high cards. Sometimes you make a favourable assumption, sometimes, because you can afford it, you allow for bad distribution. In either case, consider what would follow from your assumption.

	♠ A 10 6 3
	♡ Q 7 5
	◊ K 10 6 4 2
	♣ 5
♣ Q led	
	♠ K J 9 7 4
	♡ A 6
	◊ A Q 5 3
	♣ A 9

Playing in six spades, you win the club lead and note that the contract is safe unless East holds all four diamonds. In playing the trumps, assume that East does hold the four diamonds. If you already knew that, you would expect East to be short in spades. So play the king of spades first and finesse against West on the next round.

PART TWO

The Defence

The Play to the First Trick

Good defence is more difficult than playing the dummy, for a player who commands 26 cards has the advantage over two defenders who control 13 each and have to concert their operations. To assist them in this, defenders exchange information by way of conventional leads and signals. This is a ground rule. You portray your hand accurately to partner, accepting the risk that the declarer may intercept the messages.

The declarer's advantage usually declines as the hand progresses, and by the time the middle game is reached defenders can often place the cards more accurately than the declarer. In the early game, however, the material for accurate analysis may be lacking and you may have to base your play on general principles. Especially is this so with the opening lead. Reversing the usual order of instruction, we examine the tactical aspects of the opening lead before studying the choice of card from a particular holding.

WHICH SUIT TO LEAD

Against notrumps, generally make an attacking lead in what you judge to be your side's longest suit.

When the outcome of a notrump contract is in doubt, it will usually depend on which side can establish long cards first. Therefore you should usually lead your longest suit, even if it is not the strongest. Suppose the opponents have reached 3NT without bidding a suit and you hold:

♠ Q 2 ♡ 9 7 5 4 3 ◊ Q 7 ♣ K 10 9 3

Lead a heart. If all goes well you can establish one more trick in that suit than in clubs. But suppose you have two suits of equal length, one stronger than the other:

♠ 10 8 3 2 ♡ K 7 ◇ K J 9 2 ♣ 9 6 5

Several factors now enter. Since the opponents have not explored for a major-suit fit, they are less likely to hold length in spades than in diamonds. On the other hand, the strength of the diamond suit means that you have a better chance to establish it quickly, though you are more likely to give a trick away in the process. Much depends on your estimate of the opponents' high-card strength. Against confident bidding you would incline towards the diamond, taking the view that the small degree of strength with which you credit your partner needs to be in the right place. Here is an illustration of that principle:

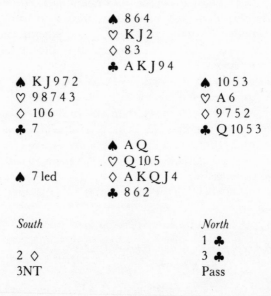

	♠ 8 6 4	
	♡ K J 2	
	◇ 8 3	
	♣ A K J 9 4	
♠ K J 9 7 2		♠ 10 5 3
♡ 9 8 7 4 3		♡ A 6
◇ 10 6		◇ 9 7 5 2
♣ 7		♣ Q 10 5 3
	♠ A Q	
	♡ Q 10 5	
♠ 7 led	◇ A K Q J 4	
	♣ 8 6 2	

South	North
	1 ♣
2 ◇	3 ♣
3NT	Pass

The bidding is strong, so you lead a spade, not a heart. It costs a trick as the cards lie, but not, you will note, a vital trick. South would have made his contract on any lead. But reverse the spades and hearts in the South and East hands, giving East ♠ A–6 and ♡ 10–5–3, and then the spade lead beats the contract. The more passive heart lead would be reasonable tactics against a contract reached in a tentative manner, such as 1NT–2NT–3NT.

We have suggested that you should usually lead your longest suit, but we really mean your side's longest suit. If partner has bid, and particularly if he has overcalled, you should lead his suit unless your

own is especially attractive. Good bidders seldom overcall in suits which they are unwilling to see led.

Sometimes you should lead partner's suit even though he has not bid it. You are South in this situation:

West	East
–	1 ♣
1 ♡	1NT
3NT	Pass

You hold: ♠ 10 3 ♡ Q 7 5 4 ◊ J 8 3 2 ♣ A 10 7

As no one has bid spades it is very likely that partner holds five or more. A spade opening is therefore more promising than a diamond.

In that example you were on fairly firm ground in supposing partner to be long in spades. Sometimes it is worth trying to find partner's suit even if this means taking a shot in the comparative dark.

West	East
1 ♠	2 ♣
2 ♠	3NT
Pass	

South holds: ♠ Q 8 6 ♡ 10 9 ◊ 9 7 4 3 2 ♣ J 8 6

The bidding sounds confident and your queen of spades is unfavourably placed. An attacking lead is therefore indicated. Even if you can establish the long diamonds it is unlikely you will ever get in to make them, so it must be better to try to find partner at home in hearts.

Safe leads are no good when the bidding suggests the presence of very long suits. Time, not tricks, is then the critical factor, and if the opening lead costs a trick it is less likely to matter. This could swing the decision on the following hand:

West	East
1 ♣	1NT
3 ♣	3NT
Pass	

South holds: ♠ A Q 6 4 ♡ 9 8 6 ◊ J 8 4 2 ♣ J 5

A lead away from the spade tenace could cost, but it is unlikely you can beat the contract unless you can take several spade tricks. You may not find North with K–x–x–x–x, but he may have five to the jack and a side entry.

Another factor to consider when you have a tenace holding such as A–Q–x–x or K–J–x–x is whether you expect the enemy guard to be on your left or on your right.

West	East
1 ♡	2NT
3 ◊	3NT
Pass	

South holds: ♠ 9 6 3 ♡ 10 9 4 2 ◊ Q 6 ♣ A Q 10 4

We would not expect a spade opening to work miracles, for East must be prepared for it. Nevertheless, it is better than leading a club, obviously up to East's king. Now suppose the bidding has gone like this:

West	East
1 ♡	1NT
3NT	Pass

This time the presumption that East holds the king of clubs is much less strong, and if West holds it we lose nothing by leading the suit. The queen is a better lead than the fourth best.

There are not many situations where you can afford to lead a winner against a notrump contract just to buy a look at dummy, but this can be right when the declarer's bidding is clearly based on a long suit. Suppose East has opened the bidding with 3NT, indicating (in these days) a long, solid minor, and has been left in. You hold:

♠ A 5 3 ♡ K 8 7 6 ◊ Q J 4 2 ♣ 8 6

Lay down the ace of spades. This gives you two chances. If declarer is wide open in spades you have launched the best attack. If his weakness is elsewhere, a sight of the dummy and of the play to the first trick may provide you with inspiration.

Against a trump contract make a safe lead unless you have a positive defensive plan.

In a trump contract there is seldom advantage in establishing long cards, so it is wrong to make a risky lead with that object. The usual idea is to play safely and make the declarer find his tricks. But there are other plans too: you may play for quick tricks, you may go after ruffs, or you may try to force declarer. More passively, you may lead trumps if you think he will need ruffing tricks. We look at situations where each type of defence in turn seems indicated.

West	East
1 ◇	1 ♠
2 ♠	3 ◇
4 ♠	Pass

South holds: ♠ 10 8　♡ K 7 4　◇ J 9　♣ K 9 8 6 4 3

Lead a heart. It looks as though both enemy suits are breaking well, so you must cash tricks quickly. As between hearts and clubs, you are always more likely to find tricks in the shorter suit. An attacking lead of this sort, away from a king or queen, is usually correct against a small slam contract when declarer appears to have a side suit, either in his own hand or in the dummy.

West	East
1NT	3 ♡
4 ♡	Pass

South holds: ♠ Q 8 5 3 2　♡ A 6 2　◇ 8 2　♣ Q 7 4

Lead a diamond. The black suits are eliminated because it is not often profitable to lead away from honours when dummy has opened 1NT. A diamond is safe and may also lead to a ruff. This chance is increased by your control in the trump suit. For example, if partner has ◇ A–x–x–x he should hold up on the first round. Then you can win with ♡ A and lead your second diamond.

A little imagination will often suggest the possibility of a ruff in a partner's hand:

West	East
1 ♡	1 ♠
2 ◇	3 ◇
3 ♠	4 ♠
Pass	

South holds: ♠ A 2 ♡ K 6 3 ◇ 8 7 4 3 ♣ J 10 5 4

Lead a diamond. On the bidding there is not much future in leading clubs, as dummy will be short. But partner may hold a singleton diamond and you have a quick entry.

When you hold four trumps, consider a forcing game:

West	East
1 ♣	1 ♠
3 ♣	3· ♠
4 ♠	Pass

South holds: ♠ K 7 4 2 ♡ K J 9 6 4 ◇ 7 2 ♣ Q 8

Lead a heart. Declarer will obviously make a lot of club tricks if he can draw trumps safely, but as you hold four trumps he may not find this so easy. If you can force him to ruff hearts he may lose control.

Sometimes you will place partner with the long trumps and play a forcing game on his behalf, as it were.

West	East
	1 ♠
2 ◇	2NT
3 ♠	4 ♠
Pass	

South holds: ♠ 6 ♡ K J 5 4 2 ◇ A Q 4 ♣ 7 6 4 3

Lead a heart. A lead from this holding would not normally be attractive when declarer had bid notrumps, but partner is marked with four trumps and the heart lead is more likely to force declarer than any other.

The time to lead a trump is when you reckon that declarer will have difficulty in establishing any of his side suits:

West	East
	1 ♠
2 ◇	2 ♡
3 ♡	3NT
4 ♡	Pass

South holds: ♠ Q 10 8 5 4 ♡ 9 8 ◇ Q J 10 2 ♣ K 4

Lead a trump. Both spades and diamonds lie badly for declarer and it may be that a crossruff will be his only route to ten tricks.

Finally, a lead from three small cards, called 'top of nothing', is sometimes condemned as too revealing to the declarer. It is nevertheless sound tactics when you feel that the contract may be in the balance and you do not want to lead away from an honour.

West	East
	1 ♠
3 ♠	4 ♠
Pass	

South holds: ♠ Q 5 ♡ Q 9 6 2 ◇ A 10 4 3 ♣ 8 7 5

Lead a club. No positive defensive plan suggests itself, so the aim is to find a safe lead that may also turn out to be constructive.

WHICH CARD TO LEAD

Against notrumps, usually lead fourth-best unless you hold three honours.

There is an advantage in leading a particular low card from a long suit rather than just any low card. By long-established convention the proper card is the fourth from the top: the 5 from K–10–8–5–3, and so on. As we shall see, when the fourth-best card is led partner can make deductions about other cards.

The principle of leading a low card holds good even when you hold two honour cards in sequence. With A–K–7–3–2, for example, the lead would be the 3. This could cost a trick – as by allowing declarer to make a doubleton queen – but more often it gains because it enables the defenders to keep in touch with one another.

When you have three or more honour cards, however, it is usually better to lead a high card to prevent the declarer from winning a cheap trick. If you have three cards in sequence, lead the highest

card of the sequence: the king from K–Q–J, the queen from Q–J–10 and so on. This principle applies down to 9–8–7–x at least. An exception is A–K–Q–x. There is no logical reason why one should not lead the ace, and indeed some players do; but the king is traditional.

It is also usual to lead an honour when you hold three high cards of which two are in sequence. Lead the king from K–Q–10–x and also from K–Q–9–x, the queen from Q–J–9–x, the jack from J–10–8–x and the 10 from 10–9–7–x. From A–K–J–x lead the king, from A–K–J–x–x lead low if you lack side entries.

When you hold three high cards and only the bottom two are in sequence, lead the higher of these two: the jack from A–J–10–x or K–J–10–x; the 10 from A–10–9–x, K–10–9–x or Q–10–9–x.

Leading high from a sequence stands to gain by trapping a missing honour, but it may cost when partner holds an honour only once guarded.

(1)	7 3		(2)	9 3	
K Q 10 5 2		J 8	A J 10 6 2		Q 5
	A 9 6 4			K 8 7 4	

These are typical situations where the conventional lead causes, at best, a block. When the leader judges that declarer is likely to hold four cards, it is better to lead low. This applies also to A–Q–J–x–x, K–10–9–x–x and similar holdings.

The lead from A–Q–10–x–x depends on various factors. Fourth-best is conventional, but if you expect the king to be on your left and are not short of side entries, the ace is a better lead. This may be the full lay-out:

	K 6 3	
A Q 10 7 2		9 5 4
	J 8	

Having cashed the ace you may judge that the situation is desperate unless you can pin the jack on the next round. The ace lead gains, as against the queen, when dummy has K–x and declarer J–x–x.

A lead from four or more small cards also presents a choice. Some players lead fourth-best, holding that it is more important to give partner a count of the suit than to warn him of the absence of high

cards. Others lead 'top of nothing' or, if this might cost a trick, the second card from a holding like 9–6–5–4. A sound compromise is to lead fourth-best when you hold enough side entries to suggest that you can establish the long cards, but top of nothing when there is little prospect of developing tricks in your hand or when you hold tenaces like A–Q–9–x in another suit and would prefer partner to switch.

When you lead a suit bid by your partner, lead the top card of any doubleton, the top card from a combination such as Q–J–x or J–10–x, the bottom card from a single honour such as A–x–x or 10–x–x. From K–J–x the low card will help to trap declarer's Q–x–x but it can also cause a block and the king or jack is a fair alternative. You will sometimes lead from these holdings even when partner has not bid the suit; in such cases choose the same card.

Against a trump contract, avoid giving away a cheap early trick.

In a trump contract the struggle is mainly for the first and second tricks in a suit and you must therefore take a short-term view. The lead from K–Q–x–x–x is the king, not a low card. In general, from five-card or longer suits, lead the higher of all touching honours – the queen from Q–J–x–x–x. the jack from J–10–x–x–x. Four-card suits such as Q–J–x–x and J–10–x–x are on the borderline; against a low contract fourth-best is reasonable, against a high contract the honour is safer. Suits headed by an unsupported ace are a special problem. The conventional lead from A–x–x or A–x–x–x is the ace, but against a low contract it may prove better to underlead. From A–K–x–x the king is normal; from A–K alone, the ace.

When leading partner's suit, normally lead low from four cards (unless headed by honours in sequence or by the ace). From K–x–x, Q–x–x, J–x–x, the low card is conventional. An exception occurs when you lack other entry cards and do not expect to take more than one trick in the suit led. For example, partner has bid hearts, opponents finish in four spades, and you hold ♡ K–x–x–x with no other card higher than a queen. Now lead the king so that you can hold the trick and perhaps lead something more dynamic at trick two when you have seen the dummy.

We must add that many good players have deserted top of nothing from a holding like 8–6–4 in favour of the middle card, the 6, to be followed by the 8. In tournament play some other special conventions may be encountered.

THE PLAY BY THIRD HAND

Finesse against dummy, not against partner.

The play by third hand is easiest when dummy has no cards of
value. The simple task then is to play the highest card you hold.



732

K 10 6 4 A J 8

Q 9 5



When West leads the 4, go up with the ace. To play the jack
would be to commit the solecism of 'finessing against partner'.
Similarly:



732

Q 9 6 4 K 10 5

A J 8



When partner leads the 4, do not meanly withhold your king.

When you hold two or more cards in sequence, play the bottom of
the sequence. The logic of that is seen in the following example:



872

K 9 5 3 Q J 10

A 6 4



West leads the 3 and East plays the 10. Whether the declarer
holds up or not, West can reasonably deduce that his partner holds
the queen and jack. If there were no convention, and the queen were
played on the first lead, West would not know the position.

Third hand has more to think about when these are high cards in
dummy. Take this common position:



J 6 2

4 led K 9 5



If dummy plays low, put in the 9, not the king. You will see the
advantage of that if you imagine declarer to hold either A–Q or A–x;
while if declarer has Q–x or A–10, you will make the same number
of tricks eventually whether you play the king or the 9 on the first

lead. It is true that the 9 will prove an error if partner has underled the A–Q, but that is inconceivable in a suit contract and at notrumps declarer will usually have something better than the 10.

Somewhat different considerations would enter if you were defending against a high trump contract. If declarer held A–10 alone it might be fatal to let him win this trick cheaply.

The principle of finessing against dummy continues down to cards of secondary rank:



A 10 4

Q 9 6 3 2 J 8 5

K 7



When West leads the 3 and dummy plays the 4 it would obviously be a mistake to contribute the jack. In effect, you finesse with the J–8 over dummy's 10–x. Similarly:



K 9 6

10 8 5 4 A J 7

Q 3 2



If dummy plays the 6 on partner's lead of the 4, put in the 7 rather than the jack. In this kind of situation you can apply the Rule of Eleven, which we now describe.

Deduct the pips of the card led from eleven and so calculate the number of higher cards in the three hands other than the leader's.

The cards at bridge in effect rank from 2 to 14 (the ace). When a player leads the 4, holding three cards higher than that in his own hand, it follows that there are seven cards higher than the 4 in the other three hands. You can arrive at this result immediately by subtracting 4 from 11. Look again at the last example:



K 9 6

4 led A J 7



East subtracts 4 from 11 and knows that seven cards higher than the 4 are shared by North, East and South. As six are in view, declarer is marked with only one high card. Again:

 Q 9 4 2
 10 8 7 5 K J 6
 A 3

West leads the 5 and declarer plays low from dummy. Now you can judge that if partner has led fourth best declarer holds only one card higher than the 5, and in all probability that card is the ace. You put in the 6, therefore.

We do not say that, for experienced players, the Rule of Eleven often makes much difference to the card selected at the first trick, but it makes a great difference to the later planning and its value extends throughout the play. The declarer, too, may profit, as in a situation like this:

 K J 8 4
 5 led
 A 7 2

At notrumps South plays low from dummy and heads the 9 with the ace. He can be reasonably certain now that a finesse of the 8 will win.

Look for chances to pin an intermediate honour in dummy.

A general principle of play is that high cards should be used to kill high cards. In situations like the following you have the chance to combine that maxim with a finesse against the dummy:

 J 7
 A 8 6 4 2 Q 9 5
 K 10 3

West leads the 4 and dummy plays the 7. You see the importance of putting in the 9, not the queen.

 10 5
 K 9 6 3 A 8 2
 Q J 7 4

Here, by putting in the 8 over dummy's 5, you annul dummy's 10.

Sometimes finesse against partner to force out the declarer's stopper.

The play of the 8 in that last example enabled the defenders to run their later tricks conveniently. For the same reason there are times when a finesse against partner is advisable.



5

K 9 7 3 2 A J 4

Q 10 8 6



When West leads the 3, the jack works better for the defence than the ace. Here again the knowledge that declarer holds four cards is relevant. The jack would be a mistake, obviously, if West had led from K–10–x–x–x–x.

With A–Q–x, particularly, the queen is generally best at trick 1.



7 4

J 9 6 3 2 A Q 5

K 10 8



If East plays the ace and follows with the queen, declarer will hold up the king. That will be bad for the defence if West holds no quick entry. The best tactical plan is to play the queen at trick one, smoking out the king. Note that this play, which has a deceptive element, must be made smoothly, not after reflection which would tell the declarer what was going on. Good defensive play, unlike justice, should be done but not be seen to be done.

Signalling

If you are not trying to win a trick it is natural to play your lowest card on it, so when you do anything else you send out a special signal of some kind. The meaning of the signal depends to some extent on whether you are playing to your partner's lead or to the declarer's. The distinction used to be simple: a high–low play, or 'echo', on partner's lead was encouragement, while the same signal on the declarer's lead meant only that you had an even number of cards in the suit led. Modern techniques are somewhat more sophisticated. The meaning of a signal depends on circumstances and you will find that to signal effectively you have to keep up with the game at all times, even when it may seem that your own cards will play no signicant part in the defence.

SIGNALLING WHEN YOUR PARTNER LEADS TO A TRICK

Play high–low to encourage a continuation, not to show a specific high card.

The most common use of the echo is in situations like this:

(1)		A 9 7	(2)		A 7 3
6 led		K 5 3 2	K led		J 9 2

In (1) dummy plays the ace and East drops the 5. A good partner will note that the 3 and 2 are missing even if you do not have a chance to complete the echo by discarding the 2 on another suit. In (2) East plays the 9 under the ace – emphatic enough to make the meaning clear at once.

In both those examples East held a high card, but the reason for signalling was not so much to indicate that card as to invite a continuation of the suit when West was next in the lead. The two motives will often overlap, but by no means always. In the first example above, although he holds the king East might want his

partner to switch to a different suit, and in that case he would drop the 2. Here is the other side of the picture:



J 7 5

K led 8 6 2



If you do not want partner to open up any other suit, it may be right to play the 6 in East's position. If South has Q–x a continuation will set up the jack, but we are assuming that the defence has nothing better to play. Having dropped the 6 on the first round East would follow with the 8.

Assume in the next lay-out that West has overcalled in the suit he is leading and so is likely to hold at least five cards.



9 4 2

K led 10 5 3



Quite a likely holding for West is A–K–J–x–x. If as East you play the 3 West can work out that it is safe to continue, but he will also take it that, having played your lowest, you are prepared for a switch. If no switch looks attractive you should play the 5.

Any signal is primarily a guide to future action, not an endorsement of what partner has so far done. Here East is strong in the suit led but judges it impolitic to invite a continuation:



♠ K 8 7
♡ A Q J 9 7
◇ J 10 3
♣ K 4





♠ Q 9 6 2 ♠ A J 3
♡ 6 5 2 ♡ 10 8 3
◇ A 7 5 2 ◇ K Q 8 6 4
♣ 10 3 ♣ Q 8





♠ 10 5 4
♡ K 4
◇ A led ◇ 9
♣ A J 9 7 6 5 2



You are defending five clubs from the East position and your partner leads ◇ A. Now it would be a mistake to play the encouraging 8, because it is quite likely that South has a singleton

and will run off the tricks in hearts and clubs. The point is that even if South holds a doubleton diamond you will still need one spade trick to beat the contract, so you may as well ask partner to lead a spade through the king while he has the lead. (There is nothing else West can switch to if you discourage the diamond lead.)

West, with his present holding, would switch to ♠ 2. That would denote both the queen and no more than a four-card suit, so the rest of the defence is solved for you. If West held something like 9–6–4–2 in spades he would switch to the 6 or 9, as it would be more important here to deny possession of a high card than to give partner the count.

Against a trump contract play high–low with a doubleton
to give partner a count.

When partner leads a high card against a trump contract it is standard to peter (another word for echo) with x–x and with 10–x or J–x, but not with Q–x. The play of the queen on partner's lead of the king means that you have the jack behind it (unless, of course, the queen is single) and means also that you are prepared, possibly anxious, for partner to underlead the ace on the next trick.

With a doubleton you generally want partner to continue, but you should still echo even if you do not. This is a common situation.:

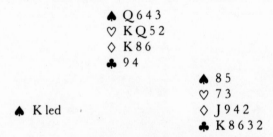

West has opened one spade and South is playing in four hearts. On the lead of the king of spades East is not sure, from his side, whether he wants a continuation or not. If West has ♠ A–K–J–9 the queen can be killed, but if he has five spades a continuation will simply establish a discard for the declarer (who will play low from dummy on the third round). East must not attempt to judge the best line of defence: he should begin a peter to show his doubleton and let partner decide.

Echo with four or six cards when it is important to indicate your length.

When it is evident that you are not petering on the strength of high cards you should begin a peter with any even number. That can be very important in a situation like this:

♠ A Q 7 5
♥ Q J 7 5 4
♦ Q 8 2
♣ 9

♠ 8 6 4
♥ 6
♦ A K 10 6 4
♣ J 10 3 2

South is in six hearts and you hold the first trick with the king of diamonds. If East can be relied on to echo with an even number of cards, you can gauge what to do next. Suppose East plays the 3 on the first trick and South the jack: ignore the jack and reflect that partner has three cards precisely. If East drops a higher card, the 7 or 9, assume that he has four cards and do not lead another diamond.

Similarly, when East holds six cards in the suit led he should peter. Suppose that against a slam or game contract West leads from A–K–x and sees Q–x–x in dummy. If his partner shows an even number, West can probably judge whether or not to continue.

*At notrumps play high–low to encourage a continuation
rather than to give a count.*

In a notrump contract an echo by the partner of the opening leader is in principle encouraging. It is generally correct to begin a small peter with a holding like 7–5–4–2, not precisely because you hold four cards but because your length suggests that partner has found a good attack. It is often helpful to peter with three cards. Take a situation like this:

9 5 3

Q led 8 6 4

As you can see the 9 in dummy you are entitled at this stage to place partner with Q–J–10–x at least. You can safely encourage him

to press on, therefore. Suppose instead that you play the 4 and declarer wins with the king. When next in, West may hesitate to play another round lest declarer hold A–K–8–x.

When you hold an important card like the jack or 10 it may be essential to tell partner about it.

(1)	7 4 2		(2)	7 4 2
K led		J 6	Q led	10 5

In both cases you should drop the honour, trusting that you can afford it. With J–x–x in example (1) it would usually be sufficient to play the middle card.

Sometimes it is very clear that the leader's partner has no strength in the suit led. It is appropriate then to play high–low from a doubleton to give partner the count.

SIGNALLING WHEN THE DECLARER LEADS TO A TRICK

Play high–low when it may be important to tell partner that you have an even number of cards.

We have seen that on your partner's lead a signal usually expresses encouragement but sometimes means simply an even number of cards. When declarer has made the lead it is the other way round: a signal by you more often shows distribution. (That is natural, because for the most part declarer is strong in the suits he attacks.) The object may be to help partner's general count of the hand or it may be specially related to the suit that declarer is playing. Taking the second situation first, suppose the contract is notrumps and dummy is short of entries.

(1)	K Q J 5		(2)	Q J 9 6 4	
8 7 6 3		A 9 2	K 7 5		8 2
	10 4			A 10 3	

In (1) South leads the 10 and continues with the 4. When West echoes with the 7 and 3 East knows it is safe to win the ace on the second round, for South must hold either two cards or four. Holding up the ace until the third round could not gain in either case.

In (2), when dummy leads the queen, East should drop the 8. West then knows he must hold off to kill the suit. If, on a different lay-out, East played the 2 to show an odd number of cards, West

would know that he could safely win. Suit-length signals of this kind
are equally valuable at trump contracts.

In the next example the defensive signals played by East enable
West, at the critical moment of the hand, to estimate how many
winners the declarer has.

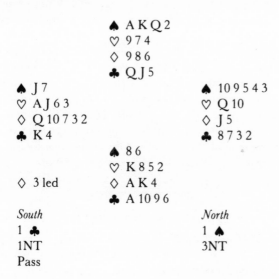

```
                      ♠ A K Q 2
                      ♡ 9 7 4
                      ◇ 9 8 6
                      ♣ Q J 5
  ♠ J 7                              ♠ 10 9 5 4 3
  ♡ A J 6 3                          ♡ Q 10
  ◇ Q 10 7 3 2                       ◇ J 5
  ♣ K 4                              ♣ 8 7 3 2
                      ♠ 8 6
                      ♡ K 8 5 2
  ◇ 3 led            ◇ A K 4
                      ♣ A 10 9 6
  South                               North
  1 ♣                                 1 ♠
  1NT                                 3NT
  Pass
```

Against 3NT West leads a diamond and South heads the jack
with the king. He crosses to ♠ Q and takes the club finesse. West
wins and has to gauge whether to continue diamonds or shift to
hearts. East has played three cards so far and they all convey a
message. The jack of diamonds tells West that South has A–K. The
3 of spades denotes an odd number of spades – no doubt five, as the
spades were not supported. Most important, the 7 of clubs signifies
four clubs. West credits South with three spade tricks, two
diamonds and three clubs. That is only eight, so West does not try a
low heart but continues with ◇ Q. If East had played a low club at
trick three, marking South with five, then West would have had to
play his partner for K–x–x in hearts. That is what partnership
means.

THE TRUMP ECHO

To show three trumps, echo in the trump suit.

In the trump suit a different convention exists: a peter shows three cards. The signal is especially useful when it directs partner's attention to the possibility of a ruff. By petering or not petering with three trumps you may be able to influence the whole course of the defence.

The trump echo, even more than the other signals described in this chapter, must be used with discretion. Declarer will often want to know the trump distribution more than your partner does, so you must not play the conventional card automatically. Indeed, there are few worse partners, or more helpful opponents, than those who signal at every opportunity. One factor in this is the relative strength of one's partner and the declarer. Obviously it is foolish to emit signals about length to a partner who neither observes nor counts.

SUIT-PREFERENCE SIGNALS

To ask for the lead of a high-ranking suit, play an unnecessarily high card.

A special type of signal makes it possible to direct partner's play in a suit other than the one currently played. For example, when leading or playing a diamond you may make a conventional play that asks partner to lead a spade at his next opportunity.

This is the system: play a higher card than necessary to direct partner to lead the higher-ranking of alternative suits; play a low card to direct the lower suit. You will find in practice that there are never more than two alternatives. This is the commonest use of a suit-preference signal:

```
                    ♠ 10 7
                    ♡ A J
                    ◇ K 10 8 5 2
                    ♣ K 5 4 3
    ♠ J 9 5 4 3                    ♠ A Q 8 6
    ♡ 7 5 2                        ♡ Q 6
    ◇ 6                            ◇ A 9 4 3
    ♣ Q 10 7 6                     ♣ J 9 2
                    ♠ K 2
                    ♡ K 10 9 8 4 3
    ◇ 6 led         ◇ Q J 7
                    ♣ A 8
```

South	North
1 ♡	2 ◊
2 ♡	3 ♡
4 ♡	Pass

East reads the lead of ◊ 6 as an obvious singleton. He can see four quick tricks for the defence – provided that West, after ruffing at trick two, returns a spade and not a club. As he wants a return of the higher-ranking suit, East returns an unnecessarily high diamond, the 9. Had East's quick entry been in clubs instead of spades he would have returned his lowest diamond.

You may ask, how in general does partner know when a card is meant to be a suit-preference signal? The answer is: when the card can have no significance in relation to its own suit. Thus it would make no difference in diamonds whether East returned the 9 or the 3.

Although suit-preference signals were devised as a solution to the type of problem seen on the last deal, their use has been greatly extended. Suppose your partner leads a winner and you give an ordinary discouraging signal. In spite of this your partner plays a second high card in the same suit. Now, by your play to this trick, you can issue a suit-preference signal.

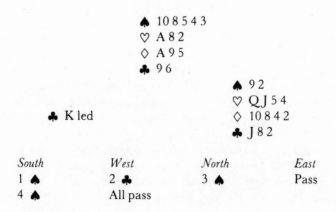

```
              ♠ 10 8 5 4 3
              ♡ A 8 2
              ◊ A 9 5
              ♣ 9 6
                              ♠ 9 2
                              ♡ Q J 5 4
     ♣ K led                  ◊ 10 8 4 2
                              ♣ J 8 2
```

South	West	North	East
1 ♠	2 ♣	3 ♠	Pass
4 ♠	All pass		

West holds the first trick with the king of clubs and continues with the ace. Having dropped the 2 on the first round, on the second round you have a free choice, as it were. You have nothing significant to say about clubs, so you play ♣ J now to indicate that your strength is in hearts, not diamonds.

There are situations, inevitably, where the difference between a normal signal and a suit-preference signal cannot be defined in advance. In the next example East's play to the first trick might be a normal signal – except that there is nothing that East could possibly want to say about the suit that has been led.

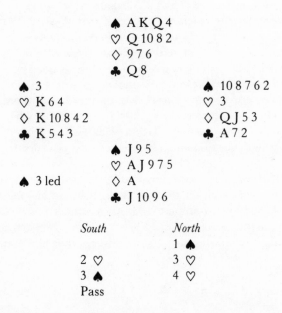

 ♠ A K Q 4
 ♡ Q 10 8 2
 ◇ 9 7 6
 ♣ Q 8
 ♠ 3 ♠ 10 8 7 6 2
 ♡ K 6 4 ♡ 3
 ◇ K 10 8 4 2 ◇ Q J 5 3
 ♣ K 5 4 3 ♣ A 7 2
 ♠ J 9 5
 ♡ A J 9 7 5
 ♠ 3 led ◇ A
 ♣ J 10 9 6

 South North
 1 ♠
 2 ♡ 3 ♡
 3 ♠ 4 ♡
 Pass

West opens the 3 of spades and dummy wins with the ace. Now if East were to play the 10 on this trick West would certainly take it as a suit-preference signal for diamonds. Logically, he should also interpret the 2, when played by a thoughtful partner, as a signal to show the club entry. The point is that both players know that East has nothing to communicate in relation to spades.

In general, suit-preference signals on the first trick should be played (and so interpreted) only in very clear positions where the third player cannot conceivably be asking for a continuation of the suit led. Such is the situation here:

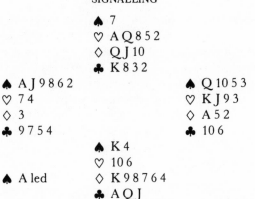

```
              ♠ 7
              ♡ A Q 8 5 2
              ◊ Q J 10
              ♣ K 8 3 2
♠ A J 9 8 6 2              ♠ Q 10 5 3
♡ 7 4                     ♡ K J 9 3
◊ 3                      ◊ A 5 2
♣ 9 7 5 4                 ♣ 10 6
              ♠ K 4
              ♡ 10 6
♠ A led       ◊ K 9 8 7 6 4
              ♣ A Q J
```

Against five diamonds West opens the ace of spades. East can play the queen of spades to suggest a switch to hearts, not clubs. The play of ♣ Q cannot be a request for a spade continuation, for the queen itself denies the king.

There is some scope for suit-preference signals by the opening leader. Say that East–West have bid high in diamonds and West, the opening leader against four spades, hold ◊ K–J–9–6–4–2. Neither the 9 nor the 2 could be a true card (fourth-best); so either one should be interpreted as a signal relating to the other suits, hearts and clubs.

Suit-preference signals can also be used at notrumps, especially when a defender who holds established winners wants to indicate where his entry card lies:

```
              ♠ J 7
              ♡ Q J 7 5
              ◊ J 10 6
              ♣ Q 10 3 2
♠ Q 9 6 5 3               ♠ A 10 2
♡ A 6 2                  ♡ 9 8 4 3
◊ 9 8 2                  ◊ A 4
♣ J 7                    ♣ 9 6 5 4
              ♠ K 8 4
              ♡ K 10
♠ 5 led       ◊ K Q 7 5 3
              ♣ A K 8
```

West leads a spade against 3NT and dummy's jack is headed by

the ace. South ducks the spade return and West drops the 3 – a normal signal to show a five-card suit. On the third round of spades West plays the queen under South's king, indicating that as between hearts and clubs his entry is in the higher-ranking suit. Note that even in notrumps the choice is clearly between two suits only. South has bid diamonds and will need to develop this suit himself.

Another use of the signal at notrumps occurs when a defender is following suit. When a player with 9–7–2 in declarer's long suit plays the cards in that order, clearly he is seeking to convey a message of some sort.

HELP FOR PARTNER

Organize your plays so as to give partner the clearest picture.

Sometimes the play of a high card will convey a clearer message than a normal peter. Suppose that partner leads a club through dummy's A–K–x and you hold Q–J–10–x–x; clearly the queen tells the best story. Here East points the way to a counter-attack:

```
                    9 5 3
      A 2                         J 10 8 7
                    K Q 6 4
```

Hoping to develop tricks in this suit at notrumps, the declarer leads the 3 from dummy. East can afford the jack; if South puts in the king or queen, as he probably will, West can win and return the suit.

A defender should always think about signalling when the situation in a suit is known to the declarer but possibly not to his partner.

```
                   ♣ K 7 4
    ♣ J 10 5 3                    ♣ 9
                   ♣ A Q 8 6 2
```

South has bid clubs and is playing 3NT. At some point he leads a club to the king and returns a club, going up with the ace when East discards. So long as there is no risk of being end-played by leaving himself with a minor tenace (10–5 against Q–8), West should play the jack. That puts East in the picture; it tells him that South has the queen but cannot run the suit without loss.

Often a defender can express both length and strength in a single discard:

\Diamond A K 7 4

\Diamond J 10 9 6 2

South is playing a contract of four hearts, let us say, and East has the opportunity for an early discard. If he thinks that partner may be under some pressure, the clearest card to throw is the jack of diamonds. West will know at once how many tricks South can take in that suit and will also know that he can discard freely from Q–x or Q–x–x.

Accurate discarding when declarer plays out a long suit is the most difficult area of the game. It is highly important now for both defenders to signify whether they have an even or odd number in suits from which they are discarding. A player who holds 7–5–4–3 may not think it matters which card he plays, but to know the count may matter a lot to a partner who is wondering whether he needs to keep a guard to the king or queen.

Manoeuvres in a Single Suit

Before we pass to the wider field of defensive tactics, there is more to say about the play in a single suit. The mechanics of play are the same for both sides, but the different angle from which dummy's cards are seen leads to some differences in technique. Our old friend, ducking play, is substantially the same for attack and defence, except that defenders sometimes have to guess.

DUCKING

To maintain communications when trying to establish long cards or give partner a ruff, duck early.

When you lead from a suit like A–x–x–x–x or A–K–x–x–x against notrumps you normally begin with a small card, the object being to keep in touch with partner's hand. In the same way it is usually correct to hold back a winner when you are in third position and partner leads your suit. The following is a standard situation:

Q 7 3

9 led A K 8 6 2

West leads the 9 against a notrump contract. It will normally be correct for East to duck the first trick, even if dummy plays the queen. Provided West holds another card, it will then be possible to run the suit as soon as either defender regains the lead.

That is the object of ducking play: to keep in touch with partner. If you withhold a winner for other tactical reasons, such as to harry the declarer's communications, or as a deceptive measure, that is not a duck but a hold-up.

There is quite an art in ducking at the right time. Unless you have seen the following situation before you may miss the best play:

7 3 2

6 led K Q 10 9 4

After East has bid this suit, South lands in 3NT, so is expected to hold A–J–x. Suppose that on the lead of the 6 East plays the queen. South may duck and win the next round with the jack. Now East will need two re-entries, one to force out the ace, the other to cash the long cards. East does better to duck the first round, as can be seen from the full deal:

```
                    ♠ A 10 2
                    ♡ 7 3 2
                    ◇ K 8
                    ♣ J 10 6 3 2
    ♠ J 9 7 6 4                    ♠ 8 3
    ♡ 6 5                          ♡ K Q 10 9 4
    ◇ Q J 10 3                     ◇ 9 5 2
    ♣ K 4                          ♣ A 9 7
                    ♠ K Q 5
                    ♡ A J 8
    ♡ 6 led         ◇ A 7 6 4
                    ♣ Q 8 5
```

East plays ♡ 9 on the first trick and South wins with the jack. Now the contract cannot be made against correct defence. As soon as South touches clubs, West wins with the king and leads his second heart, forcing out the ace while East still holds the ace of clubs.

The following is a variation of the same theme:

```
                    Q J 2
    6 5                             K 10 9 4 3
                    A 8 7
```

West leads the 6 and dummy plays the jack. If the entry situation is similar to the previous deal it will pay East to duck, leaving West with a card to lead when he wins the first defensive trick. If East covers dummy's queen on the first round South can shut out the long cards by ducking. Another variation:

```
                    A J
    6 5                             K 10 9 8 3 2
                    Q 7 4
```

West leads the 6, dummy plays the jack, and East must duck. If East puts up the king first time the suit is dead unless he holds two re-entries.

It is equally common for the opening leader to duck a return of the suit after his partner has won the first round.

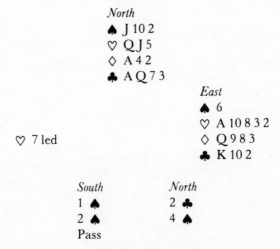

 Q 4
 A 9 7 3 2 K 6 5
 J 10 8

On the lead of the 3 East wins with the king and returns the 6. In most cases it will be right for West to duck. Note that East by convention returns the next highest card when he held three originally, the fourth-best from four or more.

In a suit contract it is often necessary to duck to prepare for a ruff.

North
♠ J 10 2
♡ Q J 5
◇ A 4 2
♣ A Q 7 3

 East
 ♠ 6
 ♡ A 10 8 3 2
♡ 7 led ◇ Q 9 8 3
 ♣ K 10 2

South	North
1 ♠	2 ♣
2 ♠	4 ♠
Pass	

When West opens a heart against four spades East has to consider whether the lead is more likely to be a singleton or a doubleton, and also which assumption will give the better chance of defeating the contract. In general, a doubleton is more likely and the right play here is to duck, hoping that partner will have a trump trick and will be able to lead a second heart for an eventual ruff. One time to expect a singleton rather than a doubleton is when partner forsakes an obvious lead, such as a suit which has been bid and supported by the defence, in favour of an unbid suit.

UNBLOCKING PLAYS

Avoid being left with a lone honour in a suit which partner
is trying to establish.

To unblock is to play an unnecessarily high card with the object, in
the present context, of enabling partner to run tricks in the suit. We
have seen that unblocking is fairly easy for a declarer who can see
both hands; for the defenders it is sometimes more difficult. We
begin with a simple situation:

```
                   A 7 4
  Q J 10 8 2                       K 6
                   9 5 3
```

When West leads the queen East must play the king whether
dummy puts up the ace or not. Even if West holds Q–J–9–x–x and
South 10–x–x, the unblock is still the best play.

It is sometimes necessary to play an irregular card in order to
avoid a block. Here South is in 3NT and West leads the 5.

```
                     2
  A J 7 5 3                        K 10 8 4
                   Q 9 6
```

East wins with the king and clearly it would be a tragedy if he
returned the normal fourth-best and blocked the suit. He must play
back the 10 and drop the 8 on the next round, trusting his partner to
understand what is happening.

Sometimes a defender must unblock at the risk of losing a trick.
This is a typical situation:

```
                   A 6
  J 9 5 3 2                        K Q 8
                   10 7 4
```

West leads the 3, dummy plays low and East wins with the queen.
Not knowing who holds the jack, East has to decide whether to
return the king or the 8. The answer will depend on the general
situation. If it is clear that the contract cannot be beaten unless the
defenders take four tricks in this suit, East must play the king
despite the risk that South may hold J–x–x.

A defender with a doubleton honour should unblock in most positions unless he can see that it would cost a trick.

$$Q 5$$

A 10 8 6 4 2 J 3

$$K 9 7$$

On the lead of the 6 declarer plays dummy's queen. Your jack could only serve to block the run of the suit and you must play it now.

Unblocking plays of that kind are usually more effective when the defender who unblocks is the one who is likely to gain the lead first. East would not drop the queen in the following situation unless he held a quick entry.

$$A K 5$$

J 9 6 4 2 Q 7

$$10 8 3$$

West leads the 4 and declarer plays dummy's ace, marking West with the jack. If East expects to win the first trick for his side he should drop the queen.

A different reason for unblocking may arise when the declarer is trying to establish a suit without letting a particular defender into the lead.

$$A 8 4 2$$

J 9 3 Q 7

$$K 10 6 5$$

South wants to establish a long card without letting West in. If he leads low from the closed hand West must insert the 9, forcing declarer to play dummy's ace. Then East unblocks with the queen, for otherwise he will be allowed to hold the next round of the suit.

There are many situations of this kind where you can create extra entries in partner's hand by unblocking with a high card that is due to fall on the next round.

$$K 8 2$$

A 10 5 J 7

$$Q 9 6 4 3$$

When the declarer tackles this suit the defenders are assured of two tricks, but it may make a difference who wins them. If entries are needed in West's hand East should drop the jack when South leads low to the king; similarly when East holds Q–x and declarer J–x–x–x–x.

BLOCKING PLAYS

Play a high card when this will block the run of declarer's suit.

We saw in an earlier chapter that the declarer can sometimes obstruct the run of an enemy suit by going up with a high card. That method often works for the defence as well.


 Q 8 7 6 4 3
 J 9 2 A 10
 K 5


Playing in notrumps, declarer leads small from the North hand. If East can place South with the king, the play is to go up with the ace and attack dummy's side entry. Similar possibilities occur when the declarer is trying to establish K–Q–J opposite 10–x–x–x or Q–J opposite 10–9–x–x. By winning at the right time the defenders put an extra load on the declarer's communications.

The defenders must sometimes be alert to prevent an entry finesse in a position like this:


(1) A J 4 3 (2) A J 4 3
 Q 9 5 10 8 7 2 K 9 5 10 8 7 2
 K 6 Q 6


These situations are not always easy to read, but it will be apparent in both cases that on the lead of the 6 West can kill an entry by going up with an honour.

HOW TO PLAY WHEN DUMMY LEADS AN HONOUR

Usually cover an unsupported honour, but wait until the last card is led from a sequence of honours.

When a small card is led from his right, a defender who holds an unsupported honour card will usually play 'second hand low', but when the lead is itself an honour the correct play is not so easy to

determine. The whist-player's slogan for this situation was 'Cover an honour with an honour'. That is right more often than not, but there are exceptions.

First, let us see why it is usually correct to cover the lead of an unsupported honour.



10 6

9 7 3 2 K 5 4

A Q J 8



If East fails to cover dummy's lead of the 10 South will let it ride and will make four tricks. By covering, East promotes his partner's 9. The principle would be the same if East held the queen instead of the king.

Failing to cover with an ace costs a trick in a situation like this:



10 2

Q 9 5 4 A 6

K J 8 7 3



Against a notrump contract East should cover dummy's lead of the 10; otherwise he may have to play it on thin air when the next lead is made from dummy.

One time when it is wrong to cover is when the declarer is not proposing to finesse at all; the lead of dummy's honour is in the nature of a deceptive move.



J 7 5 2

8 Q 6 3

A K 10 9 4



South intends to play for the drop but it costs nothing to lead the jack from dummy, tempting East to cover. The tip-off to this kind of deception is that there are not many positions where a good declarer will lead an unsupported honour if he intends to take a finesse. In general, a defender may take it that if an unsupported honour is led from a three- or four-card holding in dummy, it is not the declarer's intention to let it ride unless he has a sequence, so that a cover will achieve nothing. Remember, too, that the object of covering honours is to promote lower cards. Thus in the example above it would be idiotic to cover the jack if South had bid the suit.

Here are some more situations where an artful declarer may lead

an unsupported honour from dummy when not necessarily
intending to take a finesse:

(1) Q 5 3 2 (2) 10 6 4 (3) 10 6 2

A J 10 7 6 4 K Q 9 8 3 A K Q 9

Another situation where it is a mistake to cover the lead of an
unsupported honour is where there is a risk of clashing with a high
card in partner's hand.

(1) Q 8 5 (2) J 7 3
 A K 9 4 A K Q 5 2
 J 10 7 6 3 2 10 9 8 6 4

In both cases it will cost a trick if East covers a lead of dummy's
honour. Remember again (a) that declarer will not normally lead an
unsupported honour unless he has a strong sequence in his own
hand, and (b) that the object of covering is to establish a lower card.

Now suppose dummy leads an honour from a sequence. The
ground rule here is to cover the last honour of that sequence.

(1) Q J 9 2 (2) J 10 7
 10 6 3 K 5 4 A 9 3 Q 5 2
 A 8 7 K 8 6 4

In (1) dummy leads the queen. If East covers, South will win with
the ace and finesse dummy's 9 on the next round. East must duck
first time but cover the next honour. Note that even if dummy held
Q–J–3–2 it would still be unsafe to cover the queen as South might
hold A–9–8.

In (2) dummy leads the jack. A cover will allow South to make
three tricks by finessing against West's 9, but by ducking the first
lead East holds the declarer to two tricks.

Do not, however, hold back an honour that is inadequately
protected. Unless the declarer is expected to hold a very long suit it
usually pays to cover first time with a doubleton king or queen.

(1) Q J 2 (2) J 10 4
 9 7 4 3 K 5 A 8 5 2 Q 6
 A 10 8 6 K 9 7 3

In (1) East should cover the first honour lead from dummy, otherwise South may lead low on the next round and make four tricks. In (2) East should cover the lead of the jack, hoping to promote the small cards in West's hand.

It is also right, with two honours, to cover when dummy has two honours.

(1)	J 10 4		(2)	10 9 4	
9 7 3		A Q 6	8 5 2		K J 6
	K 8 5 2			A Q 7 3	

East must cover the 10 in both instances. A defender must be wary of the same position when the 10 or 9 is led from the closed hand.

HOW TO PLAY WHEN THE DECLARER LEADS AN HONOUR

Do not cover in front of a single honour.

This is the general rule when declarer leads a high card: cover when there are two honours on your left, but not when there is only one. Examples:

(1)	K 10 8 7 2		(2)	A 8 6 3	
Q 5 3		A 9 6	K 5 2		Q 9 4
	J 4			J 10 7	

In (1) West covers South's lead of the jack because there are two honours on his left. It is true that from West's point of view South may have led the jack from A–J–9 to tempt a cover; all one can say is that the defender must consider, *before* the jack is led, which is more likely – that South has J–x or A–J–9. In (2) there is only one honour on the left, so West must not release the king when South leads the jack.

Here is a fairly obvious situation where it must be wrong to cover even though there are two honours on your left:

	A 10 6	
K 8 4 3		7 5
	Q J 9 2	

West does not cover South's lead of the jack because he can see that his king will command the fourth round of the suit.

FINESSING AGAINST PARTNER

When you hold A–Q–x in the suit partner has led, finesse to avoid losing touch.

We have already seen (at the end of chapter 8) that to finesse the queen from A–Q–x is almost a standard play at notrumps. The same play sometimes presents an advantage against a suit contract:

```
                       North
                       ♠ K 10 8 3
                       ♡ Q 8 7 5
                       ◇ 8 6
                       ♣ 10 5 3
                                      East
                                      ♠ 9 7 4 2
                                      ♡ 6 4
         ◇ 2 led                      ◇ A Q 9 3
                                      ♣ 8 7 6
```

South is in two hearts after West has opened a weak notrump. The defence probably needs to establish some club tricks. In the hope of gaining an entry if West has led from ◇ K, East should play ◇ Q on the first trick. If East wins the first trick with ◇ A West may not be able to risk underleading the king later.

When the third-hand player holds A–J–x instead of A–Q–x, a finesse of the jack may cost a trick if the declarer holds the unsupported queen, but it is often advisable to take that chance.

```
                       ♠ J 8 7 3
                       ♡ Q 5
                       ◇ 8 2
                       ♣ A Q 10 8 4
    ♠ 9 5                                   ♠ A 6 4 2
    ♡ 10 4 2                                ♡ 9 8 6 3
    ◇ Q 10 7 5 4                            ◇ A J 3
    ♣ 6 5 3                                 ♣ K 2
                       ♠ K Q 10
                       ♡ A K J 7
         ◇ 5 led       ◇ K 9 6
                       ♣ J 9 7
```

South is in 3NT, and when West opens the 5 of diamonds it is

obvious to East that the defence will prevail if partner's diamonds can be brought in. East should therefore finesse ◊ J, for he can afford to let South win a free trick if he holds ◊ Q–x–x. Provided the jack is played smoothly, it will appear to South that his best chance is to win with the king and take the club finesse.

There is a rarer type of finesse that is made only against suit contracts. This time the object is not to keep in touch with partner but to discover whether he holds a certain card.

South is in five diamonds and West opens a low heart. Suppose that East makes the normal play of the king. South will win and lose the diamond finesse to East. Now East will be in a dilemma whether to return a spade or a heart.

East solves his problem by putting in ♡ J at trick one. This is a 'discovery play'. When the jack loses to the queen East knows that when he gets in with ◊ K he must try the spades. If, on a different lay-out, the jack fetched the ace, East would play on hearts for the setting trick.

Tactical Moves at Notrumps

Success in a borderline notrump contract will usually go to the side that is first to establish and cash its long cards. This, in turn, will depend on communications and 'tempo'. It follows that most tactical moves at notrumps are concerned with entries or with timing.

A defender will sometimes have a choice between a play to establish his own suit or an attack on the opponent's entries. In general, a play that cuts off declarer's main suit is likely to be the more effective of the two, as on this deal:

North
♠ 2
♡ K J
♢ Q 10 8 7 3 2
♣ 8 7 5 4

East
♠ 10 9 5 4
♡ A 8 7 2
♢ K J 5
♣ J 9

♠ 6 led

South	*North*
1 ♣	1 ♢
3NT	Pass

West opens the 6 of spades and East's 9 is won by declarer's jack. South plays ace and another diamond and West discards the 4 of hearts on the second round. Now East's problem is whether to continue spades or drive out the entry for dummy's diamonds. It is true that the defenders will need to make spade tricks eventually, but the important factor here is that they can afford to wait. The

first essential is to kill dummy's diamond suit. The correct return is a low heart, just as effective as playing ace and another. The ace will be needed later as an entry for a spade or club lead.

That is an example of one type of tactical plan, killing an important entry. Other plans include creating entries to partner's hand, switching from suit to suit or merely playing to give nothing away. The art, of course, lies as much in recognizing what sort of plan is needed as in knowing how to execute it.

KILLING ENTRIES

Hold up a winner when the declarer's cards are sequential or when he takes a finesse which he is sure to repeat.

In studying the declarer's play we noted the effectiveness of the simple hold-up in the opponents' long suit. This is the commonest entry-killing stroke and is frequently used by the defenders. Like the declarer, they must often hold up with a double guard.

(1)	Q J 10 8 3	(2)	K J 10 7 6
A 7 5 2	K 6	9 3 2	A Q 5
	9 4		8 4

In (1), when South leads the 9, East may not be sure – though he often will be – that West holds the ace, but he should take that chance. The hold-up kills the suit unless dummy holds two side entries.

In (2), when South finesses the jack, East should hold off. Again dummy will need two side entries to bring in the suit. When we recommend holding off, it is on the assumption (*a*) that the finesse can be repeated, and (*b*) that the finesse is taken in a key suit.

This is especially likely to be the case when declarer finesses in trumps, as in the following situation:

$$6\ 2$$
K 8 5 10 7
$$A\ Q\ J\ 9\ 4\ 3$$

This suit is trumps, South having bid it twice. In dummy at an early stage, he leads low and finesses the queen. Now on many hands it will be good play for West to hold off. This does not exactly kill an entry but it may cause declarer to misuse an entry. For

example, thinking the trump finesse is right he may use a valuable entry to dummy for a repeat finesse, when a finesse in another suit would have rewarded him better; or he may play a side suit on a wrong assumption because he thinks he has no loser in trumps.

Beware, however, of one of the most insidious errors in the game – that of executing a familiar tactical stroke without reference to the general situation.

```
            ♠ 7 3
            ♡ 8 6 4 2
            ◊ K 8
            ♣ K Q J 10 5
♠ Q 9 8 2                    ♠ J 10 6 5 4
♡ Q 7 5 3                    ♡ J 9
◊ 5 4 3                      ◊ A 9 7
♣ 9 8                        ♣ A 7 4
            ♠ A K
            ♡ A K 10
♠ 2 led     ◊ Q J 10 6 2
            ♣ 6 3 2
```

South	North
1 ◊	2 ♣
3NT	Pass

Against South's 3NT West leads a spade, won by the king. South plays a club at trick two, on which West starts an echo. Observing that dummy has no side entry, East may think this is a standard situation for a hold-up, but if South is allowed to win one club trick he will switch to diamonds and make the contract. With his top control in the only other suit bid by his opponents, East must judge that four club tricks will probably not give the declarer game. He must take ♣ A at once and clear the spades.

When declarer is about to take a combination finesse, play high from second hand.

One of the most effective entry-killing manoeuvres is the play of a high card to prevent declarer from establishing a suit by means of a combination finesse. Assume in the following examples that declarer lacks entries to dummy:

(1) A J 10 5 (2) A J 9 7 4
 K 8 6 Q 9 2 K 10 3 Q 6 5
 7 4 3 8 2

In (1) South intends to finesse the jack, and if West plays low he can make three tricks whether East ducks or not. By going in with the king first time West holds him to two tricks, for if the ace is played the entry for the long card disappears.

In (2) South intends to finesse the 9. If West plays low and East releases the queen, South will make four tricks. By letting the 9 win, East can hold the declarer to two tricks. Best, however, is for West to go in with the king on the first round. This keeps South to one trick. The second-hand player can make the same sort of play when the long suit is concealed in declarer's hand.

Apart from its effectiveness as a communication play, that sort of manoeuvre has deceptive value as well, for South may allow the king to hold and finesse the jack next time. (We do not want to distract the reader from the main point, but this position raises psychological considerations. With K–Q–x in front of A–J–9 it is usual to duck, expecting declarer to finesse the 9; this leads to a world of bluff and double bluff.)

The same principle applies, and the play is more difficult to judge, when the ace is in the short hand:

 J 7 5 4 2
 K 9 3 Q 8
 A 10 6

When dummy leads low it is good play for East to put in the queen if he suspects this distribution.

Another time when second hand high is indicated is when declarer is bent on ducking the trick into the opposite hand.

 A K 10 9 7
 Q 5 2 J 8 3
 6 4

With no side entry to dummy, South intends to duck the first round and play for a 3–3 break. If West wants the lead he should put in the queen, which South must allow to hold. These are other positions of the same kind.

```
(1)         A K Q 9 4          (2)           7 3
     10 5              J 8 7 3        J 9 5              K 6
            6 2                          A Q 10 8 4 2
```

In (1) West is the danger hand. South wants to be sure of four tricks and plans to duck the lead to East. West can prevent this by going up with the 10. In (2) South wants to set up his suit without letting East into the lead. When dummy leads the 3, East goes up with the king; if South is short of entries and cannot afford to let East win, he is in a dilemma. These examples show that a defender who has a doubleton honour should usually go up with the honour.

When attacking an entry, lead a high card to block a finesse.

We started this chapter with a deal where East switched to a new suit to remove an entry from dummy. When attacking a suit for this reason it is often advisable to lead the highest card. The following are very common situations:

```
(1)         A K 5 4           (2)           A J 6 4
     Q 9 6 3          10 8 7        K 10 7 2            9 5 3
            J 2                            Q 8
```

Suppose that West is on lead and proposes to open up one of these suits, either to attack the entries or because he has nothing else to play. In (1) the lead of a small card will remove one entry but it may lose a trick in the process, as South may let it run to the jack. The correct lead is the queen. In (2) the king is the card to lead, preventing South from winning three rapid tricks. Note that the king would also be right if dummy held A–Q–x–x and declarer J–x.

One of the most dramatic of the entry-killing plays is similar in appearance but may actually concede an extra trick in the interest of killing an entry. This play is sometimes called the Merrimac Coup or, by an extension from its original meaning, the Deschapelles Coup.

```
                    ♠ A 8
                    ♡ 7 2
                    ◊ Q J 8 7 4 2
                    ♣ 9 5 3
    ♠ K 10 4 2                      ♠ 9 7 6
    ♡ J 10 9 5 3                    ♡ 8 6 4
    ◊ K                            ◊ A 6 3
    ♣ Q 8 6                        ♣ K 10 4 2
                    ♠ Q J 5 3
                    ♡ A K Q
    ♡ J led         ◊ 10 9 5
                    ♣ A J 7
```

Playing in 3NT, South wins the heart opening and leads the 10 of diamonds. Dummy's only side entry, the ace of spades, must be removed, but if West leads a small spade South will let it run to the closed hand. The correct return is ♠ K, even though this gives away a spade trick.

CREATING AN ENTRY TO PARTNER'S HAND

Consider an unblock in declarer's suit when the play marks partner with particular high cards.

From the way that declarer tackles a suit it is generally possible to form an idea of his holding. The defenders should be ready to act on those inferences when a successful unblock would improve their communications.

```
 (1)            10 7          (2)          Q 10 8 4 2
       Q 9 2          J 8 5          K 5           J 9 3
          A K 6 4 3                      A 7 6
```

In (1) South, who is not short of entries to either hand, plays off the ace and king. If he wants East to win the third round West can safely drop the queen, for if South had held the missing jack he would have finessed.

In (2) South lays down the ace. This is a strong indication to West that his partner holds the jack, for otherwise South would presumably take the finesse. If West wants his partner to gain the lead he must drop the king under the ace. Note that South does better to lead a low card on the first round, not the ace, if his

objective is to keep East out of the lead.

Many unblocking plays can be made with confidence on the second round.

```
                      7 4
    J 9 6                              K 10 3
                    A Q 8 5 2
```

South finesses the queen, then lays down the ace. Obviously East can place his partner with the jack.

The Deschapelles Coup, which we mentioned above, is a manoeuvre in which a player makes a sacrificial lead to establish an entry for his partner.

```
                    ♠ J 8
                    ♡ J 10 8 3
                    ◇ K Q
                    ♣ A 7 6 4 2
    ♠ A K 3                            ♠ 9 7 6 4 2
    ♡ Q 9 7                            ♡ K 6 4 2
    ◇ J 8 5 2                          ◇ 10 7 4
    ♣ K J 5                            ♣ 9
                    ♠ Q 10 5
                    ♡ A 5
    ♠ K led         ◇ A 9 6 3
                    ♣ Q 10 8 3
```

South is in 2NT and West leads three rounds of spades. South wins with the queen and plays ace and another club, leaving West on play. Now West needs to find his partner with an entry card. If East has either red ace, West will have time to find it. The important extra chance is that East may hold ♡ K. In search of that, West leads ♡ Q – not a low heart. Whether South wins immediately or holds off for one round, East's king will be an entry card.

Another spectacular means of creating entry to partner's hand is the well-timed disposal of a card that would otherwise be obstructive. Be on the look-out for situations like this:

```
                    ♠ 10 6 4
                    ♡ A K 8
                    ◊ 9 3
                    ♣ A J 8 5 2
   ♠ K 9 7 5 2                       ♠ A 3
   ♡ J 9 4                           ♡ Q 10 7 5 2
   ◊ J 8 4                           ◊ K 7
   ♣ 9 3                             ♣ Q 10 7 4
                    ♠ Q J 8
                    ♡ 6 3
   ♠ 5 led          ◊ A Q 10 6 5 2
                    ♣ K 6
```

South	North
1 ◊	2 ♣
2 ◊	2 ♡
2NT	3NT
Pass	

East wins the spade lead and returns the suit. West can tell from the fall of the cards that East has only two spades, so he does not hold up. The best defence is to take the king and play a third round. Realizing that the only possible entry for his partner must lie in diamonds, East must discard the king. Then South cannot establish the diamonds without letting West in, and without the long diamonds he can make only eight tricks. If East failed to throw ◊ K South would make a standard avoidance play, leading diamonds twice from dummy and ducking when the king was played.

The unblock of ◊ K is not difficult here, because that card cannot possess any value. Note that if East held A–x or Q–x the discard would be equally necessary.

SWITCHING FROM SUIT TO SUIT

Abandon your first suit when you see that it will not produce the necessary tricks in time.

More rewarding than any of the technical manoeuvres we have been looking at is good judgement in changing the line of attack. No single injunction will help you to develop that quality. In West's position on the following hand, you just have to be up with the play.

```
                    ♠ 10 3
                    ♡ J 9 8
                    ◇ 9 2
                    ♣ A J 9 5 4 3
      ♠ K 9 7                        ♠ A Q 8 6 5
      ♡ A 6 2                        ♡ 7 4 3
      ◇ Q 10 8 6 5                   ◇ J 4 3
      ♣ K 2                          ♣ 8 7
                    ♠ J 4 2
                    ♡ K Q 10 5
      ◇ 6 led       ◇ A K 7
                    ♣ Q 10 6
```

South opens 1NT and North, relying on the club suit, raises to
3NT. West leads the 6 of diamonds and the jack is headed by
South's king. South plays a small heart and all eyes are on West.

West has already marked South with the ace of diamonds and he
draws another firm inference from South's seeming disinterest in the
long club suit. This surely means that South holds ♣ Q, is banking
on six tricks in the suit, and is trying to snatch a ninth trick in
hearts.

West goes straight up with ♡ A, therefore, and switches to the
king of spades. Note that the 7 of spades would be ambiguous: East
might conclude that west was putting him in to return a diamond.

*If partner can conveniently lead the main suit from his side, use your entries to
play a suit which can only be led from your side.*

Remember that an opportunity to lead is – an opportunity. It is
often more important to make a constructive play in a new suit than
to return a suit which partner can play himself. That is the situation
on the following hand:

```
                    ♠ J 7
                    ♡ 10 5
                    ◊ J 9 8 2
                    ♣ Q 10 7 4 3
    ♠ 6 4 3 2                      ♠ Q 10 9 8
    ♡ A 9 8 7 2                    ♡ Q J 3
    ◊ A Q                          ◊ 7 6 5 3
    ♣ J 5                          ♣ K 9
                    ♠ A K 5
                    ♡ K 6 4
    ♡ 7 led         ◊ K 10 4
                    ♣ A 8 6 2
```

South plays in 1NT and West leads a heart, East's jack losing to the king. South plays ace and another club, East returns the queen of hearts and West drops the 2. Now it would be very wooden to continue hearts, for East must realize that even after West has cashed the long cards two more tricks will be needed to beat the contract. Having held the trick with ♡ Q, East should use his next lead to help establish those tricks. He should take it that West's 2 of hearts is a suit-preference signal for a diamond return, the only play to beat the contract.

With a trick in the bag, look for another suit that will develop an equal number of tricks.

Feint in one place, strike in another. In bridge terms, take a trick in a suit where the declarer must hold off, then turn to another suit where you have equally good prospects. To give a simple illustration, suppose you are on lead against a notrump contract, with K–Q–J–10 in two suits. You lead one of them and the declarer holds off. Now clearly there will be an advantage in switching to the other suit; there is more to go for, as the stockbrokers say. Alternatively, it may be good play to switch, then return to the first suit. That is the theme of the following hand:

```
                    ♠ A 8 2
                    ♡ Q 2
                    ◊ 10 6
                    ♣ K J 10 8 6 3
   ♠ K 9 7 6                        ♠ Q J 4
   ♡ 10 8 7                         ♡ 9 6 5 4 3
   ◊ K 5 3 2                        ◊ Q 9 7 4
   ♣ A 4                            ♣ 2
                    ♠ 10 5 3
                    ♡ A K J
   ♠ 8 led          ◊ A J 8
                    ♣ Q 9 7 5
```

South	North
South	*North*
1 ♣	3 ♣
3NT	Pass

West leads the 6 of spades against South's contract of 3NT. If declarer could be sure this was from a four-card suit he would put up the ace and tackle clubs, but in practice he may hold up for one round, guarding against the ace of clubs and a doubleton spade in East's hand. In with the jack, East reflects that with five spades West would probably have overcalled; also, South's 3NT is more likely to contain three low spades then only two. Three spades and a club won't beat the contract, so East shifts to the 9 of diamonds. Now the declarer is doomed. If he wins with the ace, the defenders will make three diamond tricks plus a trick in each black suit. If he ducks, West will win and switch back to spades.

Tactical Moves Against Trump Contracts

The early defence against a suit contract is the most critical area in the play of the cards. Later on you can at least see what the declarer is about and can organize counter-measures. At the beginning you know less. Form a good habit by studying the dummy and relating it to the bidding. Is the dummy weak for the bids it has made? Then incline to a passive defence. Is it strong? Then do something dynamic. Is there a side suit? Then cash winners. Might there be an entry problem? Then attack the entries.

As the play proceeds you will get a clearer picture. Does the declarer seem to have enough winners for his contract? Then you must do something special to stop him. Does he seem to lack the necessary tricks? Then you must do nothing to help him.

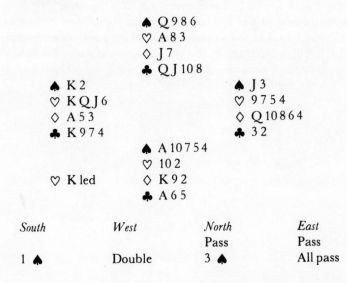

```
                    ♠ Q 9 8 6
                    ♡ A 8 3
                    ◊ J 7
                    ♣ Q J 10 8
      ♠ K 2                       ♠ J 3
      ♡ K Q J 6                   ♡ 9 7 5 4
      ◊ A 5 3                     ◊ Q 10 8 6 4
      ♣ K 9 7 4                   ♣ 3 2
                    ♠ A 10 7 5 4
                    ♡ 10 2
      ♡ K led       ◊ K 9 2
                    ♣ A 6 5
```

South	West	North	East
		Pass	Pass
1 ♠	Double	3 ♠	All pass

Playing in three spades, South holds off the heart opening, wins

the continuation and ruffs a heart. West wins the second spade and leads a heart, South ruffing. After entering dummy with a trump declarer leads ♣ Q and West wins with the king. Looking at it from West's point of view, you will see that the problem is whether to exit passively with a club or attack diamonds.

Count South's winners. He has four trump tricks, one heart and three club tricks. That is not enough for the contract, so your tactics are to do nothing to help him. Exit passively with a club and let South tackle diamonds himself. If you consistently make ordinary plays like that, you will be no ordinary defender.

The next hand is more difficult because you may not realize that you have a problem. Nobody rings a bell.

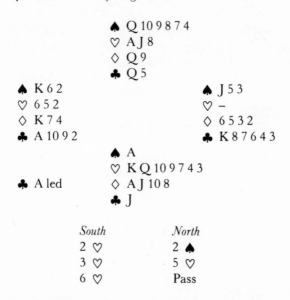

	♠ Q 10 9 8 7 4	
	♡ A J 8	
	◇ Q 9	
	♣ Q 5	
♠ K 6 2		♠ J 5 3
♡ 6 5 2		♡ –
◇ K 7 4		◇ 6 5 3 2
♣ A 10 9 2		♣ K 8 7 6 4 3
	♠ A	
	♡ K Q 10 9 7 4 3	
♣ A led	◇ A J 10 8	
	♣ J	

South	North
2 ♡	2 ♠
3 ♡	5 ♡
6 ♡	Pass

Defending against six hearts, you lead the ace of clubs and East signals with the 8. Do not assume that because you appear to control the side suits it must be safe to continue clubs. Instead, consider whether South can possibly have the material for twelve tricks. Clearly not, unless he brings in the spade suit. How can you shut out spades? By attacking dummy's entries, and that means the trump suit. A heart at trick two is the only play to beat the slam. On a club continuation South can set up the spades and discard three diamonds.

GETTING RUFFS

Do not ruff declarer's losers even with a 'useless' trump.

We now study tactical moves in and around the trump suit,
repeating an injunction made in the previous chapter: beware the
trap of following a familiar tactical plan without relating it to the
general situation.

One of the most destructive habits in the game is to ruff in a
situation like this:

	A 7 3 2	
5 led		Q J 10 8 4
	K 9 6	

West leads this suit against a trump contract and South wins with
the king. Later, East gains the lead and returns the queen at a time
when West holds a 'useless' trump. If West ruffs, he is in effect
ruffing East's winner. Even if declarer had a doubleton the ruff
would probably not help, for the ace would provide a discard for a
loser in another suit. West's trump may seem unimportant, but by
expending it on the air he will help declarer.

In general, do not regard ruffs with small trumps as free tricks and
do not ruff without purpose. In particular, it is almost always bad
play to ruff in front of the declarer when he is developing a side suit,
as in this kind of position:

North
♠ A 10 9 3 2
♡ K 10 8
◇ 7 6 4
♣ 8 3

East
♠ K Q 8 4
♡ J 6 4
◇ 2
♣ A 7 6 5 2

♣ 10 led

South	*North*
1 ♡	1 ♠
2 ◇	2 ♡
3 ♡	4 ♡
Pass	

Defending against four hearts, East wins the first trick with the ace of clubs and South drops the jack. Sometimes it is imprudent, especially with a weak partner, to lead a singleton when you are not keen to ruff the return, but here it is possible for West to hold ◊ A–x–x–x and the king of clubs as an entry. East therefore returns ◊ 2, South plays the queen and West the king. West, who holds ◊ K–J–9–x and ♣ Q–10–9–x, exits with a spade, won by dummy's ace. Another diamond is led from the table and at this point East must on no account ruff in front of declarer. If he does so, declarer will be able to extract the trumps in two rounds and establish his diamonds by ruffing the fourth round.

Here East has a rather more difficult problem of the same type:

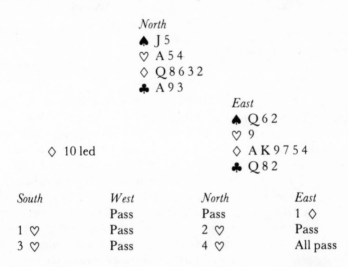

North
♠ J 5
♡ A 5 4
◊ Q 8 6 3 2
♣ A 9 3

East
♠ Q 6 2
♡ 9
◊ A K 9 7 5 4
♣ Q 8 2

◊ 10 led

South	West	North	East
	Pass	Pass	1 ◊
1 ♡	Pass	2 ♡	Pass
3 ♡	Pass	4 ♡	All pass

East wins the diamond opening and South drops the jack. Now East has three possible lines of defence. First is a low diamond. That is almost certainly bad, for South will discard a loser and West may have to ruff from a holding such as Q–10–x–x. Secondly, he might play the ace of diamonds. That stops South from discarding a loser, but he will ruff low and the queen of diamonds will later provide a discard. Thirdly, East can exit in another suit, say with ♡ 9, and on the whole that looks best. It may clarify a problem in the trump suit for the declarer, but the trick is likely to come back.

The situation would be quite different if East held a quick side entry, such as the ace of spades, Then the return of a low diamond, with the threat of another diamond after ♠ A, would be a much

more promising defence.

Purposeless ruffs often enable the declarer to put dummy's trumps to work when they would otherwise have been useless. Observe the effect of West's miscalculation on the following hand:

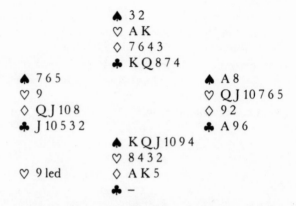

South lands in four spades after East has opened one heart. Dummy wins the first trick and leads ♣ K, which is covered and ruffed. East wins the first round of trumps and returns a heart, which West ruffs. A trump return at this point will put South two down, but West may think that as he holds ♠ 7 there is no need to remove dummy's 3. If West returns a diamond South will lead a heart, and although West can ruff in front of dummy, that will be the defenders' last trick. Dummy's trump will be used to ruff the fourth heart, at the same time providing entry for a diamond discard on ♣ Q. The lesson is that when a defender expends small trumps by ruffing he may strengthen declarer's control of the hand in an unexpected way.

Look for opportunities to give partner a ruff.

Any player can see the chance of a ruff in his own hand when he holds a short suit. More imagination is needed to construct a ruff for partner. Study East's reasoning when he wins the first trick on the following deal:

```
                        ♠ Q 10
                        ♡ 10
                        ◇ A K 10 8
                        ♣ A Q J 5 3 2
       ♠ A 6 3                          ♠ K 4
       ♡ Q 9 8 5 3 2                    ♡ A J 7 6 4
       ◇ J 4                            ◇ 9 5 2
       ♣ 10 4                           ♣ 9 7 6
                        ♠ J 9 8 7 5 2
                        ♡ K
       ♡ 5 led          ◇ Q 7 6 3
                        ♣ K 8
```

South is in four spades and West leads a low heart. East wins with the ace, and when the king falls East must gauge that the defenders can beat the contract only by taking three tricks in the trump suit. So the first necessary assumption is that West holds ♠ A. From there it is not difficult to visualize the possibility of a diamond ruff. Having reached this stage, East leads a diamond at trick 2. Dummy wins and leads ♠ Q. East lets this run up to his partner and West returns a diamond; operation successful.

Before giving partner a ruff, consider what the situation will be afterwards.

Giving partner an early ruff will often leave the defence in a dead position where the player who has ruffed has nowhere to go. Whenever possible, try to organize a double-barrelled action with a ruff for both defenders.

```
                        ♠ Q J 8 4
                        ♡ K 5 2
                        ◇ Q J 9 5
                        ♣ A 10
       ♠ 7 6 3                          ♠ A 2
       ♡ 6 4                            ♡ A Q 9 7 3
       ◇ K 7 3 2                        ◇ 8 6
       ♣ 9 8 5 3                        ♣ Q J 6 2
                        ♠ K 10 9 5
                        ♡ J 10 8
       ♡ 6 led          ◇ A 10 4
                        ♣ K 7 4
```

South	West	North	East
			1 ♡
Pass	Pass	Double	Pass
2 ♠	All pass		

Against two spades West leads the 6 of hearts. East cashes two hearts and can read his partner for a doubleton. If he gives West an immediate ruff the defence will take no more than five tricks. East must gauge that the contract is unlikely to be beaten unless West holds the ace or king of diamonds and must switch to a diamond at the third trick. When he comes in with ♠ A he gives West a heart ruff and gets a diamond ruff in return.

That kind of forward planning is often needed. Suppose this suit is led by West:



◊ Q J 9 3

◊ 4 2 ◊ A K 7 6

◊ 10 8 5



If East has a quick side entry it may be sound play to give partner a ruff, regain the lead and play a fourth diamond. Where that prospect does not exist it will probably be better to look for a trick in another suit before giving partner a ruff; otherwise the fourth diamond may provide declarer with a valuable discard. If that seems to be the situation East must switch immediately, keeping ◊ A for re-entry.

TRUMP PROMOTION

Aim for a situation in which a defender threatens to overruff.

An effective way of winning extra tricks in the trump suit is by contriving a situation in which a defender is in a position to overruff the declarer or dummy. Suppose this is the trump suit and the declarer has sufficient entries and no outside losers:



A Q J 4

7 6 5 2



West leads a suit of which both dummy and East are void. No matter how favourably the outstanding cards are distributed, South

must lose at least one trump trick. Suppose, for example, the finesse is right; if dummy ruffs with the jack, the declarer will surely lose the third round.

To gain the maximum from this type of situation, the defenders should overruff with a small trump that would not otherwise take a trick but should usually refuse to overruff with a card that is likely to be a natural winner in any case. The importance of the second precept is apparent in this situation:

<p style="text-align:center">A Q J 4</p>

9 8 K 10 3

<p style="text-align:center">7 6 5 2</p>

Suppose that on the lead of a plain card by West dummy ruffs with the jack and East overruffs. Then South can draw the rest of the trumps without loss. By refusing to overruff East gains a trick.

In that example the advantage of not overruffing was clear to East. The same principle should be followed whenever the defender's trumps are capable of promotion. Observe the effect in a situation like this:

<p style="text-align:center">J 6</p>

9 5 3 2 K 10

<p style="text-align:center">A Q 8 7 4</p>

East plays a side suit to which dummy will have to follow and South trumps with the 8. West may think it a fine opportunity to make a trick with the 9, but if he obeys the general principle and discards he will end up with two tricks instead of one.

We look now at some promotion plays in the context of a complete hand. Defenders often embark on this kind of play because it is obvious that the tricks needed to defeat the contract can come only from the trump suit. That should be East's diagnosis on this deal:

```
                        ♠ 10 6
                        ♡ A K J 10
                        ◊ A K J 5
                        ♣ J 6 2
    ♠ J 4                                 ♠ 9 5 3
    ♡ 8 6 4 2                             ♡ 9 7 5
    ◊ Q 7 3 2                             ◊ 10 8 4
    ♣ Q 10 3                              ♣ A K 7 5
                        ♠ A K Q 8 7 2
                        ♡ Q 3
    ♣ 3 led             ◊ 9 6
                        ♣ 9 8 4
```

West leads the 3 of clubs against four spades. East must judge that the only chance is to make three clubs and a trump trick. Playing West for three clubs to the queen, East returns ♣ 5 at the second trick. Having won the next club he plays back the thirteenth.

It is often more difficult to discern the chance to promote a trick in partner's hand than one's own. Here the opening is hard to spot:

```
                        ♠ J 10 9 3
                        ♡ A Q 10 3 2
                        ◊ Q J 7
                        ♣ 5
    ♠ A                                   ♠ Q 8 4
    ♡ J 7 6 4                             ♡ 9 8
    ◊ A K 8 4 2                           ◊ 9 6 3
    ♣ Q 7 4                               ♣ J 9 8 6 2
                        ♠ K 7 6 5 2
                        ♡ K 5
    ◊ K led             ◊ 10 5
                        ♣ A K 10 3
```

Against four spades West leads the king of diamonds. Not wanting to invite a switch, East drops the 6, and on ◊ A the 9.

Realizing now that the setting trick can come only from the trump suit, West plays a third diamond. Declarer will probably lead ♠ J from dummy and let it run to West's ace. Now another diamond promotes a trick for East's Q–8, for if dummy does not ruff high the 8 will force the king, and if dummy ruffs with the 10 East will refuse to overruff.

We have seen that for the purposes of trump promotion a bolster in partner's hand can produce surprising results. On the next deal East has to visualize what that bolster may be.

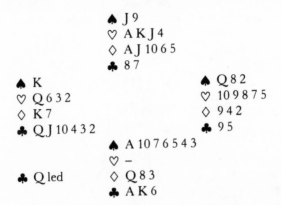

♠ J 9
♥ A K J 4
♦ A J 10 6 5
♣ 8 7

♠ K ♠ Q 8 2
♥ Q 6 3 2 ♥ 10 9 8 7 5
♦ K 7 ♦ 9 4 2
♣ Q J 10 4 3 2 ♣ 9 5

♠ A 10 7 6 5 4 3
♥ —
♣ Q led ♦ Q 8 3
♣ A K 6

South is in six spades and West leads the queen of clubs. Hoping to avoid the diamond finesse, the declarer plans to ruff a club in dummy and discard two diamonds on ♥ A–K. When the third round of clubs is ruffed with dummy's jack East must realize that there are no tricks to be had in the side suits, so that the slam will be made unless West holds ♠ K. In that case East can make sure of two tricks by not overruffing. Though not relevant to this hand, it is worth adding that if South had held six or seven spades to the A–K–10, failure to overruff dummy's jack would probably not cost a trick. Misplacing the queen, declarer would play off the top honours.

Finally, a different situation: by not overruffing, the defender does not promote his trumps in rank but prevents the declarer from bringing in a long side suit.

```
                    ♠ K 7 3
                    ♡ Q 6 5 3
                    ◇ 8 7 6 3
                    ♣ A 5
   ♠ 5                              ♠ J 10 6 2
   ♡ A J 10 8 4                     ♡ K 9 7 2
   ◇ K Q J                          ◇ A 9 5 4
   ♣ J 9 3 2                        ♣ 10
                    ♠ A Q 9 8 4
                    ♡ —
   ◇ K led          ◇ 10 2
                    ♣ K Q 8 7 6 4
```

South	West	North	East
1 ♣	1 ♡	1NT	2 ♡
2 ♠	3 ♡	3 ♠	4 ♡
4 ♠	All pass		

Against four spades the defenders play three rounds of diamonds and South ruffs. He lays down ace and king of trumps, then plays ace and another club, East discarding a heart. South now ruffs a low club on the table. If East overruffs, South can draw trumps and claim the rest of the tricks. If East does not, the hand collapses, for South cannot return to his hand without shortening his trumps.

You may have noted that South's technique was poor. He should play at most one trump, the king, then tackle his side suit, playing ace of clubs and a club from dummy. Now East can make only one more trick.

THE UPPERCUT

If you cannot ruff behind declarer, ruff high in front of him at a point where he has no useful discard.

The uppercut is a trump promotion play that takes place the opposite way round, as it were. Instead of threatening to overruff, a defender ruffs in front of declarer or dummy, forcing out an important trump while his partner keeps his own holding intact.

```
                    8 6 3
        K 9 4                   10 5
                    A Q J 7 2
```

If either defender can lead a plain suit which the other can ruff, the defence will make two trump tricks. With West on play, East ruffs a side suit with the 10, uppercutting the declarer; now if South overruffs West will make two tricks. With East on play, a plain card from him will result in a trump promotion of the type that has already been studied.

Sometimes the declarer can be uppercut more than once. West may make three tricks in the following situation:



5 3

A Q 7 8 6 2

K J 10 9 4



West leads a plain suit and East ruffs with the 8. West wins the first round of trumps and another uppercut with the 6 establishes a trick for the 7.

Like all promotion plays, the uppercut is most effective when the declarer has no useful discard. This means that in a situation like the following West has to make a key play before launching the uppercut.

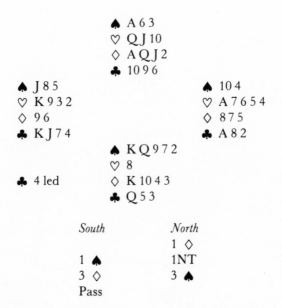



♠ A 6 3
♡ Q J 10
◇ A Q J 2
♣ 10 9 6



♠ J 8 5 ♠ 10 4
♡ K 9 3 2 ♡ A 7 6 5 4
◇ 9 6 ◇ 8 7 5
♣ K J 7 4 ♣ A 8 2



♠ K Q 9 7 2
♡ 8
◇ K 10 4 3
♣ Q 5 3



♣ 4 led



South	North
	1 ◇
1 ♠	1NT
3 ◇	3 ♠
Pass	



South is in three spades and the defenders take three rounds of

clubs. Since the bidding suggests that South may hold only one losing heart, West decides that a trump trick will be needed to beat the contract.

By playing a fourth round of clubs West can invite East to uppercut the declarer, but first it is important to cash a heart, for otherwise South will discard his loser instead of overruffing. West must lay down ♡ K; then a club lead ensures a trump trick for the defence, provided East ruffs with the 10.

It may be noted, also, that it would have been good play for East to cash ♡ A before returning his partner's club lead.

As this example will suggest, the declarer's standard counter to an uppercut is to discard a loser instead of overruffing. This sort of trump situation can be deceptive:

(1)	A Q 5 4	(2)	6 5 2
K 9 6	8	10 7 4	Q
	J 10 7 3 2		A K J 9 8 3

In each case an uppercut by East will promote a trump trick for the defence. If he has any side loser South must discard it when East ruffs.

PART THREE

End-Plays and Deceptive Plays

Eliminations and Throw-ins

One of the first things we noticed about the play of a single suit was that a trick is often gained if one can induce an opponent to lead the suit. Eliminations and throw-ins exploit that factor. Broadly speaking, there are two ways in which you can profit from an opponent's lead. One is concerned with position, as in this example:

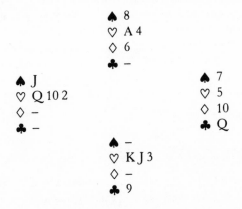

Playing notrumps, South leads a heart to the ace and exits with a spade, forcing West to lead a heart up to the K–J. This is a 'throw-in'.

The second way of profiting from an opponent's lead occurs only in a trump contract:

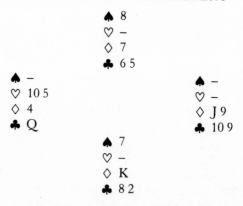

Spades are trumps and South wants three of the last four tricks. First he must cash ◇ K, eliminating that suit from his own hand and dummy. Then he throws the lead to West with a club, and West has no alternative but to lead a heart. This provides South with what is known as a 'ruff-and-discard', something a declarer can never obtain except as a gift. He ruffs in one hand and discards a loser, in this instance a club, from the other. In an elimination you must have at least one trump in each hand after you have thrown the lead. We will consider this type of play first.

ELIMINATIONS

Before throwing the defender in, strip him of cards that can be safely lead.

Hands that end in a ruff-and-discard elimination are often very easy, because the correct play does not depend on reading the opposing hands.

```
                    ♠ A K 5
                    ♡ A J 7 3
                    ◇ Q 10 8 4
                    ♣ 6 5

      ♣ Q led
                    ♠ 7 3
                    ♡ 10 6 4
                    ◇ A K J 9 5 2
                    ♣ A 7
```

South is in five diamonds and a club is led. We are not exaggerating, or practising any form of one-upmanship, when we say that in a fairly experienced game the declarer would not be required to play another card after he had won with the ace of clubs. The play is very simple and nothing can possibly go wrong. South draws trumps and takes three rounds of spades, ruffing the third and so eliminating this suit. Then he exits with the second round of clubs. Assume the worst – that West wins this trick and leads a heart to his partner, who holds K–Q–x. South plays low from dummy, and when East wins with the queen he is end-played. If he leads a black card he allows a ruff-and-discard; if a heart, this will be up to the A–J.

There are many suit combinations that are described rather loosely as 'guaranteed eliminations'. That is to say, they are sure to be effective if the opponents are forced to lead. The heart holding above, A–J–x opposite 10–x–x, was one of these. Let us look at some others.

(1) K 10 5	(2) Q 7 6
8 4 2	J 8 5

With (1), once you have reached an elimination position, you lead low from hand and put in the 10 unless West plays an honour. You cannot lose more than two tricks however the cards lie. With (2) your exit card must be in another suit. So long as the opponents are the first to play this suit, you are safe to lose only two tricks.

(1) A Q 9	(2) Q 10 4
7 4 2	A 9 3

With (1) you will lead low and cover West's card. If West plays the 10 or jack you will still have a major tenace after the queen has lost to the king. With (2) you have a guaranteed elimination if you can exit in another suit or if you can lead from dummy, but not if you lead from your own hand.

Far more numerous are the holdings where your chances are improved if the opponents have to lead, but you cannot be certain of saving the important trick.

(1) K 10 3 (2) A J 4

 A 9 4 K 9 3

The first situation is extremely common. If you can force an opponent to lead you greatly improve your chances of making three tricks. A defensive point arises here, which we will look at later. With (2) you are safe if East is on play; if West has to lead your chance is much better than if you have to lead yourself, for you play low from dummy and lose a trick only if East has both queen and 10.

Q 9 4

A 6 3

This is an interesting combination. You lose only one trick if East has to make the first play. Now suppose that you have to open up the suit yourself and have reason to place East with the king: you can lead from the South hand and put in dummy's 9 if West plays small. If West plays the 10 or jack, you have to guess whether he holds J–10–x or has made a good play from perhaps K–J–x or 10–x–x.

Provided you have a trump in each hand it is not essential to have a finesse position in a side suit. You can succeed even if you have a plain loser, so long as the defender to whom you throw the lead has no more cards of that suit.

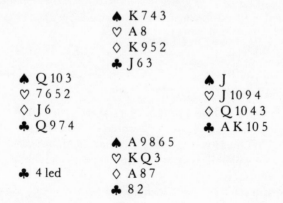

Defending against four spades, East cashes two clubs and switches to the jack of hearts. South wins in dummy and takes two

rounds of spades, discovering that he must lose a trump trick to West. It may look as though he has to lose a diamond as well, but there is the chance of an elimination. This depends simply on finding West with not more than two diamonds. After the second spade South cashes two more hearts, discarding dummy's last club and arriving at this position:

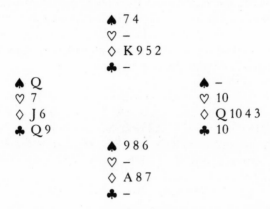

South cashes the ace and king of diamonds and exits with a trump. Having no more diamonds, West has to concede a ruff and discard. An elimination of that kind, which depends on a favourable distribution of the outstanding cards, is called a partial elimination.

The prospect of elimination play often causes the declarer to renounce a natural finesse. Observe how South develops an extra chance on a deal of this kind:

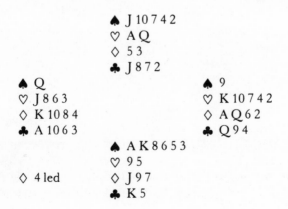

South is in three spades and a diamond is led to East's ace. At the second trick East returns ◊ 2, South plays the 9 and West the 10. Now West switches to a heart.

The first thing declarer should note is that, playing in three spades, he does not need two heart tricks. If West holds ♡ K the contract is guaranteed, for South can go up with ♡ A, draw trumps, ruff the third diamond and exit with a heart, forcing West to lead a club or concede a ruff-and-discard. Having worked that out, South can play the ace on West's heart return without necessarily considering what he will do if East turns up with ♡ K. That problem is considered when, after the elimination, East wins with ♡ K and returns a low club.

South has a guess now, but there are indications. East has turned up with ♡ K and ◊ A – that you know. It is also certain that he has ◊ Q, for if West's diamonds had been headed by K–Q–10 he would have led the king. It is unlikely that East holds ♣ A as well, so the best chance is to play low on the club return. This wins the contract.

Look for a way of throwing a loser on a loser while surrendering the lead.

In the examples above, declarer played the same suit from each hand when throwing the lead. He may also exit in one suit and discard a loser in another. This is called a loser-on-loser elimination.

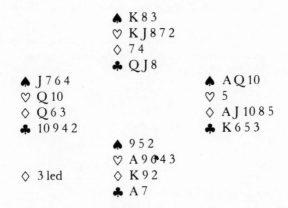

South plays in four hearts after East has opened the bidding with one diamond. There are some interesting defensive points in this deal, but first we will consider how the play might go in practice. West leads a low diamond, East wins with the ace and returns a

diamond, taken by South. After two rounds of trumps the declarer leads ♣ J from the table.

When there is a lead from a sequence it is usually a mistake to cover the first honour, so we will assume that East plays low on ♣ J. South lets it run, cashes ♣ A, ruffs the third diamond and leads ♣ Q from the table. When East plays the king, South discards a spade – a loser-on-loser play. This leaves East with the familiar dilemma of leading up to ♠ K or conceding a ruff and discard.

As we hinted above, the defence can do better. Go back to the first trick, where West has led ◊ 3. An expert and imaginative East would be inclined to place South with ◊ K and would appreciate the importance of constructing an entry to his partner's hand: he would therefore put in the 10 of diamonds, so that West could win the next diamond and switch to spades.

As we described the play above, East made a second slight error when he declined to cover ♣ J. He should foresee the elimination ending and should cover with ♣ K, playing his partner for ♣ 10–9. The battle is still not over. South wins, ruffs the third diamond, and plays off ♣ Q. That leaves the cards as follows:

South leads the club from dummy, intending to discard a spade if East covers. When East plays low South ruffs and leads ♠ 2. Now West must be wide-awake. If he follows with a low spade, South will put in the 8 from dummy and East will be end-played. To prevent this, West must go up with the jack of spades, for the only hope if to find his partner with A–Q–10. This type of ending is quite common.

If short of trumps, leave one outstanding when you throw the lead.

In all the examples so far South has been able to draw trumps and still have one left in each hand when he exits. Sometimes he cannot draw all the trumps without exhausting himself in one hand. In such a case he may leave a trump outstanding.

South plays six hearts and West leads the king of spades. South wins, leads a heart to the ace, and returns a heart to the jack. If both opponents had followed, the elimination would have been perfect. Instead, there is only a partial elimination, but because West does not hold the oustanding trump it is equally effective. South takes three rounds of clubs, ruffing the third, crosses to ◊ A and ruffs a fourth club. Then he exits with ♠ J. There is still a trump out, but West can only lead a diamond or a spade and South escapes the diamond finesse.

HOW TO DEFEND AGAINST ELIMINATIONS

Don't help declarer to eliminate the side suits.

To defend against any form of end-play, the first requirement is to have a good understanding of the play from the declarer's side. Starting from there, you may be able to frustrate the declarer's plan in one of three ways. First, you can refrain from assisting him to eliminate the side suits. Do not assume that making the declarer ruff is always a safe defence.

```
                    ♠ K 4 3
                    ♡ A 7 5 2
                    ◇ J 10 6
                    ♣ 9 5 3
    ♠ 9 7                              ♠ J 2
    ♡ Q J 10 4                         ♡ K 9 8 3
    ◇ A Q 5                            ◇ 9 8 4 2
    ♣ K J 7 6                          ♣ 10 4 2
                    ♠ A Q 10 8 6 5
                    ♡ 6
    ♡ Q led         ◇ K 7 3
                    ♣ A Q 8
```

South	West	North	East
	1 ♣	Pass	Pass
2 ♠	Pass	3 ♠	Pass
4 ♠	All pass		

South wins the heart lead in dummy and ruffs a heart. That is already a sign that he plans an elimination. He takes two rounds of spades, ruffs another heart and exits with a low diamond. Now West must not play a heart: he must take his two high diamonds and exit with a diamond. South can win in dummy, having thrown ◇ K under the ace, but if he then ducks a club to West, the defence can exit with the fourth heart.

Discard, or cash, high cards so that you will not be left 'holding the baby'.

The second line of defence lies in unblocking. The defenders must be wary of this combination:

```
                    J 7 5 3
    K 6                              Q 10 9 4
                    A 8 2
```

If South lays down the ace, even early in the hand, a defender in West's position who holds Q-x or K-x must always consider whether to unblock. Generally it is right to do so, for if the declarer held, say, A-Q-x he would surely play differently.

This is a somewhat simpler situation:

```
                 K 6 3
    J 9 7 2                      Q 4
                 A 10 8 5
```

If East has the sort of hand on which he wants to avoid being
saddled with the lead he must not fail to throw the queen under
dummy's king. With Q–J–x a defender may have to unblock both
honours.

Another form of unblocking is to cash early on high cards with
which you may be thrown in. As a rule, play off singleton kings or
aces. In particular, beware of ducking the first round of trumps
when you hold A–x. Declarer later put you on play with the ace.

When thrown in, study how to present declarer with a guess.

Thirdly, the defenders can sometimes save themselves at the last
hurdle, even after being thrown in. Take this common ending:

```
                 A 9 5
    Q 8 4                     J 7 6 2
                 K 10 3
```

The defender in the lead should play an honour, leaving it open to
the declarer to play him for Q–J–x. If a low card is led, declarer
cannot go wrong. Conversely, if you are put on lead when you do
hold Q–J–x, don't assume that you are necessarily destined to take
no trick in the suit. Provided you are recognized as a player who is
capable of leading an unsupported honour in the previous situation,
declarer may still go wrong.

Here the defenders can save themselves by force:

```
                 A 5 4
    Q 7 2                     J 9 6 3
                 K 10 8
```

If West is on lead the 2 is right; if East, he must lead the Jack, no
other card.

Here are two more positions where there is room for manoeuvre:

```
(1)          K 7 5           (2)          Q 9 5
    Q 9 4 2        A J 6         A J 6 3        10 8 4
             10 8 3                       K 7 2
```

In (1), when West finds himself on play, it is obviously no use leading a low card. The queen will give South a guess, for it might be from Q–J–9 and in that case it would be wrong to cover with the king. Note that the queen would also be the best card from A–Q–9–x.

With (2) the only card to give West a chance of two tricks is the jack. South may run this up to the king and finesse the 9 on the next round.

THE THROW-IN

When contemplating a hold-up, consider the advisability of retaining an exit card.

Throw-in play, as distinct from elimination play, is more common at notrumps than at a suit contract. When this form of play is on the horizon you should think twice before making what would otherwise be a normal hold-up in the enemy suit.



♠ 7 5 4
♡ A K 2
◇ K Q 10
♣ A Q 5 3



♠ 10 led



♠ A Q 8
♡ Q 9 8
◇ J 7 4
♣ J 10 7 2



You play in 3NT after East has bid spades. Since it is likely that East holds the king of clubs as well as the ace of diamonds and a five-card spade suit, there is a danger of losing five tricks. The best chance is to throw East in as a means of avoiding the club finesse, so it is important not to duck the first spade lead. Win and drive out the ace of diamonds. Having won the spade return, cash the red suits, the idea being to throw East in with the 8 of spades. Success is not certain for, as we shall see later, East may leave himself with a singleton club and four other winners. If he does that you will have to read the position at the finish.

The following deal shows how the defenders' discards will often betray them in a situation of that kind:

South is in 3NT and West leads ♡ 6. East holds the first trick with the king and returns the 3. From the spot cards it is probable that West has led from a five-card suit, but in any case South should not hold up because he has eight tricks on top and must retain a heart as an exit card.

South takes the second heart, therefore, and plays off four rounds of diamonds. West throws a club, East a spade and a club. The spade discard, with four showing in dummy, suggests that East began with five spades. The following cards are left:

With an end-play in view, South plays off ♠ A and ♠ K to eliminate spades from the West hand. Now when the jack falls it is true that West might have started with ♠ Q–J–x and that a club finesse could be the only way to make the contract. In such situations declarer thinks back to the discards. If East had held

4–2–2–5 distribution his first discard would probably have been a club. So South exits with a heart and West has to lead a club after making his hearts.

The loser-on-loser theme is common in ordinary throw-ins as well as in eliminations.

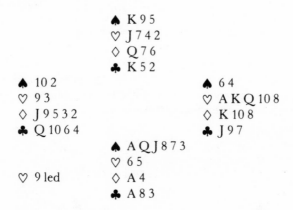

South plays in four spades after East has opened the bidding with one heart. When West leads ♡ 9 South must cover with the jack in dummy, for otherwise East will let his partner hold the trick and switch to a diamond. The defence continues hearts, declarer ruffing high on the third round.

The contract is safe now, provided that South does not misjudge the end game. He should play off trumps, arriving at this position:

On the last spade a club is thrown from dummy and East will

probably throw a club. Then South takes two top clubs and throws East in with a heart, forcing him to lead away from ◊ K.

DEFENCE TO THROW-IN PLAY

Attack the declarer's tenace positions before he can execute the throw-in.

All the stratagems of exit play and unblocking which can be used to thwart an elimination are available in defence to a throw-in. An additional weapon is the attack on the declarer's tenace holdings. If he is planning to force a lead up to A–Q you should aim to lead through the ace while there is still time. The following hand was played in a world championship series:

	♠ 9 7 5 3	
	♡ 4 3	
	◊ K 10 4	
	♣ A K J 3	

♠ 8		♠ K 10 6 4
♡ A K Q J 9		♡ 10 8 6
◊ Q 9 8 6		◊ 7 5 2
♣ 9 6 2		♣ Q 8 7

	♠ A Q J 2
	♡ 7 5 2
♡ K led	◊ A J 3
	♣ 10 5 4

South	West	North	East
	1 ♡	Pass	Pass
Double	Pass	2 ♡	Pass
2 ♠	Pass	4 ♠	All pass

Against this aggressive bidding West began with two rounds of hearts, then switched to ♣ 2. South won in dummy, finessed ♡ Q, ruffed a heart and finessed again in trumps. After cashing ♠ A he played three rounds of diamonds, finessing against West and finishing in hand, then exited with his last trump. East now had to return a club up to dummy's K–J.

The contract can be beaten if West switches to a club after the first heart. He comes in later with a heart and plays a second club, destroying the value of dummy's tenace.

If the throw-in is inescapable, foresee the end position and organize your discards to mislead the declarer.

You can sometimes rob the declarer of what rightfully belongs to him by anticipating the end-play and discarding in a way that he will not expect. As a rule it is not difficult to count the declarer's winners and so to gauge how many discards you will eventually have to make. Usually, though the psychology of the players enters into this, it will be good play to unguard honours, often before the last turn of the screw. Take a hand from earlier in this chapter and assume that the full deal is as follows.

```
              ♠ 7 5 4
              ♡ A K 2
              ◇ K Q 10
              ♣ A Q 5 3
  ♠ 10 2                      ♠ K J 9 6 3
  ♡ 7 5 3                     ♡ J 10 6 4
  ◇ 9 8 5 3 2                 ◇ A 6
  ♣ 9 8 6                     ♣ K 4
              ♠ A Q 8
              ♡ Q 9 8
  ♠ 10 led    ◇ J 7 4
              ♣ J 10 7 2
```

Playing in 3NT, South wins the spade opening, drives out the ace of diamonds and wins the spade return. When West follows, East is marked with a five-card spade suit. South now cashes his red suit winners. If East had to follow suit all the time a throw-in would follow inevitably. As it is, East has to discard on the third diamond. His best chance is calmly to unguard ♣ K. Then if declarer finesses he will go two down and if he tries a throw-in, placing East with three clubs and West with the thirteenth heart, he will find East with one more winner than he expected. To make the contract, South must read East at the finish for a singleton club.

Further Plays in the Trump Suit

We have not yet exhausted the range of special plays that can be made in the trump suit, some concerned with extra safety, others with dashing recovery from danger. We begin with some safety precautions.

PROTECTING MASTER CARDS

When top cards are open to a ruff, shelter them from assault.

As we noted in an earlier chapter, many of the declarer's manoeuvres in the trump suit are designed to protect his winning cards from rude assault. A simple situation occurs when the defenders attack a suit of which declarer has honours in each hand.



A 7 6 5

Q led

K 8 4



This is a side suit and declarer is missing the ace of trumps. It would be unfortunate if he were to win with the king, lose a trump trick to West, and then sustain a ruff of dummy's ace. In such situations South must consider which defender is more likely to hold a singleton of the suit led. If the bidding provides no clue he must study the lead. The queen could be a singleton, it is true, but it could equally be top of a long sequence, and on the whole that is more probable. It is advisable, therefore, to win with the ace in dummy so that East cannot ruff a winner on the next round. If the opening lead were the 9, then that would appear to rule out the possibility that East had a singleton and South would win with the king.

That sort of safety play can take many forms. Suppose that West has overcalled in a suit and you have this combination:

K 7 4 3

A led

8 2

West leads the ace and follows with the queen. Obviously there is a danger that the king will be ruffed. If you have another loser that you can discard later, save the king for that purpose. With A–x–x–x in dummy, a singleton in hand, there may be a time when you can demonstrate your expertise by not covering a lead of the king.

When developing a two-suiter, a declarer who cannot draw all the trumps often has to play the side suit in a special way. A well-known manoeuvre is to play low on the second round with A–K–x–x–x opposite x–x, escaping the ruff of a master card when the suit breaks 5–1. The same theme occurs here:

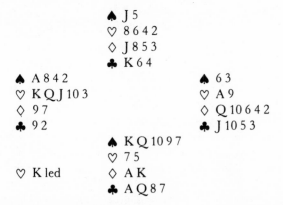

Playing in three spades, South ruffs the third round of hearts. If trumps are led, West will win the second round and force again in hearts; then South will never enjoy a third club, as he will have lost trump control. Instead of leading trumps South might play off three top clubs, intending to ruff the fourth round. That would gain if a defender ruffed from A–x, for he would not be able to draw dummy's trumps, but as the cards lie West will ruff and draw two trumps, leaving South with a club loser. The winning play is to take two top diamonds, then ace, king and a low club. If the defenders play ace and another spade South draws trumps and makes his master club, and if they do anything else he ruffs the fourth club with the jack of spades.

AVOIDING AN OVERRUFF

To sustain a ruff is bad enough, but an overruff can be especially damaging. There is nothing complicated in the play of the following hand, but many players would miss the right line:

```
                  ♠ 7 4
                  ♡ K 9 2
                  ◊ A 10 7 6
                  ♣ A K 8 4
♠ Q 10 8 5 2                    ♠ J 6
♡ J                             ♡ 10 8 3
◊ K J 8 4                       ◊ Q 9 5 3
♣ J 7 2                         ♣ Q 10 6 5
                  ♠ A K 9 3
                  ♡ A Q 7 6 5 4
   ♡ J led        ◊ 2
                  ♣ 9 3
```

West opens his singleton trump against six hearts. It does not seem wrong to win with the queen, cash two top spades and ruff a third spade with ♡ 9; but East unpleasantly overruffs and plays a third trump, leaving South with an inescapable spade loser. The solution is quite simple: ruff the third spade with ♡ K, return to hand with a diamond ruff and let East make his trump trick by overruffing the fourth spade.

When dummy holds no trump high enough for that kind of play, you may be able to side-step a threatened overruff by trading ruffs between two suits. On the following deal South sees an overruff coming in the heart suit.

```
                   ♠ 9 8 6
                   ♡ J 2
                   ◇ A 9 8
                   ♣ K 7 4 3 2
   ♠ 5                          ♠ 10 7 4 3
   ♡ K Q 10 9 8 6               ♡ 7 4
   ◇ Q 6 4                      ◇ J 10 7 3
   ♣ A J 10                     ♣ 9 6 5
                   ♠ A K Q J 2
                   ♡ A 5 3
   ♡ K led         ◇ K 5 2
                   ♣ Q 8
```

South	West	North	East
1 ♠	2 ♡	2 ♠	Pass
4 ♠	All pass		

Playing in four spades, South wins the second round of hearts. As it may not be safe to ruff a heart in dummy, he cashes ◇ K and leads towards the ace. When all follow, he returns to ♠ A and plays his last heart, throwing a diamond instead of ruffing. Later he ruffs a diamond.

AVOIDING TRUMP PROMOTION

Many keen struggles centre around attempts by the defence to gain trump tricks by stealth. We have noted such stratagems as trump promotions and uppercuts. Sometimes there is a neat way in which the declarer can deflect these strokes. See if you can spot the opportunity that South missed on this deal.

```
                   ♠ 9 7 6 4
                   ♡ Q 8 7 2
                   ◇ A
                   ♣ A Q 10 9
   ♠ K 10 3                     ♠ A
   ♡ A 10 6 4                   ♡ K 9 3
   ◇ 10 9 7                     ◇ J 6 5 3 2
   ♣ 6 3 2                      ♣ J 8 5 4
                   ♠ Q J 8 5 2
                   ♡ J 5
   ◇ 10 led        ◇ K Q 8 4
                   ♣ K 7
```

Pushing the boat far out to sea, South opened one spade and was raised to four. A heart lead would have curtailed the proceedings, but the absence of scientific inquiry was rewarded in a way, for West, possessing no clue from the bidding, opened ◊ 10.

South hastened to discard a heart on the third round of clubs, then led a trump. Now East played well by cashing the king of hearts, following with a fourth club. South put in the queen of spades, but West knew enough to refuse the bait and South had to lose two more trump tricks.

From the praise that we have bestowed on East for cashing ♡ K, you will have realized South's error: he should have played a fourth club and disposed of his second heart loser, thus averting the trump promotion.

In the next hand South has to refuse a trump finesse and make another good play to stop West from making an extra trump trick.

```
                    ♠ 8 7 3
                    ♡ A K 8 7 4
                    ◊ A Q 10
                    ♣ Q 10
    ♠ K 10 4                       ♠ 9 5
    ♡ Q 3                          ♡ J 9 6 2
    ◊ K 9 5                        ◊ 7 6 3 2
    ♣ A K J 6 3                    ♣ 9 7 4
                    ♠ A Q J 6 2
                    ♡ 10 5
    ♣ K led         ◊ J 8 4
                    ♣ 8 5 2
```

South	West	North	East
Pass	1NT	Double	Pass
Pass	2 ♣	Pass	Pass
2 ♠	Pass	3 ♠	Pass
4 ♠	All pass		

South is in four spades and West plays three rounds of clubs, forcing dummy to ruff. Now, apart from the fact that a trump finesse is sure to lose, there is the danger of an uppercut. No doubt the clubs are 5–3, and a ruff of the fourth club may well establish a second trump trick for the defence.

It is not sufficient simply to play ace and queen of spades, for as

the cards lie West will exit with a heart and declarer will not be able
to come off the table without losing a diamond or an extra trump.
South must therefore cash ♡ A–K before playing ace and queen of
spades. When West wins with ♠ K he cannot prevent South from
gaining the lead to draw the outstanding trump.

The early cashing of the top hearts in this sort of situation is a
form of play for which no one has found a name. From the element
of extraction, it might be called the 'dentist coup'.

ALLOWING A RUFF-AND-DISCARD

Consider a ruff-and-discard as a means of escape from an elimination.

Turning to the defence now, we propose to extol a form of play
which does not altogether deserve its bad reputation; that is,
allowing the declarer to obtain a ruff and discard. Some elimination
positions are a mirage in the sense that the defenders have a
complete answer: if not too lazy to count, they will know that a ruff-
and-discard will be of no use to the declarer.

```
                    ♠ K Q 5 2
                    ♡ A 8
                    ♦ A 7 3
                    ♣ K 6 5 3
   ♠ 9 4                              ♠ 7 3
   ♡ Q 10 7 6 5 2                     ♡ K J 9 4
   ♦ 8 6 4                            ♦ Q J 10 5
   ♣ Q 4                              ♣ J 8 7
                    ♠ A J 10 8 6
                    ♡ 3
   ♡ 6 led          ♦ K 9 2
                    ♣ A 10 9 2
```

Playing in six spades, South draws trumps, eliminates hearts and
plays three rounds of diamonds. East wins and, observing that a red
suit will allow a ruff and discard, exits with ♣ J or ♣ 7, according to
his style in such positions. South plays for split honours and makes
the contract. Here East should have done a little counting; then he
would have known that a ruff-and-discard would not have benefited
South, holding four clubs in each hand. It is never wrong to offer a
ruff-and-discard when declarer has no loser that he can profitably
discard.

Another good moment for this form of play occurs when declarer is proposing to establish a suit by ruffing. It is better to let him ruff a *different* suit, for then he makes no progress towards establishing his long cards. Here is an example of those tactics:

♠ K 7 3
♡ 7 2
◇ Q 6
♣ A 7 6 5 4 3

♠ 9 5 2
♡ K Q 10 8
◇ A J 10 3
♣ K 8

♠ 8 6 4
♡ J
◇ 9 8 7 5 2
♣ Q 10 9 2

♠ A Q J 10
♡ A 9 6 5 4 3
◇ A led ◇ K 4
♣ J

Defending against four spades, West begins with ace and another diamond. South plays off ♡ A and exits with a heart, on which East discards a diamond. Now suppose that West exits with a club. South wins in dummy, leads a spade to the queen, ruffs a heart with ♠ K and draws two more rounds of trumps. Then he gives up a heart and makes the rest of the tricks.

When he wins the second round of hearts West should say to himself: 'South is going to ruff hearts in dummy; I might just as well let him ruff a diamond; the result in immediate tricks will be the same, but he will be no further towards establishing his heart suit.' If you play out the cards you will find that against this defence South can make only four spades in his own hand, two ruffs and one trick in each of the other suits; he will not be able to get his long hearts going.

TRUMP COUPS

When you cannot take advantage of an ordinary finesse position, play to shorten your trumps.

The remainder of this chapter is concerned with a form of play in which the declarer extricates himself from an unfortunate trump situation. Special play is sometimes needed because dummy cannot lead a trump for a normal finesse. Here is an example of a trump coup which requires a little preparation:

```
              ♠ 7 6 4
              ♡ A 9 6 4 2
              ◇ K 5
              ♣ A 8 3
♠ 10 9 8 5                      ♠ A 3 2
♡ K J 7 3                       ♡ Q 10 8
◇ 4                             ◇ J 9 6 2
♣ J 7 6 4                       ♣ 10 5 2
              ♠ K Q J
              ♡ 5
♠ 10 led      ◇ A Q 10 8 7 3
              ♣ K Q 9
```

South is in six diamonds and the defence begins with a spade to the ace and a spade back. If South is playing a simple game he will lead a diamond to the king and return a diamond to the ace. After that he will have no way of escaping a trump loser. He can reach an end position where dummy is on lead with three hearts and he has ◇ Q–10–8, but obviously East will not play a trump and South will be forced to ruff at trick 11 and give up a trick to the jack.

With the aid of a little foresight, plus understanding of this form of play, South can give himself an additional chance. When he wins the spade return he leads a heart to the ace and ruffs a heart. Then he plays ace of diamonds and a diamond to the king, on which West shows void. Another heart is ruffed, and the value of these manoeuvres is that South reduces his own trumps to the same length as East's. After cashing winners in the black suits, he arrives at this ending:

```
                    ♠ -
                    ♡ 9 6
                    ◇ -
                    ♣ A
                                   ♠ -
                                   ♡ -
     immaterial                    ◇ J 9
                                   ♣ 10
                    ♠ -
                    ♡ -
                    ◇ Q 10
                    ♣ 9
```

Now a club is led to the ace and East's diamonds are trapped.

This type of trump reduction is also the right game when the declarer judges that the trumps are strongly held on his left. This was a celebrated hand between Italy and Norway:

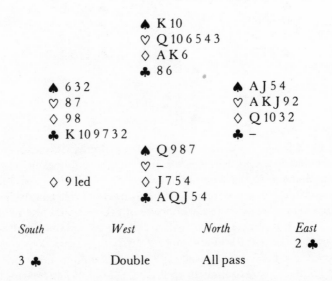

```
                      ♠ K 10
                      ♡ Q 10 6 5 4 3
                      ◇ A K 6
                      ♣ 8 6
       ♠ 6 3 2                        ♠ A J 5 4
       ♡ 8 7                          ♡ A K J 9 2
       ◇ 9 8                          ◇ Q 10 3 2
       ♣ K 10 9 7 3 2                 ♣ —
                      ♠ Q 9 8 7
                      ♡ —
       ◇ 9 led        ◇ J 7 5 4
                      ♣ A Q J 5 4
```

South	West	North	East
			2 ♣
3 ♣	Double	All pass	

Two clubs in the Roman system proclaimed a three-suited hand of limited strength. West was perhaps thinking of an irregular pass, likely to be the best spot for his side, when South intervened.

A diamond was led and the declarer soon showed that his overcall was based on more than raw Viking courage. He led ♠ K at trick 2, ruffed the heart return, played ♠ Q and ruffed a spade. A second heart was ruffed and the other top diamond was cashed. South by this time was down to ♣ A–Q–J and three other cards, while West was contemplating six trumps which had long since lost their attraction. South made his three top clubs, and the contract, by simply leading a plain card whenever he was in.

Sometimes ruff winners to shorten your trumps.

When in the process of reducing his trumps the declarer ruffs a winner, he is said to play a *grand coup*. Another variation is the undertrumping coup, where the declarer ruffs in dummy and underruffs in his own hand to shorten his trumps. The following hand has the air of a problem deal, but it contains some instructive features:

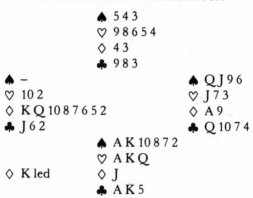

South plays in four spades after West has shown length in diamonds. East overtakes the diamond lead and returns the suit. South, as a matter of habit and technique, ruffs with the 7, not the 2. On the first round of trumps West shows void. Declarer continues with three top hearts, then ace, king and another club. West is left on play in this position:

When West leads a diamond the 4 of spades is played from dummy. Now if East discards South will underruff with the 2. If East ruffs with the jack South will underruff with the 8, so that when East exits with a club he can play ♠ 2 and overtake in dummy with the 4.

There is no defence to the end-game, but East could have played better at the beginning. The diamond return at trick 2 was wrong in principle, because East could see that it would give South a chance

to shorten his trumps. A player with tricks in the trump suit should never do this. If East returns a heart at trick 2 he will make a club and two spades later.

COUP EN PASSANT

If no finesse position exists, try to by-pass the defender's trump holding.

Another kind of trump coup may gain tricks even without a tenace holding. When his right-hand opponent holds strong trumps, the declarer sneaks an extra winner through the side door, leaving the opponents to play their good trumps and their side winners on the same trick. This is an example:

```
                 ♠ 10 5 2
                 ♡ 8 6 2
                 ◇ A Q 4
                 ♣ K 6 5 3
  ♠ 9                          ♠ Q J 8 7
  ♡ J 9 5 3                    ♡ K Q 10
  ◇ 10 8 7 6                   ◇ 9 5 3
  ♣ Q 9 4 2                    ♣ J 10 8
                 ♠ A K 6 4 3
                 ♡ A 7 4
  ♡ 3 led        ◇ K J 2
                 ♣ A 7
```

Playing in four spades, South captures the heart lead and lays down ♠ A–K. When West shows out, South appears to have four losers – two in trumps and two in hearts. One of these is easily circumvented. South takes three rounds of clubs, ruffing the third, then three diamonds, finishing in dummy. The position is now:

```
                    ♠ 10
                    ♡ 8 6
                    ◇ –
                    ♣ 6
                                ♠ Q J
                                ♡ K 10
   immaterial                   ◇ –
                                ♣ –
                    ♠ 6 4
                    ♡ 7 4
                    ◇ –
                    ♣ –
```

Declarer plays the fourth club from dummy and, whether East ruffs or not, must make another trump *en passant*, as it is called. That is his tenth trick.

15

Squeeze Play

Squeeze play, like putting at golf, is a department of its own which can be studied and practised independently of the rest of the game. Some not very gifted players are quite adept at squeeze play, while some of international class know little about the theory of the squeeze. From experience they may generally play the cards in the right order, but they would be still better players if they were not too haughty or too lazy to master the theory.

Whole books have been written about squeeze play and several chapters are devoted to it in *Reese on Play* and *The Expert Game*. We have taken the view that in a single chapter the most useful course is to treat the subject in a theoretical way that will illustrate the diversity and effectiveness of the squeeze. After those rather forbidding phrases let it be added that for anyone whose mind runs in that direction, squeeze play is not difficult to master. As with crossword puzzles, in time you acquire the knack.

HOW TO SQUEEZE ONE OPPONENT

Look for two suits that can be guarded only by a particular opponent.

A defender is squeezed when he has control of two suits and cannot discard except at the cost of a trick. Here is the basic ending of a squeeze against a single opponent:

At notrumps South leads the 8 of clubs and West, who has controlling cards in spades and hearts, is squeezed. East does not come into the picture, since he lacks control of either suit.

Three cards in each hand is the minimum space in which a squeeze can operate, yet even in so basic an example all the essential elements of squeeze play are present.

1. In the North–South hands there are cards in two suits – the 9 of hearts and the 5 of spades – which can be described as 'threats' or 'menaces', as they threaten to become winners if the opponents let go the controlling cards.

2. Both menaces lie against the same opponent, West. (If you gave a second spade, higher than dummy's 5, to East, or if you gave him a heart higher than the 9, the squeeze would be frustrated.)

3. South's 8 of clubs is a 'squeeze card' – a card which, when led, subjects the opponent to a fatal choice of discards.

4. Whereas South's ♡ 9 is a 'one-card menace', North's ♠ K–5 is a 'two-card menace'. At least one two-card menace must be present in any squeeze; it must be in the hand opposite the squeeze card; and there must be an entry to it – in this case South's ♠ 7.

5. The defender who is to be squeezed must not hold any spare cards outside the ones that control the declarer's menaces. Much of the art of squeeze play lies in the necessity of meeting this condition. You often have to surrender tricks early on so that later, when the squeeze card is played, the key hands will contain no superfluous cards.

Making no apology for a schoolmasterish approach, we ask you to identify the squeeze elements in this next ending. Do not assume that the player to be squeezed is necessarily West.

South is on lead at notrumps. Mark off (1) the squeeze card, (2) all the menace cards, (3) the two-card menace, (4) the entry to the two-card menace.

The squeeze card is the jack of diamonds, obviously. There are possible menaces in each of the other three suits, but only two of these, ♡ 6 and ♠ 8, lie against the same opponent, who happens to be East. We can forget about clubs, and also the rest of West's cards.

North's spades represent the two-card menace, and South's ♠ 5 is the entry thereto. All the necessary elements being present, the lead of ◊ J squeezes East.

You may be impatient to see whether this sort of analysis can help you in the play of a complete hand, but bear with us for a moment while we draw your attention to one further aspect of squeeze play – the positional factor. In the two examples you have looked at so far, the two menaces – the one-card menace and the two-card menace – have been in opposite hands. Clearly that is a convenient arrangement, for two hands can contain between them more cards than the single hand of the victim. Such an arrangement produces an 'automatic' squeeze; that is to say, it works equally well against either East or West, provided he holds the right cards.

What happens if the menaces are both in the same hand? Now all depends on position:

The West and East cards are as before. What we have done is exchange the club and heart menaces between North and South. Now, as before, the opponent who might be squeezed is East, as he alone controls the menaces in two suits. Unfortunately, when the squeeze card is led, North has to discard in front of East. So nothing can be done. You may write that down as one of the rare 'nevers' in bridge: you can never squeeze an opponent in two suits when he is the hand sitting over both menaces.

Exchange the East and West hands, and a happier situation emerges:

Now the squeeze works because North discards after West. This is called a 'one-way' as opposed to an 'automatic' squeeze. There is a variation of the one-way squeeze which we must also look at:

On the lead of ◊ J West must throw the heart or unguard his spade control. This form of two-card menace is called a 'split' menace. It works only in a one-way squeeze.

With the theoretical knowledge you have acquired, let us see if you can pick out the squeeze elements in a complete deal:

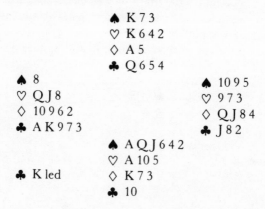

You play in six spades and West leads the king of clubs. When he sees his partner's 2 he does not continue the suit, as he expects declarer to hold the singleton. He switches to a diamond and you win with the ace. There is a slight possibility that the ace of clubs will come down in three rounds, so while in dummy you lead a low club and ruff it. You play a high trump, and when all follow you know it will be safe to ruff the third diamond with the king of spades. While in dummy you lead another club, ruffing again. Now you have reached this position:

So far, you have done nothing special. How are you going to escape the heart loser? You are safe in assuming (from the opening lead) that the queen of clubs is a menace against West. If you can find West with exclusive control of hearts – any four hearts or the Q–J – you will be able to squeeze him. You play off three rounds of trumps and on the last round West, holding ♡ Q–J–8 and ♣ A, has no good discard. You may think you could have achieved this without any tutoring, and that may be true, but not all squeezes happen in a natural sort of way like that. If you understand the elements you will be able to produce squeezes that need to be planned in advance.

When both opponents control a suit where you hold a menace, aim to exclude one of them.

In the next example·you have to work a little harder because one of the menace cards on which you depend is initially controlled by both opponents.

```
                    ♠ 7 4 2
                    ♡ A 8 7 4 3
                    ◊ 10 8
                    ♣ A 6 5
      ♠ J 10 3                    ♠ 9 8 6 5
      ♡ Q 9 6 5                   ♡ K 10 2
      ◊ A 4 2                     ◊ 5
      ♣ K J 9                     ♣ 10 7 4 3 2
                    ♠ A K Q
                    ♡ J
      ♠ J led       ◊ K Q J 9 7 6 3
                    ♣ Q 8
```

West leads a spade against six diamonds. Suppose you play trumps; West will probably win the second round and exit either with a spade or a heart. You can play off a lot of trumps, but against reasonably good defence you will achieve nothing. West will cling to ♣ K–J and will let go hearts.

You begin play a trick short and to overcome this you need to squeeze the player (you must assume it is West) who holds ♣ K. To do so you must have another menace against him, and it can only be in hearts. To make hearts an effective menace against West you must destroy the heart guard in East's hand. After winning the spade opening your first play must be a heart to the ace and a heart ruff. Then you lead a low diamond, and if allowed to win this trick in dummy you ruff another heart. You force out ◊ A, win the spade or diamond return, and play for this ending:

```
                    ♠ –
                    ♡ 8
                    ◊ –
                    ♣ A 6
      ♠ –
      ♡ Q
      ◊ –
      ♣ K J
                    ♠ –
                    ♡ –
                    ◊ 7
                    ♣ Q 8
```

The last diamond operates a one-way squeeze. The important play in this hand was ruffing two rounds of hearts early, to 'isolate the menace'. This is a very common manoeuvre. Often the declarer will have a holding in a side suit such as A–x opposite K–x–x–x. It will generally be good play to ruff the third round at some point, so that only one opponent will be able to control the fourth round.

To prepare for a squeeze, project the play mentally to the point at which you lead the squeeze card.

This is psychological rather than technical advice. There are many hands where the main difficulty lies in making the preparatory moves in time. It is easier to carry out a plan if you visualize the three- or four-card ending.

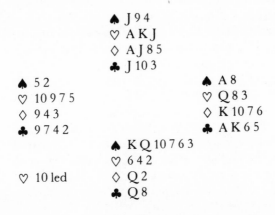

```
                    ♠ J 9 4
                    ♡ A K J
                    ◊ A J 8 5
                    ♣ J 10 3
    ♠ 5 2                              ♠ A 8
    ♡ 10 9 7 5                        ♡ Q 8 3
    ◊ 9 4 3                           ◊ K 10 7 6
    ♣ 9 7 4 2                         ♣ A K 6 5
                    ♠ K Q 10 7 6 3
                    ♡ 6 4 2
    ♡ 10 led        ◊ Q 2
                    ♣ Q 8
```

South plays in four spades after East has opened a vulnerable notrump of 15–17 points. On the lead of ♡ 10 declarer goes up with the ace in dummy and leads trumps. East wins the second spade and exits with ace, king and another club. That leaves the cards as follows, with the lead in dummy:

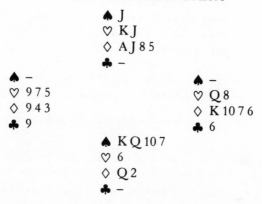

A player whose mind did not run on squeeze play would perhaps have discarded a diamond on the third club. Then he would try to bring down the king of diamonds in three rounds, with a heart finesse as a last resort. The squeeze practitioner notes instead that he has menace cards against East in hearts and diamonds. Projecting the play to the smallest compass, he visualizes an end position in which he holds ♠ 7, ♡ 6 and ◊ Q, while dummy holds ♡ K–J and an idle card. On the lead of ♠ 7 East will be squeezed.

Having formed that picture, South will make the critical play of leading off ◊ A while in dummy. If he fails to do that, the squeeze will not work. This play of the ace of diamonds, whose effect is that the one-card menace, the queen of diamonds, becomes correctly positioned for an automatic squeeze, is called the Vienna coup. It is a common manoeuvre.

Seek to arrive at a position where you can take all the remaining tricks but one.

All squeezes are easier to play, and many can only be played, when you have arrived at a situation where you can win with top cards all the remaining tricks but one. That is to say, if you are playing a contract of four spades and hope to win the tenth trick by a squeeze, aim to lose three tricks early on while you still have everything under control. Then, supposing there are seven cards left, six will be top winners. Or, if you are in 6NT, give up one trick early on.

The reason for this is that you must not allow any 'slack' in the end position. Look at this four-card ending:

The menaces and entry cards are suitable for a squeeze against West, but there is an idle card in the defending hand. When you lead the squeeze card, the king of diamonds, West will discard his heart and you will have achieved nothing. But if you cross out the four hearts in the diagram, assuming that you disposed of that suit at an earlier stage, the squeeze will work.

Thus, in 3NT contracts especially, a good declarer will seek to bring about the situation where he has lost his 'book' of four tricks and retains entries and menace cards. It is often good play to return the suit opponents have led, allowing them to run off their winners, so that afterwards they will be pressed for discards. In 6NT declarer will often duck the opening lead. The play is known as 'rectifying the count'. Here is an example in a slam contract:

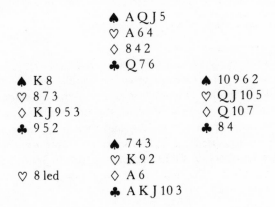

You are in six clubs and the 8 of hearts is led. There is something

to be said for winning in dummy, but it is not essential and we will
say that the lead runs to the 10 and king. You draw the trumps in
three rounds, East discarding a heart.

You need the spade finesse, obviously, and a 3–3 break in spades
would give you twelve tricks. However, you must not rely on that;
you must plan for a squeeze in case spades are 4–2. The fourth spade
will be a menace against whoever has the length, and the 9 of hearts,
to judge from the play to the first trick, is probably a menace against
East. It is unlikely that much can be done with the diamonds, as
both opponents will be able to control this suit.

Whether you work the hand out in this way or not, it is good
technique to concede one trick immediately. You do that by playing
a low diamond from both hands, giving up a trick without prejudice
to your menace cards. Say that East wins and returns a diamond to
your ace. Now you finesse ♠ J, cash the ace of hearts (Vienna coup)
and return by ruffing a diamond. This is the end position:

You play the last club and East is squeezed.

There are several ways of going wrong on this hand. For example,
if you finesse spades twice before ducking the diamond, a third
spade from the defence will break up the entries for a squeeze. Less
obvious, if you draw three trumps and then play ace and another
diamond, a third diamond will inconvenience you, for after playing
off the ace of hearts you will be unable to return to hand.

HOW TO EXECUTE SQUEEZE VARIATIONS

When the conditions are not right for a basic squeeze, look for an extra menace or extra entry.

The fundamental of a squeeze – two menace cards against the same opponent, entry to a two-card menace, a squeeze card, correct timing – are invariable, but there are many types in addition to those we have been looking at. In general, where the arrangement of menaces or entries is not of the most convenient kind, some sort of compensation will be needed. The meaning of that will be apparent in the following examples.

1. *You have no two-card menace headed by a winner.* When you lack a two-card menace of the ordinary sort, the only substitute is to have two two-card menaces which are not headed by winners. They must be in opposite hands and each must be faced by a winner.

When South leads ◊ J he executes what is known as a criss-cross squeeze. It works against either opponent. You should look for this sort of squeeze when you hold a blank honour combination like ♠ A–K above.

2. *Both opponents control the two-card menace.* Previously both menaces have threatened one opponent. If both can guard the two-card menace you need a one-card menace against each opponent, producing a double squeeze. If both one-card menaces are favourably positioned, the double squeeze will be simultaneous.

That is to say, both opponents will be squeezed at the same trick.

Both opponents are squeezed when ♣ J is played. This is the commonest form of double squeeze. The spades, being controlled by both opponents, are called a double menace.

3. *Both one-card menaces in a double squeeze are in the hand opposite the squeeze card.* To compensate for the fact that one of the one-card menaces is under the opponent who is to be squeezed, there must be a special arrangement of the double menace.

The one-card menaces, ♡ J and ◊ 10, are the same as in the previous diagram, but they are now in the same hand. The diamond menace is 'under' East. The extra control and entry in spades, the suit of the double menace, is the compensation. This, too, is a simultaneous double squeeze.

4. *Both one-card menaces in a double squeeze are in the same hand as the squeeze card.* Now the double menace must be headed by two winners to make room for the extra cards in the opposite hand.

The spades in the North hand represent an 'extended menace'; the opponents need to keep three cards of the suit, while the player with the squeeze card needs only one. The queen of clubs operates a double squeeze.

5. *A criss-cross squeeze in which a trump is substitute for a top control.* A squeeze that is possible by virtue of the trump element is called a 'ruffing squeeze'. In this example spades are trumps:

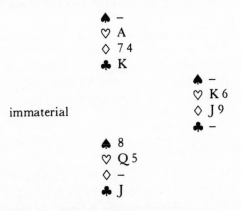

South leads the jack of clubs to dummy's king and East is squeezed. The play is similar to a criss-cross squeeze, with declarer's trump in this example playing the role of a top diamond.

Finally, we look at an arrangement of menace cards where the declarer is able to gain two tricks from the squeeze.

6. *Two tricks from a squeeze*. To achieve this, declarer needs two two-card menaces and one one-card menace, favourably positioned, all lying against the same opponent.

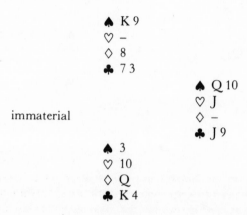

Declarer has only three top winners out of five cards, but East has control in three suits. Whatever he discards on ◊ Q he can be subjected to a further squeeze on the next trick.

It is also possible to gain two tricks from a squeeze when there is an extended menace opposite the squeeze card and two one-card menaces in the same hand as the squeeze card. This leads to a 'repeating' or 'progressive' squeeze.

There are many squeeze positions besides these, some including the element of a finesse, throw-in or unblock. The way to become proficient at squeeze play is to study the mechanics, so that you know what you are looking for. You will find that there are squeeze possibilities in a high proportion of the hands you play.

HOW TO BEAT SQUEEZES

Play to kill menaces or keep guards in both hands.

In the diagrams we have given there has been no defence against the squeeze. In actual play more than half the contracts that are made by squeeze play could be saved by best defence. To take deliberate action to prevent a squeeze from developing you need to be an expert in squeeze play yourself. We will do no more here than give some advice under general headings.

Discarding. There are two principles worth bearing in mind. (1) When both your partner and yourself guard two double menaces, release the suit that is held on your left rather than the suit that is held on your right. (2) When both partner and yourself control declarer's two-card menace and his one-card menace, and you have to release one or the other, release your grip on the two-card menace. That is because (with one rare exception) a one-card menace which both defenders control is of no value to the declarer.

Killing menace cards. Try not to leave odd menace cards in dummy or the declarer's hand. For example, as West you may lead the following suit against a trump contract:

```
                    9 7 4 2
        A K Q 10 8              J 3
                    6 5
```

You win the first two tricks. Now, if you have another quick entry, and other cards to protect, it may be necessary to continue the suit so that you will be able to play a fourth round before declarer can exert any pressure.

Share the burden of controlling menace cards.

If you cannot kill a menace completely, try to arrange that both defenders control the suit. This requirement will often make it unwise to continue a suit you have led. Example:

```
                    9 7 5 3
        A K J 4 2               Q 10 6
                    8
```

You lead the king of a suit which partner has supported. If you fear a squeeze ending, do not play a second round. Declarer may not have enough entries to ruff away East's guard.

Wrecking the declarer's timing. This is the most skilful form of defence. As we explained above, a declarer in, say, 6NT will generally need to lose a trick early on in order to execute a squeeze. The defenders can often thwart this plan by refusing to take their winner. For example, a declarer with K–x opposite Q–J–x may want to force out the ace. The best defence, very likely, will be to refuse to win either on the first or second round. Similarly, when the contract is 3NT, a defender should usually not cash the fourth trick for his side unless he can see clearly where the fifth trick is coming from.

How to Steal Tricks

Discretion may be better than valour, but deception can be more effective than either. A player whose manoeuvres are not transparent and who has a knack of turning up with unexpected cards will win much more than one whose game is sound but predictable.

Before examining the standard moves in a single suit, we look at some bluffs that amount to complete tactical plans. These often depend on psychology and the calibre of the opposition, but that does not mean that they work only against moderate opponents. Some deceptions will work only against good players, and some, of course, are effective only against weak players who do not see the flaw in the picture you are trying to present.

Defenders tend to do the opposite to the declarer, so as declarer you can exploit that by pretending to do something that you do not really intend. One homely manoeuvre, when you want a trump lead, is to play as though you want to ruff. Another is to lead your weakest suit at notrumps, such as from x–x–x to J–10–x in the closed hand. Equally well known, and less likely to meet a humiliating counter, is the stratagem of losing the lead at an early stage before the defenders can read the position.

```
                  ♠ K 8 3 2
                  ♡ A K 3
                  ◇ 7 5 3
                  ♣ 8 7 2
    ♣ 4 led
                  ♠ A Q 5
                  ♡ Q 10 2
                  ◇ A J 9 6 2
                  ♣ K J
```

South	North
South	*North*
1 ◇	1 ♠
2NT	3NT
Pass	

West leads the 4 of clubs and East plays the queen. Rebidding notrumps instead of raising partner has turned out well, for West will have no reason to place you with such strong spades. If you cross to the ace of hearts and lead a diamond to the 9, West will have no way of telling, at this point, that your jack of clubs is unprotected. (He knows from the play to the first trick that you hold the jack.) If he is not counting your points, West may entertain hopes of finding his partner with the ace of spades. Now you can test spades, reverting to diamonds if they do not break. This is a much better line than playing spades immediately, disclosing that you have tricks in the suit and possibly giving the opponents a chance to make informative discards.

Don't wait for a holding like K–J or A–J in the opponents' suit for that kind of play. If you win boldly with A–x or A–x–x, your opponents may credit you with more protection than you really have, from the failure to hold up.

The early play of a suit will often put a defender under pressure. A lead towards K–x–x–x may tempt a defender to go up with the ace, lest the lead be a singleton. As declarer you can exploit that tendency by making the same play when you have Q–x in the closed hand. It is also good play to lead early from x–x to K–J–x–x. If West plays low he is more likely to hold the queen than the ace, which he might be tempted to play.

Now suppose you are defending against 3NT and the declarer, disdaining a long broken suit on the table, leads another suit. What inference do you draw? Unless the bidding has suggested that declarer may have a singleton or void, always assume that he holds the missing cards in dummy's suit and is trying to snatch a trick before you can read the position. So do not hold up a winner in the short suit. That is a recognized principle of defensive play, so as declarer you have to be cunning in a situation like the following:

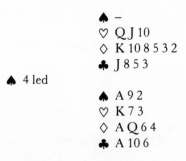

```
                          ♠ —
                          ♡ Q J 10
                          ◇ K 10 8 5 3 2
                          ♣ J 8 5 3
        ♠ 4 led
                          ♠ A 9 2
                          ♡ K 7 3
                          ◇ A Q 6 4
                          ♣ A 10 6
```

You open 1NT and partner hopefully raises to 3NT. A hold-up of the ace of spades is not likely to gain, so you win East's queen with the ace. With eight tricks in sight, what is the best chance of snatching a heart trick?

If you play off the diamonds you will not have much chance against respectable opponents, and if instead you lead a small heart towards dummy, West will think it odd that you are not interested in diamonds. You must emit some kind of smoke screen.

Suppose you lay down the ace of clubs, then lead a small heart. If West holds the queen of clubs it will appear to him that you are bent on a finesse, and that matters are not progressing unsatisfactorily for the defence. He is now more likely to duck with ♡ A. The lesson is: try a small diversion before making the critical play.

Because defenders expect the declarer to take quick discards if he can, there is opportunity for deception on a hand of this type:

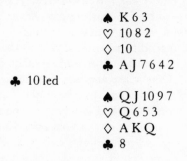

```
                          ♠ K 6 3
                          ♡ 10 8 2
                          ◇ 10
                          ♣ A J 7 6 4 2
        ♣ 10 led
                          ♠ Q J 10 9 7
                          ♡ Q 6 5 3
                          ◇ A K Q
                          ♣ 8
```

Playing in four spades, South wins the club opening and decides that the best chance is to play for two heart ruffs in dummy. If he cashes the diamonds and pitches two hearts the defenders will win a heart lead and play ace and another trump. Instead, South should lead a heart from dummy at trick 2. If the queen loses to West's ace

or king, a club may come back and now it may be possible to ruff the hearts without interference.

As at poker, it is useful to be known as a possible bluffer even if few of your bluffs actually succeed. Once you are recognised as capable of that kind of stroke, you gain benefits on hands where you are not bluffing at all.

Some of the best bluffs occur when you start at the bottom of the class and can only climb upwards.

(1) J 10 5 (2) K 6 4

 Q 8 6 3 2 J 7 2

In (1) you are in a slam and this is your trump suit. In an international match, what would you give for your chances of making the slam? In (2) you are playing at notrumps, with no entry to the South hand. What are your prospects of taking two tricks?

Unlikely as it may seem, both stories had a happy ending. With the first combination, the declarer led small from dummy and won the trick with the queen. Realizing that West might have held up with K–x–x, South played on the defender's nerves by leading low towards the table. West, fearing he had given some indication and determined not to be caught, went up with the king.

With the second combination the declarer led dummy's king, which held, and continued with a lead towards the jack, which also held. West had held off with A–x–x, placing South with Q–J, and it had not occurred to East to put up the queen on the second round from Q–10–x–x. The lead of an unsupported king from dummy always has some chance of succeeding against good opponents.

Defenders do not have as many opportunities for bluff tactics as the declarer, who has no partner to worry about, but there are three general situations where a defender can expect his partner to co-operate in, or at any rate not to be misled by, an imposture. One consists of pretending to be able to ruff. This is a routine measure for good defenders, who will try to rattle declarer in a situation like this:

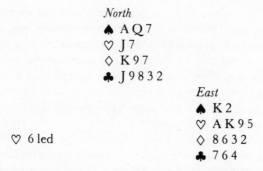

```
                    ♠ Q J 10 3
                    ♡ K Q 7
                    ◊ A Q J 5
                    ♣ 7 3
    ♠ 9 7 4 2                          ♠ A
    ♡ 9 8 6                            ♡ J 5 4 2
    ◊ 8 7 4                            ◊ 10 6 3 2
    ♣ A Q 5                            ♣ J 9 6 2
                    ♠ K 8 6 5
                    ♡ A 10 3
    ♡ 9 led         ◊ K 9
                    ♣ K 10 8 4
```

After opening a weak notrump South lands in four spades and wins the heart opening in hand. A trump goes to the 10 and ace, and it is natural for East to switch to clubs. The best card is the 9. West cashes the ace and queen and leads a third round. Now declarer, not knowing that the spades are 4–1, may ruff high in dummy.

Another occasion for deceptive play by the defenders is when the declarer is on a discovery mission. There can be great art in concealing high cards as well as in searching for them. Here is a simple example:

```
                    North
                    ♠ A Q 7
                    ♡ J 7
                    ◊ K 9 7
                    ♣ J 9 8 3 2
                              East
                              ♠ K 2
                              ♡ A K 9 5
    ♡ 6 led                   ◊ 8 6 3 2
                              ♣ 7 6 4
```

South is in six spades after East has dealt and passed. On the lead of ♡ 6 East must play the ace, not the king. He expects the heart to be ruffed and to come in later with ♠ K. If by that time East has revealed ♡ A–K as well as ♠ K, South will place West with all remaining significant cards.

Finally, a defender can achieve surprising results by not playing off a winner. Sometimes it is a matter of ordinary technique to hold

back a winner until you can see where the setting trick is coming from, but such a move may also have deceptive implications.

```
                    ♠ K 6 2
                    ♡ K Q 4
                    ◊ K J 2
                    ♣ A Q 7 5
  ♠ J 8 7 5 4                      ♠ A 10 3
  ♡ 9 6 3                          ♡ J 10 8 5
  ◊ A 8                            ◊ 9 6 4 3
  ♣ 10 4 2                         ♣ K 8
                    ♠ Q 9
                    ♡ A 7 2
  ♠ 5 led           ◊ Q 10 7 5
                    ♣ J 9 6 3
```

South is in 3NT and a spade is led. Declarer plays low in dummy and wins East's 10 with the queen. West wins the second round of diamonds and on the return of ♠ J South, unable to tell who has the ace, puts up dummy's king. A third spade will beat the contract at once, but East can work out that South cannot run more than eight tricks on any return. East leads a diamond, therefore, and now South will surely try the club finesse and go two down.

We turn now to a group of single-suit plays about which much has been written in books and magazine articles. They have thus become standard equipment for good players. Most of these plays have many variations and we will attempt no more than to give the most familiar setting.

FALSE-CARDING BY THE DEFENDERS

With a choice of cards to play, select the one that you are known to hold.

An important principle of defence is to play at an early opportunity a card of no trick-winning value which declarer knows you hold.

```
(1)           K J 2        (2)            A Q 8 4 3
      Q 10 4         8 5 3       K J 5 2          10 9 6
              A 9 7 6                       7
```

With (1) declarer finesses the jack and continues with the king. Since West is marked with the queen he should drop it on the second

round. With (2) South finesses the queen and cashes the ace, intending to ruff out the suit. So long as the king is unplayed, South will know he can safely ruff low.

The same principle can be extended to situations where a defender is not already marked with a certain card but soon will be.

```
              A Q J 6 5 2
     K 9                       10 7 4
              8 4
```

There is no problem if West plays low on a lead from the South hand. If West puts up the king South may be impelled to duck, either because of lack of entries to dummy or because he cannot afford to lose a trick to East.

Drop a high spot card to induce declarer to make a losing play.

There are endless variations of the following theme:

```
(1)        A Q 7 2            (2)        A Q 9 7
     K 6           10 9 3          4              J 8 5 2
           J 8 5 4                    K 10 6 3
```

In the first example East must drop the 9 or 10 when South finesses dummy's queen; otherwise South will have no option but to continue with the ace. The play of the 9 leaves it open to South to re-enter his hand and lead the jack, playing East for 10–9 or a singleton.

In the second diagram South leads low to the queen. Now it is good play for East to drop the 8. Unless South knows his way around he will return to the king, expecting East, if anyone, to be short in the suit.

When forced to open a dangerous combination, consider the unorthodox lead of a high card.

There are not many occasions where the defenders are better able to deceive than the declarer, but it can happen when a 'dickey' suit is played. For example:

```
(1)        K 7 5              (2)        J 9 2
     A Q 2         J 9 6 3         Q 10 6        K 7 5 3
           10 8 4                     A 8 4
```

In (1) West leads the queen, intending to continue with the 2 if South ducks. The declarer cannot tell whether West is leading from his actual combination or from Q–J–9. In (2) East is on play and leads the king. South may duck, placing him with K–Q–10–x.

If these two examples are looked at from a different angle, so that North–South are the defenders, it will be seen that the declarer cannot present his opponents with the same dilemma. That is the defenders' advantage. The lesson is that in these situations the lead of an unsupported high card is often best. We noticed the same point when studying the defence to elimination play.

SINGLE-SUIT PLAYS BY THE DECLARER

Conceal your strength in the suit the defenders attack.

At notrumps, especially, the defenders will sometimes attack in a welcome quarter. To encourage them, the declarer plays what would be an encouraging card if he were the leader's partner.

```
                        10 3
        Q J 9 8                       5 4
                      A K 7 6 2
```

On the lead of the queen South encourages with the 6, and if West continues South gains a tempo. Note that we advise the 6, not the 7. In general, when making a false signal of that sort, play the nearest card above the one played by the right-hand opponent.

Another good move, when a welcome suit has been led, is to duck even when you have a possible chance to take all the tricks.

```
                         K 3
        10 8 7 5                      J 4
                      A Q 9 6 2
```

West leads the 5 and East plays the jack. Drop the 6, concealing the 2. East will return the suit and you will have gained a tempo.

Sometimes the way to conceal strength is to win with a higher card than necessary. The following situations are well known, but still effective:

```
(1)             8 4                (2)              6
       K 10 7 6       J 9 5 3             A Q 9 5 4       10 8 7
             A Q 2                              K J 3 2
```

In each case South is in notrumps and is wide open in another suit. Knowing that the first defensive trick will be won by West, South plays deceptively on the opening lead. In (1) he wins the jack with the ace, in (2) the 10 with the king. When West is in, he may lead low again.

In the middle game, arrange your plays so as to interfere with the defenders' signals.

There are some tricky ways of preventing a defender from reading his partner's signal in a situation like this:

KQJ3

10 7 5 A 9 4

862

South does not want East to hold up the ace till the third round. If South leads the 2 East will observe West's 5 and will hold up. To make it more difficult, South leads the 6 or 8 first time and makes the next lead from dummy. East then has to play to the second trick without knowing whether West is proposing to complete an echo. In all such situations, the aim is to make the defender with the stop card play second to the vital trick.

Similar plays can be made with a more general purpose.

(1) K Q 5 (2) A Q J 2

A 6 2 K 8 3

In (1) South is merely crossing to dummy. By leading the 6, concealing the 2, he may leave at least one of the defenders in some doubt as to who holds the ace. In (2) South should lead the 8 to dummy's queen. West may think that East has urbanely held off.

Tackle suits in such a way as to mask the closed hand.

What is apparent to the declarer may be hidden from the defenders. Consider these two diagrams:

(1) A Q 6 2 (2) Q 6 3 2

8 4 K 8

In each case you want two tricks. The orthodox play in (1) is the finesse, in (2) low to the king, ducking later rounds as necessary.

If the general situation permits, it may help to execute those plays in a particular way, the object being to disguise the holding in the closed hand. In (1), lead low from the table on the first round. If nothing happens you can still finesse on the second round, but meanwhile East may oblige by going up with the king. In (2), having led low to the king in the normal way, do not lead the second round from the closed hand. Instead, cross to dummy and lead away from the queen. East may think your original holding was K–J bare and that it is time to go in with the ace.

The same principle may present an advantage when you are simply cashing winners, not developing them. Suppose you are in a trump contract with one of these combinations:

(1) A J 5 2 (2) ♠ A K 3
 ♡ J 8 7 5

 K Q 3 ♠ Q J 10 6 2
 ♡ A K Q

In the first diagram you are planning a cross-ruff and want to cash three tricks in this side suit. There is only one correct order of play: the king, low to the ace, then back to the queen. If East has a doubleton he may put you with K–x.

In the second diagram spades are trumps and you have no outside entries to dummy. You want to cash three hearts and be in dummy after the third round of trumps, so that you can cash ♡ J. The best sequence is ♠ Q, followed by ♡ A and ♡ K. Then cross to ♠ A and lead towards ♡ Q. Even if East is out of hearts he may not ruff, as it may seem that you began with ♡ A–K alone and are trying to bring down the queen.

To crash the defenders' trump honours together, lead an honour towards the closed hand.

Because it is often correct for the defenders to cover an honour with an honour, a declarer can sometimes induce them to make a wrong play in situations like the following:

(1) Q 6 3 2 (2) J 8 6 2

 J 10 8 7 5 4 10 9 7 5 3

The principle is to lead the high card from dummy. In (1) East may cover with K–x, hoping West holds 10–x–x. In (2) he may play the ace from A–Q–x, or even an honour from K–Q–x.

In an earlier chapter we remarked that defenders should be suspicious of the lead of an unsupported honour, since such a lead is not often sound play and may therefore have a deceptive purpose. However, if the bidding or play has marked West with a shortage in the trump suit, you can put East to the test in this type of situation:

(1)	9 7 3	(2)	Q 6 5 3
	A K 6 5 4		10 8 7 4 2

With (1), when you lead the 9 from dummy, East knows you are going to play him for length and may cover with Q–J–8–2. Now you can manoeuvre to lose one trick instead of two. The point of this type of play – there are many similar situations – is that you lose nothing if the suit breaks in civilized fashion, or if East refuses to be drawn.

With (2), provided East is marked with more than a singleton, it is good play to make the unusual lead of the queen. If East holds K–J–9 or A–J–9 you cause him a pensive moment.